RIGHTFUL TERMINATION

DEFENSIVE STRATEGIES FOR HIRING AND FIRING IN THE LAWSUIT-HAPPY 90'S

JAMES WALSH

MERRITT PUBLISHING, A DIVISION OF THE MERRITT COMPANY

SANTA MONICA, CALIFORNIA

Rightful Termination

First edition 1994
Third printing
Copyright © 1994 by Merritt Publishing, a division of The Merritt Company.

Merritt Publishing
401 Wilshire Boulevard, Suite 800
Santa Monica, California 90401

For a list of other publications or for more information, please call (800) 638-7597. In Alaska and Hawaii, please call (310) 450-7234.

Library of Congress Catalog Card Number: 94-076409

Walsh, James
Rightful Termination—Taking Control
Defensive strategies for hiring and firing in the lawsuit-happy 90's.
Includes index.
Pages: 362

ISBN: 1-56343-067-3
Printed in the United States of America.

Acknowledgements

In writing this book the author has benefited greatly from the enthusiasm of many people whose help proved invaluable. All agreed that business people could use a book about hiring and firing employees firmly and fairly. This book seeks to fill that need.

The author would like to thank the following for their assistance and input: the American Society for Personnel Administration; the American Society for Training and Development; William Bell; the California Manufacturers' Association; Chubb Insurance Group; Clark, Ladner, Fortenbraugh & Young; the Dartnell Group; James Dertouzos, Rand Corp. Institute for Civil Justice; Steven Drapkin; Edgar Ellman; the Employment Law Institute (San Francisco); Richard Epstein, University of Chicago Law School; Philip Garment; William Gould, Stanford Law School; Ronald Green; Robert Half International, Inc.; Jones, Day, Reavis & Pogue; Jorgenson & Associates; Chris Keiner; Peter Kelly, Korn/Ferry International, Inc.; the Massachusetts Restaurant Association; the National Tooling & Machining Association; the New Hampshire Insurance Co.; David Perrault; Pinkerton's, Inc.; Linda Reitman; Brad Seligman; Gloria Shanor, Georgia-Pacific Corp.; Kenneth Teel; and Tom Zito, Digital Pictures Inc.

As long as this list is, many more people and groups added information and insight to the book. Our thanks to all of them.

Rightful Termination is the second title in Merritt Publishing's "Taking Control" series, which seeks to help employers and business owners grapple with and overcome the host of extraordinary risks facing the modern enterprise.

Upcoming titles will cover strategic planning, product development and marketing, corporate finance and liability, among other subjects. To keep these projects — and the series as a whole — well focused, we welcome feedback from readers.

Rightful Termination
Table of Contents

Prelude: Taking Control

This book is about dire consequences. Every time you hire a worker, you risk being sued, especially if you make the worker want to punish you. Hell hath no fury like an employee you've just fired.

Why?

Work is important; almost everybody engages in it. People work to make money, but also to define themselves. Thus power of a very subtle kind flows from work. Naturally enough, this attracts government. Government knows a lot about power but very little about work. It knows nothing about the subtle ways in which work transforms the life of the individual.

This makes government a stumblebum regulator of the job market and, worse, an abettor of the unhappy worker who wants to sue.

Make no mistake about why government intervenes, however. It wants employers to treat their employees fairly—a noble goal. And it involves itself because workers feel themselves wronged and powerless when they lose a job, and because the relationship between employer and employee is not one between equals.

The Unequal Party

By its sheer bulk government skews that relationship way off in the other direction. In the form of the courts, especially, it offers itself as a source of power to the unequal party, the employee. Unhappy workers use that power to get even with those who have wronged them. They resort to government's formal means of resolving differences and turn them into instruments of revenge.

At its best this prevents the unscrupulous employer from running roughshod over the employee. At its

Power of a subtle kind

It doesn't get easier with practice

worst it strips the fair employer of the prerogative to govern the workplace in accordance with the needs of the enterprise.

But government can't overwhelm the relationship between you and your employees. It paints with a broad brush. It can't micromanage, however much it might seek to do so. It can't look over your shoulder at every moment of every day.

It can't strip you of your freedom to *manage* relations with your employees, in other words.

This leaves you plenty of weapons with which to fight back — plenty of ways to take control of what you do in hiring and firing people. Your weapons lie hidden under layers of bureaucratic, legalistic sludge, but they're there. You just have to dig for them.

Never an Easy Job

Employers fire or lay off more than three million workers every year in the United States. The overwhelming majority of these workers — more than 80 percent, by most estimates — find other jobs.

But it doesn't get easier with practice. Firing people is one of the toughest and most unpleasant things you do as employer. Your stomach tightens and your throat gets dry as you prepare to call someone in for the meeting that begins, "There's no easy way for me to do this. . . ."

If you're like most employers, it feels as much like a failure on your part as on the worker's.

In a sense you have failed; you didn't hire the right person for the job. Now you bring on a crisis in the life of the individual and his or her family. It's not easy to do this without feeling responsible.

Worse, you may push your unhappy employee out the door into the arms of a lawyer only too ready to enlist in the worker's effort to punish you. It's hard to emerge from such a fight unscathed, even when you win.

It wasn't always this way. In America's years of rapid industrial growth, the demand for labor was high, and employers hired and fired without doing great

damage to the lives of their workers. Jobs weren't hard to find. Neither were workers.

But in this century work became scarce and labor plentiful. Labor enlisted government on its side, bringing about a fundamental change in the way employers and employees deal with one another.

At the state and federal levels, government began regulating the relations between employer and employee in earnest in the 1930s. It engaged in a flurry of lawmaking in the 1970s. It may engage in a similar flurry in this decade.

In this process the legislative branch of government concentrated on how employers go about hiring people. The courts, on the other hand, concentrated on how employers fire people.

By any measure, the courts plow a more fertile field. According to Paul Tobias, founder of the plaintiff-side National Employment Lawyers Association: "We get 500 to 1,000 telephone calls a year, and of those, no more than 5% concern hiring. And of our 50 or 60 cases in court,[1] I don't think one concerns hiring."

The Old Assumptions

In this climate, the old presumptions concerning the employer-employee relationship — about what makes a contract, what constitutes a legitimate business interest, and who controls the relationship — don't automatically apply. Workers hold rights they didn't have a century ago.

The courts enforce these rights rigorously and expand them where possible.

Worse, the legislative branches of the federal and state governments don't act consistently in intervening between employer and employee. The ensuing disarray of statutes and rulings prompted one judge to write that employment termination law has become "an amorphous mass of confusion."

This uncertainty encourages increasing numbers of employees to bring lawsuits alleging wrongful termination. They sue with a good chance for some kind of settlement or award. If the Equal Employ-

[1]In late 1992.

Don't wait to fight in court

exceeded $150,000, almost equaling the damages paid.

Attorneys profit almost as much as their putative beneficiaries. And they don't lack for business. "Now, every time a person is terminated, an employer faces a lawsuit," says one California lobbyist.

Little wonder that employers hesitate to fire even unproductive workers.

Rather than hesitate, however, you must fight back by arranging things so as to make a post-termination lawsuit difficult.

This means *preventing* litigation. *It does not mean that you wait to win your case when it goes to trial,* because by that time you've already lost.

Avoiding Lawsuits

It also means being careful. In protecting yourself from lawsuits, you can create new problems if you get sloppy.

For example, if your practices don't match your policies, you leave yourself open to depredation. If you specify too closely what you expect from your workers, you may create contracts you didn't intend. (You may also convince your employees that you don't trust them. This hurts morale, increases turnover and boosts the likelihood of lawsuits.) If you don't specify closely enough what you expect, on the other hand, you force your employees to work in confusion — with the same result.

In a 1992 study, the Rand Corp. assessed the costs of the tendency to hang on to unproductive workers. "[F]irms can avoid the legal threat by not firing workers even when justified by economic conditions or poor job performance," the study found. "The firm might adjust the employee mix, trading off production efficiency for diminished exposure to liability. . . . Firms would be prone not to adopt new technologies that displace labor in favor of capital equipment."

Simply put, the harder it becomes to fire employees, the harder it becomes to hire them. As employees

assert their rights, employers assert one of their own — the right not to hire at all.

Everybody loses when they exercise that right.

The State Mishmash

The states vary widely in their treatment of the relations between employer and employee. As they pass laws governing these relations, legislators respond to the pressures of the moment, pleasing this interest this year and that interest next.

The resulting mishmash hurts everybody. It hurts your employees, who don't know their rights; it hurts you because you end up with few reliable standards to show you how to act fairly in discharging employees.

The same uncertainty, meanwhile, gives the courts wide latitude to hack away at the presumption that the employer may hire and fire at will.

To a degree, you can protect yourself from this uncertainty by buying employment practices liability insurance. To a lesser degree, you can protect yourself by lobbying your legislators to change this or that law. But like muskets, these are imperfect weapons of uncertain aim — and not always available.

The better way is to give no opening to those who "protect" workers by separating employers from their profits. You do this by taking control of your workforce and of the ways in which you hire and fire: by hiring and managing in such fashion that when you must fire an employee — or choose to fire one — you may do so without damaging your operations or spending a lot of money on lawyers.

A few principles guide you in this process:

- Like it or not, you must acknowledge the importance of the paper trail. Employers err greatly in failing to document what they do in hiring and firing. Lawyers subpoena records not so much for what they hope to find as for what they hope not to find. They want you *not* to document your decisions and actions. This leaves them free to characterize how you do

Treat your employees fairly

business to suit their own purposes. You aid and abet them greatly if you can show nothing to prove them wrong.

On the other hand, lawyers get nervous when they see lots of paperwork detailing how you hire and manage people — and fire those who don't cut it.

You must make certain, of course, that your paper trail doesn't prove the wrong things. It must show what you want it to show: that you treat your people fairly and that you don't act on whim. Lawyers don't sue such people.

- In all you do respecting your employees, seek simplicity and consistency.

You know the needs of your enterprise better than anyone else. Build a program that focuses on those needs, and stick to it. Understand that in seeking to regulate hiring and firing, government paints on a very broad canvas. For this reason, it often contradicts itself, and in any case it can't address the particulars of your operation because it can't know them. You can, so it makes sense to go about hiring and firing people with those particulars in mind.

- Hire with an eye toward firing.

This is a hard lesson to learn — maybe the hardest, because it goes against the natural hopefulness of the employer. Hiring, after all, is an act of faith; you hire in the expectation that your worker will succeed, not fail, and it's hard to accept failure.

But you can't guarantee anything at all, and you can't rub out the difference between expectation and reality. You may be a shrewd judge of character, but you can't know in advance what anyone will or will not do. Tomorrow you may have to fire someone who wins your confidence today. It doesn't matter what hopes you entertained in hiring the individual; things don't always work out.

You must take precautions against this very likely possibility at every turn. In hiring someone you must prepare to fire the same individual. You must state your faith in the future without, as it were, insisting that the future prove you right. You must act with no illusions. You must hire people in the hope

that they will do well, but never kid yourself as to your prescience.

- Don't listen to those who make their living by intruding into the relations between you and your employers. They love jargon and technicalities; they *invent* jargon and technicalities so as to put you on the defensive. But you don't have to go along. You invent something of your own every day—namely the success of your enterprise. You depend on that success, and so do the people who work for you. They have an interest in that success, too, and they don't like jargon and technicalities any more than you do. Work *with* your employees to ensure success and to make jargon and technicalities irrelevant. Above all, don't despair. It's hard to take control, but it's not impossible.

Learn from Circumstances

As Ben Franklin said, if you prepare for the worst, the not-so-bad comes as an pleasant surprise.

To be sure, you can't make firing someone a pleasant afternoon's interlude no matter how you prepare. And you can't escape a sense of error since, after all, if you fire someone, it means that you didn't hire the right person in the first place. But errors are part of business — and life. You do best to resolve them quickly and learn from the circumstances that surround them.

Besides, *not* firing a problem worker is often the worst thing you can do. It keeps the problem worker around to create trouble for the enterprise as a whole, making a bad situation worse. That's not fair to you or to your other employees.

But if you can't keep people from doing unpredictable things, you can make sure that you give your employees no grounds on which to pick a fight. You can put into practice the notion that, in hiring and firing, the best offense is a good defense, and thus ensure that, even if you send someone away unhappy, that person will not seek revenge.

This books seeks to show you how to avoid the many

The good of all

troubles centering on hiring and firing. It takes as its own the Boy Scout motto: Be prepared. It argues that you limit the unpleasantness of firing people if you prepare to do so right from the beginning of the relationship with each individual. It lays out the ways by which you retain your freedom to fire people, when necessary, without running undue risk of litigation.

Above all, this book argues the notion that the relations between you and your employees are of fundamental importance to both, and that the power to govern those relations for the good of all lies in your hands. Money and power pass from you to your employees, and lots of folks, seeing the loot, seek to intrude. But only you hold the power to shape the way your workers sign on, advance in, and depart from your employ. You decide whom to hire and to fire. You decide when. You decide how.

Ammunition

You decide, in other words, whether to give ammunition to those people — angry workers, union bosses, lawyers, the courts, the legislatures, the regulators — who want to stand between you and your freedom to govern the future of your own enterprise.

You just have to cross all the t's and dot all the i's, of which there are many.

If you succeed, you do good things for many people, starting with yourself and those who work for you.

CHAPTER 1:
AT WHOSE WILL?

Most disputes over hiring and firing focus on one question: Does the employee work at the will of the employer?

The concept of at-will employment originates in the 1877 *Treatise on Master and Servant* of legal theorist Horace Wood. Wood defined at-will employment as including all general or indefinite hiring. He argued that unless a contract specified definite periods or terms of service, the employer retained the right to dismiss employees "without notice at any time or for any reason, or for no reason at all."

Likewise, employees could quit at any time and for any reason.

Things have changed quite a bit since 1877. The tides flow heavily against the at-will presumption, whose critics see it as anachronistic, harsh, and inconsistent with the realities of economic life. More and more, the courts go along with these critics. They limit the circumstances in which you may fire a worker simply because you want to. They read implied contracts into the vaguest language, even into inadvertent action. They see malicious intent in innocent habit.

A One-Way Street

It comes as no surprise that as the courts limit the freedom of the employer to hire and fire at will, they do little to limit the freedom of the employee to come and go at will. Employers salt "non-compete" clauses into the employment contracts with which they seek to bind important workers to the enterprise, but in state after state the courts tend to uphold such contracts only grudgingly. And to be sure, in the absence of any employment contract, the employee remains free to quit on a moment's notice irrespective of the harm done to the enterprise.

The central question

In the debt of the trial bar

Politics motivate this progression. Interest groups like the American Civil Liberties Union and the American Trial Lawyers Association stand ready to try the cases of workers who feel themselves wronged, and employers who feel *themselves* wronged need not apply. Worse, the trial bar keeps countless politicians in the statehouses and in Washington in its debt by contributing heavily to their campaigns.[1] Time after time this influence pays off as tort reform bills die slow deaths.

The ACLU, meanwhile, believes that more than 150,000 workers lose their jobs each year under what it calls the "archaic 19th-century doctrine [of] employment at will." The organization argues that employees should be fired "only if their conduct impair[s] job performance in a significant way," violates company rules or is serious enough to warrant termination.

The ACLU — which protects the right of Nazis to march in places like Skokie, Illinois, and the right of pornographers to pass themselves off as artists — wants to write your employment policies. To a surprising degree, it already has.

'Just Reason'

In 1987, Montana passed landmark legislation taking this debate one step farther. It required employers to show "just reason" when firing workers. Other states require that you show good faith (and sometimes just cause) when firing an employee who has worked at your company for a variously defined "long time."

The hazard to the small employer is real. The employees most subject to at-will termination work for small business, and as employees become more litigious, they take aim at small employers. The trial bar gladly takes on such cases if the employer carries employment practices insurance. If not, the case promises less lucre, but a good trial lawyer knows the nuisance value of such a case to the penny — and insists on it.

[1]The trial bar was, for example, one of the biggest contributors to the campaign of Bill Clinton for the presidency in 1992.

The bias of the legal system in favor of the employee probably increases turnover, despite the limitations imposed by the scarcity of work and the surplus of labor. This in turn makes recruiting new employees all the more expensive. Even more pressure on costs comes from the threat of wrongful termination suits from fired workers.

A host of laws backs the angry worker up, ranging from the National Labor Relations Act to Title VII of the Civil Rights Act of 1964, and, on the state level, from statutes precluding discharge for filing workers' compensation claims to those protecting employment under the guise of civil rights. All circumscribe the at-will doctrine.

What can you do to preserve what remains of that doctrine? More than you might think.

Most important, you can assert your right to it, despite the bias of the law and the courts against it. Asserted — and defended — aggressively, it protects you from the growing number of wrongful termination lawsuits filed every year. The key here is to go about doing so aggressively. This chapter focuses on the degree to which you can assert and defend your freedom to hire and fire at will by reviewing the history and status of the at-will presumption.

Remember as you read it that the trial bar and the ACLU count on your knowing nothing about the law. Your ignorance is their greatest weapon.

The Challenge

Your claim to the at-will presumption is like a copyright. If you want to keep it, you have to enforce it. You may still lose it even if you enforce it. But you must try anyway.

A clear example of the erosion of the at-will presumption comes from the 1989 California Court of Appeals case *Bell v. Superior Court of Los Angeles County (in fact: 20th Century Insurance Co.).*

Kay Bell claimed wrongful termination when she lost her job as vice president of California-based 20th Century Insurance. The company fired her without notice or explanation in 1988 after more

An implied contract

than eleven years of service.

At the time, Bell was vice president of human resources — always a tough person to fire. Throughout her tenure she had won praise for her performance, receiving promotions and salary increases, bonuses and stock grants.

She claimed that, in doing this, 20th Century implicitly promised that it would not dismiss her except for justifiable cause.

Written Policies

The company did make such promises — though not to Bell personally — in written personnel policies and procedures that Bell helped draft.

The crux of Bell's argument was that her longevity of service proved that the policies applied to her specifically.

The California Court of Appeal agreed. Under state law, the court noted, corporate officers serve at the pleasure of a company's board of directors, but this didn't prevent Bell from seeing an implied employment contract in the policies she helped draft.

The court pointed out that, although California labor law presumes that "employment, having no specified term, may be terminated at the will . . . this presumption may be superseded by a contract, express or implied, limiting the employer's right to discharge the employee."

It ruled that Bell had established "that, despite the absence of a specified term, the parties agreed that the employer's power to terminate would be limited . . . by a requirement that termination be based only on good cause."

The Bell ruling has implications in the dozens of states — from Massachusetts to Texas to Oregon — that limit the at-will doctrine.

From a judge's perspective, the at-will employer enjoys a bundle of privileges, all of which you can surrender by word or deed.

In the widely quoted 1988 California Supreme Court decision *Foley v. Interactive Data,* the court

acknowledged "the fundamental principle of freedom of contract: Employer and employee are free to agree to a contract terminable at will."

This reflected Horace Wood's theory that when employer and employee don't agree to formal terms, the law presumes the employee to hold at-will status.

Thus in *Foley* the court argued that getting fired is the equivalent of a ruptured business relationship, not a personal trauma. But *Foley* did one other good thing for employers. It outlawed punitive damages in most termination cases, thus stripping the trial bar of the financial incentive to bring litigation. The court had never squarely addressed the issue, but most attorneys assumed punitive damages allowable under termination law.

Impassioned Dissent

The most impassioned dissent from the *Foley* decision reflected this bias. Justice Allan Broussard, unabashedly pro-labor, wrote that the decision "gives the employer an immunity from tort damages he did not expect, and takes from the worker a remedy he thought he possessed."

He had a point. Case law expanded the rights of a worker to collect a full array of damages when an employer breached a contract, if there was one, or acted in bad faith if there was none. *Foley* changed all that by saying that employees may seek only lost earnings when suing for breach of contract or bad faith. Juries could not compensate them for emotional injury, for example, or award punitive damages.[2]

Still, wrongful termination cases remain fertile hunting grounds for plaintiffs' attorneys around the country. Decisions like *Foley* acknowledge the at-will presumption but don't protect it. They stress that you alter the at-will presumption by agreeing to

[2]A caveat: Foley preserved certain kinds of lawsuits for fired employees. Chief among these: breach-of-contract claims even when no written employment contract exists, claims against termination that violate public policy, and claims of defamation or fraud. See Chapter 10 for a full discussion of *Foley.*

Take care what you promise

follow certain procedures in firing employees — or by not firing them for certain reasons.

This means, in short, that you must take care what you promise because you may inadvertently limit the grounds on which you may fire someone.

As recognized by the state courts, the most common exceptions to the employment-at-will doctrine fall into three classes: the implied contract, public policy, and good faith and fair dealing.

The Implied Contract

Lawyers love to argue that an implied contract existed between their wronged client and the employer; it's their favorite exception to the at-will doctrine. In *Bell*, the court defined an implied contract as "one, the existence and terms of which are manifested by conduct." It went on: "The essential difference between an implied and an express contract is the mode of proof."

If that sounds like legal hair splitting, it isn't. It means that you prove the existence of a written contract by producing the contract itself. You prove the existence of an implied contract by citing the conduct of the parties.

The conclusion has to be that you escape the threat of the implied contract only by making sure to stress in writing — on your job applications, in your employee manuals, and on all other forms and documents relating to employment — that your workers serve at will: at *your* will. This is the essence of the hiring-and-firing paper trail.

In looking for implied contracts, the courts study written and oral evidence in the effort to determine company practices and employee work histories. If you have disclaimers on all relevant forms, you give the courts no room to maneuver against you.

But beware. You and your employees needn't agree to explicit terms for the courts to find implied restrictions on your freedom to fire at will. In some states, your employees don't even have to know that terms existed for the courts to go against you.

Generally, the courts seek to enforce the actual

understanding of the parties to a contract. In doing so they inquire into the parties' conduct to see whether it demonstrates an implied contract.

This can diminish the at-will presumption to an arguable question of intent, determined by evidence presented in court. Utah, for example, which had held that an employee hired for an indefinite period was an employee at will, changed its position in the 1987 case *Berube v. Fashion Center*. In this case the Utah Supreme Court decided that 1) the terms of an employee manual can operate as an implied contract rebutting the at-will presumption, and 2) the continued performance of the employee's duties was adequate consideration to support that implied contract.

The Ordinary Details

But the courts find implied contracts in the ordinary details of the life of the enterprise. Longevity of employment, commendations, promotions, even the absence of criticism of the employee's work—all may constitute implied assurances of job security.

And no amount of management savvy can prevent another sometimes-accepted limitation to the at-will doctrine: The courts occasionally rule that seniority itself implies certain arrangements that can limit the at-will presumption. The *Bell* case illustrates this issue explicitly.

Trial lawyers seek limits on the at-will presumption everywhere. They don't always succeed, but that doesn't keep them from trying. In the South Dakota case *Tarkington v. American Colloid*, an employee alleged that a secrecy agreement containing a non-compete clause constituted an implied contract.

In a previous case, the South Dakota Supreme Court had ruled that "a promise of lifetime or permanent employment [is] terminable at will in the absence of some executed consideration in addition to the services being rendered." The additional consideration usually meant the refusal of other job opportunities, an equity investment or — occasionally — significant seniority.

Employees rely on your promises

In *Tarkington*, the fired employee had signed a secrecy agreement containing a non-compete clause. The relevant parts read:

> *Employee further agrees [that] during his employment and for a period of three (3) years after the termination of his employment he will not engage in the development, manufacture or sale of . . . products then being developed, manufactured or sold by the company, either directly or indirectly, as principal, agent, employee or consultant for any firm or corporation . . . without the prior written consent of the company.*

The South Dakota Court took the position that such a standard non-compete agreement — "boilerplate language in an otherwise innocuous document" — did not constitute a waiver of American Colloid's right to fire Tarkington at will. So the company won.

Employee Sacrifices

But not all courts see mere "boilerplate language" in the promises you make to your employees or in the requirements you impose on them. Certain kinds of employee sacrifices can constitute additional consideration and an implied contract.

Avis, for example, transferred a reluctant manager from San Francisco to New York, assuring him that if his new position didn't work out, he could have his old job back. It didn't work out. Avis fired him, and he sued. A federal court in New York ruled that the company had made a promise on which the employee had relied, to his detriment.

A promise is a promise, and it can be enforced by the courts — in the Avis case, to the tune of $300,000 in lost wages and benefits.

If you have a grievance procedure, or even an open-door policy for employee complaints, the courts may interpret your practices to constitute an implied contract for handling problems. In such circumstances, if you fire someone without a hearing — without, in other words, following your own practices — you could lose.

In the 1989 New Mexico case *Newberry v. Allied Stores*, the jury considered whether an employer's words and policy manual constituted an implied contract that limited its ability to fire the employee at will.

Newberry testified that when he took the job with Allied Stores, he understood he would have a great future there. During his training as a manager he was told that the company policy manual was "his Bible," which he must follow.

The manual had all the makings of an implied contract.

The manual's section on involuntary termination stated: "To be discharged as the result of rule infractions, poor performance, or other 'cause' is a situation you, and only you, control."

The New Mexico Supreme Court found that this statement suggested that Allied Stores had a policy of not terminating employment except for good reason. "Based on the totality of the parties' relationship and surrounding circumstances," the court wrote, "it is clear that . . . Newberry could expect [Allied Stores] to conform to the procedures in the policy guide." The employer lost.

Public Policy

The courts overcome the at-will presumption when they find that the firing of a worker undermines "public policy." Usually they do so to protect employees who might otherwise be coerced — via the threat of discharge — into committing crimes, concealing wrongdoing, or otherwise harming society.

It's good policy, but it opens the employer to all kinds of exposure. Under this doctrine you can't fire someone:

- If doing so would be discriminatory under equal employment opportunity law;

- In retaliation for exercising a right protected under the Equal Employment Opportunity Act or legislation such as OSHA, EPA, wage-and-hour or workers' compensation laws; or

The fruits of the contract

- Because the worker undertakes a public duty such as voting in an election or serving on a jury.

Good Faith and Fair Dealing

Some courts limit the employer's at-will presumption when they find a firing motivated by malice or bad faith — a fairly recent doctrine. As time progresses, this complaint may win ever more favor in the courts.

All contracts, including at-will employment agreements, assume that all parties enter into it in good faith — i.e., without intending to defraud one another. The good-faith covenant requires that no party interfere with the right of another to receive the fruits of the contract.

In hiring and firing, the good-faith doctrine usually shows up in cases in which employers terminate workers to avoid paying benefits. Thus an employer shows bad faith in firing someone to prevent the employee from vesting in a pension plan. Even if you produce documentation proving legitimate grounds for the firing, you can still be accused of bad faith.

In a troubling extension of this argument, some states find a good-faith obligation on the part of the employer to keep an employee on the job as long as his or her performance remains satisfactory.

In a Montana case that led to that state's 1987 termination law, a retailer told a store cashier either to resign or face termination. The employer promised to give the woman a good recommendation if she went willingly. Caught by surprise, she signed a resignation letter but never got the recommendation. She went to court and won $1,891 in actual damages and $50,000 in punitive damages.

As this case shows, the courts want you to treat employees fairly to establish good faith—and you don't get to decide what "fairly" means. Judges and juries decide that.

This extension of the good-faith covenant departs radically from the at-will presumption. It holds you

to a standard of behavior not prescribed by public policy and not set forth in an oral or written statement — but no less mandatory for all of that.

Other exceptions to the at-will presumption:

- The Special Detriment Theory — When you recruit someone, and cause the individual to move and lose benefits enjoyed with a previous employer, the courts may find that you had an implied contract not to terminate the employment arbitrarily.

- Invasions of Privacy — An employee in Massachusetts, discharged after the employer forced him to take a polygraph test and answer questions about drug use, sued the employer for invasion of privacy. The employee won $358,000 in potential lost wages and benefits, and an additional $50,000 for the employer's having told other employees that he had been discharged for drug use.

- Intentional or Negligent Infliction of Emotional Distress — If you fire an employee in such a way as to make a jury suspect that you intended to hurt the employee emotionally, the court may limit your at-will presumption.

The Wrong Man

In 1984, an Arizona appeals court allowed a credit analyst to sue American Express for firing him. Amex had fired the analyst for allegedly sending obscene material to a management employee.

The analyst — an exemplary employee for more than 10 years — got no chance to rebut the allegation. Another employee later admitted responsibility for the act.

When the analyst took the company to court, he brought along the employee manual. It declared: "We have enthusiastically accepted our responsibility to provide you with good working conditions, good wages, good benefits, fair treatment and the personal respect which is rightfully yours. . . ."

Employee rights expand

On the strength of that, the court decided that such "representations made by an employer in a personnel or policies manual may become part of an employment contract and may modify the employer's right to terminate an otherwise at-will employee."

Amex had no idea that the blandishments of a handbook could become the binding terms of a contract. Like other employers, it learned that the courts have created a new era of employer-employee relations expanding worker rights and increasing employer obligations.

What can you do to protect yourself?

Many employers choose a legalistic approach to preserve the remains of the at-will prerogative. This breeds a false sense of security. It can make you reactive and defensive, focused on procedures, not on getting at whatever bothers your employees. It can also make the employer seem antagonistic, damaging employee morale and fueling litigation.

A Mistake at Several Levels

This represents a mistake, on several levels. For one thing, you can't be sure that the courts in any state will go along with the at-will presumption. For another, even a strong paper trail, by itself, can't cover every legal exposure. The paper trail prevents the marginal complaint from taking shape as a lawsuit, but otherwise you're smart to use the at-will presumption as only one of several lines of defense.

That said, you still gain some benefits from a legalistic approach, chiefly because it disciplines you to think hard about how you hire and fire. It's a good idea to:

1) Review your recruitment and hiring practices to make sure that they emphasize the at-will nature of the employment relationship. Do they, on the contrary, promise job security?

2) Articulate your standards for termination. Let every employee know in advance how you go about firing people. Can you justify what you do in court? Do you review terminations to check for consistency?

3) Review employee handbooks and purge language that implies job security. Use dis-

claimers: "This manual is not an employment contract. . . . This policy does not in any way affect our right to terminate an employee for any reason, at any time, nor does it affect your right to leave at any time."

4) When someone does separate from your company, get the individual's signature on a separation agreement reinforcing the at-will status and, if possible, waiving the employee's right to sue.

To serve yourself best, make the at-will status of your employees an integral part of your hiring and firing process — not a coerced agreement forced upon them.

Abandoning the At-Will Presumption

In the confusion over the at-will presumption, some employers cede all right to fire at will. They opt for certainty and give their employees contracts guaranteeing that they can lose their jobs only for good reason or "just cause."

Tom Zito, head of Digital Pictures, a Silicon Valley software company, says other employers often ask why he gives away what most employees wouldn't think to ask for. "It flies in the face of how I ought to do business," he says.

Beginning in 1991, he offered his employees contracts affirming his right to fire them only for just cause — including theft or copyright infringement. "The contract basically sets out what the obligations of the employee are and what the obligations of the company are," Zito says.

He has many reasons for violating common business sense. He calls himself a product of the 1960s who has retained that era's ambivalent attitude toward the traditional corporate structure. He also has strong memories of less-than-benevolent employers.

But he says that in the main, he grants job security to attract and keep good people.

"People can assume that when they come here, unless they really screw up, they have a place as long as

Some employers cede the right to fire at will

A clear code of conduct

they work here," he says. "It's a two-way street. It isn't fair for the employer to have the right to fire someone willy-nilly."

This inspires loyalty, solidarity and high productivity. It also avoids a big cause of workplace resentment — abrupt termination.

Besides, Zito says, taking on employees whom he can't jettison easily "makes you much smarter about whom you hire."

Few employers go so far as Zito. Instead, many articulate a clear code of conduct for employees, impose "progressive discipline," follow fair and consistent termination procedures, and institute an impartial grievance and appeal system.

This preventive approach recognizes your employees' legitimate expectations of job security. It plays to the strength of the good-faith-and-fair-dealing argument. It encourages employees to understand and participate actively in the hiring and firing process.

The Montana Solution

In the early 1980s, the Montana courts oversaw several cases that weakened the at-will doctrine and hit employers with big judgments. In response to the outcry, the legislature reformed state law in January 1987.

In one case, *Flanigan v. Prudential Federal Savings*, a 62-year-old employee was judged to have been wrongfully discharged from her job as an assistant loan counselor. The jury awarded her $1.3 million for punitive damages, $100,000 for emotional distress, and $93,000 for economic losses.

After 34 years of service, Prudential Federal gave Flanigan four months' notice that she would lose her job because of economic conditions. Later the bank advised her to attend a week-long training program in another state to prepare for a new job as a bank teller.

She did so, but the bank discharged her without notice less than one month after she began working as a teller. She received six months' severance pay.

The bank eventually offered her work as a part-time teller, but she refused.

The court reasoned that Flanigan's discharge violated a covenant of good faith and fair dealing implicit in employment relationships. The Montana Supreme Court affirmed the awards in June 1986.

In another influential case, *Farrens v. Meridian Oil,* Michael Farrens lost his job for allegedly buying drilling mud from a supplier at inflated prices and for taking bribes from that supplier. A state court found the allegations to be incorrect and awarded Farrens $2.5 million for economic losses.

The Ninth U.S. Circuit Court of Appeals upheld the liability claim but ruled that the evidence supported only $1.7 million in economic damages. (When he lost his job Farrens was earning $85,500 per year.)

A Disincentive to Business

Extreme as they are, *Flanigan* and *Farrens* reflect the potential losses that employers face in wrongful termination cases. They also spurred the legislature to act. Employer groups protested the awards in wrongful termination cases, citing the uncertainty and expense created by the evolving common law. Indeed, wrongful discharge had become the favored tort claim in the state. According to the Billings Chamber of Commerce, the number of cases in that city alone jumped from two in 1981 to 89 in 1985. The claims had become a disincentive to business development.

The reform legislation enacted in Montana imposes a standard of "just cause" for dismissal, but it appealed to employers because it limits punitive damages to cases in which the employee establishes that the employer acted with "actual fraud or actual malice." Otherwise the employee recovers only four years of wages and benefits, less wages earned elsewhere in the interim.

The reform encourages binding arbitration, which generally confers smaller awards than jury trials. It defines a dismissal as wrongful if not "for good cause," or if "in retaliation for the employee's refusal to violate public policy," or if in violation of an

Most countries regulate firing

express provision of the employer's personnel policy. Layoffs don't qualify if they result from "business-related" reasons.

The law gives the employee a "property right" to the job (after a probationary period) as long as he or she performs adequately.

Some economists argue that limits on employment-at-will hurt union organizing, but Montana's labor unions did not oppose the legislation, which protected union and nonunion workers alike.

Similar Legislation

Employers may not like the tone of the Montana reform, but it did move things out of the courts. California, Colorado, Connecticut, Michigan, Montana, New Jersey, Pennsylvania, Vermont, Washington and Wisconsin have considered similar reform bills.

Colorado, Delaware, Florida, Georgia, Iowa, Louisiana, Mississippi, Rhode Island, Utah, and Vermont allow no exceptions to the at-will presumption.

Alabama, Alaska, Arizona, Arkansas, the District of Columbia, Illinois, Indiana, Kentucky, Maine, Massachusetts, Michigan, Minnesota, Missouri, Montana, Nebraska, Nevada, North and South Dakota, Ohio, Oklahoma, Oregon, Pennsylvania, New Jersey, New Mexico, New York, Wyoming, Texas, Virginia, and Washington allow implied contracts as exceptions to the at-will presumption.

California, Connecticut, Hawaii, Idaho, Kansas, Maryland, New Hampshire, North and South Carolina, Tennessee, West Virginia, and Wisconsin allow tort actions for violation of public policy as an exception to the at-will presumption.

Most Western industrialized nations set standards for termination. Canada, Great Britain, Germany, France, Italy, Sweden, and others have long protected employees from unjust discharge.

Most of these nations presume managerial decisions valid to the extent that they reasonably reflect efforts to achieve productive and profitable opera-

tions. They protect management's prerogatives respecting dismissals based on bona fide business necessity (for example, economic downturns or employee incompetence). Union agreements permit the same.

Pressure now builds for nationwide standards in the United States. The National Conference of Commissioners on Uniform State Laws promotes a Uniform Employment Termination Act as a model for legislation in all the states. Business supports such legislation to keep the state courts from breaking the at-will doctrine. In the absence of legislation, it remains difficult to stop the erosion of this doctrine in the courts because of the force of precedent.

Prospects and Solutions

Human resource and legal experts expressed surprise that employers supported the Montana reform, which abolished the at-will presumption altogether. They shouldn't have.

Employers judged that the right to fire workers at will won't exist much longer anyway, and they happily accepted a just-cause firing standard — in exchange for limited liability.

In other states, as things now stand, the confusion over the at-will doctrine generates great uncertainty over job rights and over the penalties facing employers who violate those rights. Even in cases with similar circumstances, juries in wrongful-termination suits hand down widely differing awards — the flaw of judge-made law.

If like most employers you stay risk-averse, the Montana reform looks good because any limitation on liability for wrongful termination promises to improve matters significantly. Employer groups support similar laws when proposed in other states. In 1985, the California Manufacturers' Association encouraged employers to support a bill similar to Montana's because it would "provide a more expedient means by which an employee may be compensated for a truly wrongful discharge — such as through the opportunity to arbitrate — and remove an employer's exposure to punitive damages."

The workers' comp bargain

It didn't pass.

Still, employers sometimes join with employee groups to support just-cause termination laws as an acceptable compromise. Such compromises recall the "great industrial bargain" that created the workers' compensation system. That bargain made employers wholly responsible for injury and illness suffered on the job but limited their liability. To be sure, the courts have expanded that liability, but the bargain remains a good idea.[3]

The Courts' Standard

With respect to hiring and firing, the courts impose an employment-*sometimes*-at-will standard — in reality, an employment-sometimes-at-the-*court's*-will standard — that produces uncertain and incomplete rights to jobs, leaving employers and employees unsure of the legality of their actions. The system imposes large transaction costs — i.e., legal fees — on both parties, and unpredictable awards costs on employers. When the prospect of gain becomes big enough, the litigious employee prefers the imperfect common law to Montana-style reforms.

Does this mean that you should support reforms? Not necessarily.

Court decisions like *Foley* limit, among other things, damage awards in cases over a breach of the covenant of good faith and fair dealing. Recent rulings in other states (for example, Michigan's *Bankey v. Storer Broadcasting*) suggest that the move away from the at-will presumption may not be as extensive as the Montana reform makes it seem.

The continuing uncertainty really stresses the importance of good management. In contradictory currents, you keep your oars in the water. Who knows but that you might find yourself in court with a judge who supports the at-will presumption.

[4]See *Workers' Comp for Employers* by the present author, 1993, Merritt Publishing, Santa Monica, CA.

No trial lawyer wants that to happen. Indeed, most of them work on contingency, and they want to spend as little time as possible in court. So they avoid any case that looks complicated. You complicate matters by preserving the at-will presumption and preparing a just-cause defense.

That makes lawyers run.

Making lawyers run

CHAPTER 2:
THE GROUNDWORK

The surest way to avoid problems in firing people is to hire them carefully. Make a mistake in the beginning, on the other hand, and you invite trouble later.

Unfortunately, in hiring people, more employers make mistakes than don't. They promise too much or imply things they don't even realize. With the best intentions, they establish personnel and staffing policies that misfire or — worse — run afoul of the countless, often confusing state and federal laws governing the relations between employer and employee.

How do you avoid this kind of trouble?

You manage employees so that no one has the grounds — or the reason — to go after you in court. You prepare yourself to avoid the pitfalls that await the unwary in the hiring and firing process. And you minimize the damage caused by the problems you can't avoid.

The First Pitfalls

These preparations (and pitfalls) begin the moment you set out to become the employer of others. Whether you know it or not, you start to establish policies with respect to hiring and firing long before you launch the search for your first employee.

In the beginning you usually do so implicitly, by envisioning what you want your first employee to do for your enterprise.

At some point you make things explicit, usually by writing an employee or personnel handbook setting out the principles by which you intend to abide in your relations with your employees.

By setting policy, you set out to govern behavior. Good policy, properly followed, makes for good behavior and limits exposure.

Avoid problems by hiring carefully

Good policy limits risk

Bad policy — or good policy not followed — exposes you to substantial legal and financial risk.

It makes sense, then, to look at the hiring and firing policies you put in place in advance of the interview with a job candidate: how you expose yourself to risk, and how you limit risk by making and following good policy.

Articulated well, good policies help to avoid the most troublesome of employment disputes — those alleging discriminatory treatment, wrongful termination and breach of contract.

More specifically, with respect to hiring and firing, good policies cover:

1) The use of job skills profiles;

2) Staffing and review;

3) The understanding between the enterprise and the employee as to the nature of the employment agreement.

The job skills profile accomplishes two tasks: It helps managers describe and fill positions and it lets potential employees know what to expect on the job and how to behave.

Keeping an Eye Open

A moment's thought shows the wisdom of keeping an eye open for your financial exposures when you make staffing policies and certainly when you put anything on paper. The day will come when you fire someone who uses every weapon available to show that you promised all kinds of things — lifetime employment, certain and regular advancement, personal improvement — and that you have broken faith.

And if you can't disprove these charges, you're in trouble.

You begin your preparations by putting together a set of coherent personnel and staffing policies that help you find and keep good people and get rid of those who don't work out, all with as little heartache and litigation as possible.

Employee and personnel handbooks are the battleground on which employers and employees fight out their policy disputes. Good handbooks settle disputes as soon as they arise — sometimes before they arise. Bad ones drag their makers into court.

Experts in hiring and firing look to the 1980 Michigan Supreme Court decision *Toussaint v. Blue Cross & Blue Shield* as the standard by which you measure bad handbooks. The decision held the Michigan "Blues" to a tough standard—one of their own making.

The Blues hired Charles Toussaint in the early 1970s to fill a middle-management position. The day Toussaint came on, a personnel officer assured him that as long as he did his job he'd be with the company until retirement at age 65.

The company gave Toussaint an employee manual that reinforced this talk. It said it was the policy of the company to fire employees "for just cause only."

This gave Toussaint a powerful weapon when, five years later, the company fired him without explanation. He took the Blues to court, claiming that the happy talk in the employee handbook constituted an employment agreement.

Futile Arguments

Blue Cross countered that it fired Toussaint for insubordination and that the manual established no such contract, but its argument went nowhere. A jury awarded Toussaint $73,000 in damages.

Blue Cross appealed and won before the Michigan Court of Appeals. Toussaint pressed on to the state Supreme Court and the issue started attracting attention around the country. In 1980 the Michigan Supreme Court resolved the matter, ruling:

Employers are most assuredly free to enter into employment contracts terminable at will without assigning cause. We hold only that an employer's express agreement to terminate only for cause, or statements of company policy and procedure to that effect, can give rise to rights enforceable in contract.

The standard for the bad handbook

The employee handbook as promise

When a prospective employee inquires about job security and the employer agrees that the employee shall be employed as long as he does the job, a fair construction is that the employer has agreed to give up his right to discharge at will without assigning cause and may discharge only for cause . . . The result is that the employee, if discharged without good or just cause, may maintain an action for wrongful discharge.

The court noted that Blue Cross' 260-page manual established elaborate procedures promising "to provide for the administration of fair, consistent and reasonable corrective discipline" and "to treat employees leaving Blue Cross in a fair and consistent manner and to release employees for just cause only." Toussaint, the court said, justifiably relied on these expressions.

The lesson here is plain: The statements you make in your employee handbook give rise to legitimate expectations in your employees. They may also give your employees contractual rights even in the absence of a signed employment agreement. So be careful. Keep your eyes open when writing a policy manual. Say nothing that might prevent you from firing an employee if you have to — nothing, in other words, that an employee might construe as an employment contract.

This approach may seem negative, but it isn't. It's aggressive and pragmatic. It prepares for success by anticipating difficulty. The alternative is not to prepare for trouble, not to anticipate that you might have to fire someone. The Michigan Blues took the easy way out and didn't prepare. They allowed someone to fill the employee manual with happy talk that became meaningful just at the wrong time.

The Job Skills Profile

If you go on gut feelings when you hire someone, you're likely to end up with gut feelings later on — namely, heartburn and ulcers.

The job skills profile keeps you away from the Maalox. Some consultants call them "skills inventories." Whatever the name, a good one enables you

to sift through your job applicants and make reasoned decisions.

To be sure, hiring is a subjective process; it usually comes down to choosing among different people with different strengths and weaknesses. But you don't have to fly blind. The job skills profile allows you to figure out what you want and, to the extent possible, make the hiring process objective. Since it commonly represents a checklist of the traits of your best employees, it gives you a composite of proven success.

A good job skills profile allows you to consider an applicant's:

- Education;
- Vocational or trade training;
- Type and scope of employment background;
- Minimum level of work experience;
- Stability in employment;
- Initiative;
- Knowledge of industry-specific techniques;
- Command of the language;
- Previous compensation;
- Organizational skills;
- Adaptability to new circumstances;
- Enthusiasm for work; and
- Physical appearance and demeanor.

Most employers carry some version of a job profile in their heads, usually reflecting their preferences based on what has worked well in the past. Hunches aren't enough, though. They give way to gut feelings all too easily.

Still, the first rule of profiling is to go with what works. Review the strengths and weaknesses of the people who work in a particular job for you now — especially the strengths. If you can't draw on much history for a given job, look to other divisions in your enterprise. If that's not enough, look to competitors

The job skills profile

List the traits you want

or similar firms. Start with a wish list, but temper it with hard facts. Profiles should reflect the qualities, not always obvious, common to top performers.

As the next step, list the traits and characteristics you want in the order of their priority. Does a strong academic background make up for weak experience or appearance? Do you want broad familiarity with your industry or deep knowledge of a niche?

Some managers grade each checklist item on a 1-to-10 scale; others use a yes-or-no format. The mechanism you use doesn't matter so long as it allows you to evaluate your candidates objectively and by the same standard.

Heed the Cautionary Signs

The second rule of using a profile is to follow it. Hiring is such a personal process that you might feel the temptation to scrap the paperwork when a friend or an especially charismatic candidate comes along. But try not to give into the moment. If your job profile represents your best thinking about a particular position, make it fit the circumstances at hand. Most of all, heed its cautionary signs.

There is one danger to using objective evaluation tools like job skill profiles: They sometimes become edicts imposed on unwilling managers.

In other words, don't let this process become a weapon wielded by the home office. Emphasize field experience — which is to say, leave a little room for intuition: yours or that of the manager for whom the new employee will work.

"We tried at first to impose a universal profile for all hiring but met resistance from managers who thought their own experience and recruitment skills were being shortchanged," says a senior executive with an East Coast manufacturer. "By training managers to construct their own skill profiles, we found that not only were their profiles essentially similar but they were more likely to use the profiles effectively in their regional hiring efforts."

This executive boiled the profiling process down to six steps:

1) List all desirable skills, defining the characteristics precisely. "A go-getter" isn't specific enough; "someone with a history of independently setting and achieving objectives" comes closer because you can measure it while interviewing or when reviewing work histories.

2) Arrange the skills into ten or so major categories. (Some managers come up with dozens.) In doing this, consider what successful performers brought to the job that allowed them to succeed — and more important, what they did on the job to differentiate themselves from their run-of-the-mill co-workers. Think closely about the characteristics most important to the job (and to you, if you expect to supervise the employee).

3) Rank the skills and categories in order of priority. Check the priorities against history — what worked well in the past. Make sure the priorities are your own; if you rate enthusiasm higher than experience, or communication skills higher than either, rank them accordingly. Aim for a realistic profile of a good job candidate, not an idealized one. If it doesn't take a Harvard MBA to fill the job, don't insist on one.

4) Determine which skills can be taught, which not. If you hire someone with no enthusiasm — which can't be taught — don't hope that your candidate will suddenly turn into P.T. Barnum. But don't forget the difference between characteristics and skills. People don't often change their characters, but they can always learn new skills.

5) Set minimal levels for each skill. This makes the profile even more specific to the needs of your operation. The thresholds will depend on the degree of training you can provide to make up for any shortfalls.

6) Put together questions and tests for the job interview that best evaluate each skill. You can't ask a candidate if he or she is highly motivated and expect to get a useful answer. But you can focus on behavior and accomplishments in the

Give priority to the skills you need

Tell your workers what you want

past and compare those with your profile characteristics. This gives highly practical direction to the job skills profile.

A job skills profile has many uses. It helps outside recruiters understand what you want and gives you a paper trail of objective decision-making at the earliest possible stage — an important item in the event that someone sues you.

The Job Description

The detailed job description has the same virtue. It's a legal tool which tells the employee what you expect but remains conspicuously silent with respect to what the employee may expect of you.

Often, job descriptions emerge from collective bargaining with unions, and to the extent that management and labor don't get along, job descriptions stand as evidence of distrust.

Which isn't to say they don't have their uses.

The consultants who write job descriptions — often attorneys — frequently fill them with the circular and hedging language of legal briefs. At the same time, they keep the things short and full of unexpected generalities in the hope that no judge can construe them as contractual arrangements.

Thus, the job description seeks to set concrete minimums and maximums of responsibility to use as demonstrable points in court. It sets standards of performance which — if not met — serve as grounds for termination.

Some managers find it easier to write the job description before the job skills profile. Either way, it makes sense to write the job description carefully. Legal precedents like the Toussaint case show that job descriptions, even unsigned, can become enforceable terms of employment.

A good job description should be brief, specific, simple, and understandable. It should:

- Describe the activities expected of the worker;
- Allow for no discrimination or bias;
- Apply to as many kinds of workers as possible;

- Avoid promises or predictions as to what the worker gets in return for meeting the minimum responsibilities of the job;

- Take the same form and use the same language as all job descriptions throughout your company;

- Comply with labor and hiring law; and

- Change with time, as the job changes.

The smart manager writes every job description on the presumption that it will be used in court — and hopes it never will be.

To the extent that job descriptions enumerate the minimum responsibilities of the position, they teach lazy workers just how little work they can do and keep their jobs. For this reason, a good job description explicitly leaves the employer free to deviate from the description at any time, without notice.

Personnel Policies

Personnel policies continue the paper trail establishing your hiring and firing process as objective and systematic — even when they deal with such mundane necessities as pay periods and parking spaces.

Personnel policies cover such things as hiring and firing, promotions, pay, performance reviews, standard management practices, and discipline. Overlook this last item at your peril; if nothing else, employees should know how often their performance comes up for review and how many warnings they get before management takes disciplinary action. If you don't make all this explicit, you leave your employee to conclude that you don't have any policy with respect to such matters — an open invitation to trouble.

Good personnel policies commit you to treating all of your employees according to an established standard of fairness. This makes it imperative that your policies be evenhanded and thorough — and not so stringent that you can't follow them.

They take some homework, too, as the following

Subtle questions about hiring practices

case study shows.

Brenda Davis sought a job as a Dallas police officer, but the city turned her down on the grounds that her application contained falsified information. Davis, who was black, sued, alleging that the city rejected her because of her race.

Her case, *Davis v. City of Dallas*, posed subtle questions of the city's hiring practices. It turned on three points involving Davis' college credit, marijuana use and traffic violations. The city required that applicants for police jobs show:

- At least 45 semester hours at an accredited college or university with no less than a C average;

- No marijuana use within the last three months and not more than 35 occasions of use within two years; and

- No more than three serious traffic tickets within 12 months and no more than six within 24 months.

Davis based her case on the argument that the criteria arbitrarily screened out black applicants. To disprove her argument the city of Dallas had to produce "a clear, reasonably specific, legitimate, nondiscriminatory reason for each" of the criteria. It succeeded — with some doing.

The Importance of Preparation

With respect to college education, the city persuaded the trial court of the importance of preparation. As the court noted:

Few professionals are so peculiarly charged with individual responsibility as police officers. Officers are compelled to make instantaneous decisions, often without clear-cut guidance from the legislature or departmental policy, and mistakes of judgment could cause irreparable harm to citizens or even to the community. Complexities inherent in the policing function dictate that officers possess a high degree of intelligence, education, tact, sound judgment, impartiality and honesty . . . College requirements are one of the tools for preparation.

With respect to marijuana, the city argued that its use impaired judgment and showed a disrespect for the law. The court agreed, approving the criterion as legitimately related to the job. It noted that cities require a high degree of devotion and skill in their police officers and must seek out individuals who live according to strict standards of conduct.

With respect to driving records, a casualty actuary, testifying as an expert witness, showed that history indeed sometimes repeats itself. People with poor driving records tend to continue in their ways, the actuary testified; if they show lots of traffic violations in the past, they are likely to show lots in the future, too.

Here again the court agreed, finding an officer's "ability to drive safely . . . an essential part" of the duties of the job.

Disappointed, Davis appealed her case to the U.S. Court of Appeals, only to lose again. The court admitted that the city's standards adversely affected blacks, but it ruled them job-related and therefore valid. It argued that Congress did not intend the Civil Rights Act "to guarantee a job to every person regardless of qualifications" but rather to remove "artificial, arbitrary, and unnecessary barriers to employment when the barriers operate . . . to discriminate on the basis of racial or other impermissible classifications."

A Two-Edged Sword

The city of Dallas prevailed against Brenda Davis because it adhered to its own, highly detailed criteria in hiring police officers. It doesn't follow, however, that the more detailed the criteria, the better. Personnel policies bind the employer as well as the employee, and in cases such as *Shaw v. Western Sugar,* the detail alone can give cover to an employee who contests a justified termination. Western Sugar prevailed in this case, but it had to prove that the detail in its policies didn't apply to John Shaw, who had worked for Western Sugar since 1954.

A warehouse packaging coordinator by the mid-1980s, Shaw held some supervisory duties,

Leave room for the unforseen

one of which was to keep watch over workers who went into large bins to clean out hardened sugar.

On June 12, 1986, Shaw sent a four-man team in to clean out a blocked bin, having told his factory manager of the problem. The next day, while Shaw attended to other things, one of the men fell into the bin and suffocated. Western Sugar investigated the accident; so did OSHA. The company fired Shaw before OSHA officials could question him — to keep him from divulging what he knew about conditions at the plant, according to Shaw.

He sued for wrongful termination and led the court through a prolonged examination of Western Sugar's highly detailed disciplinary procedures, all in an attempt to show that the company hadn't followed its own rules in firing him. The procedures required that the company counsel an employee as the first step in discipline, then issue a written reprimand, and then give a final warning before termination.

'A Higher Level'

Shaw argued that these procedures applied to all employees, including those with supervisory duties. Western Sugar countered that they didn't and that, in any case, the procedures gave the company an out—that is, the freedom to fire a worker—when "the nature of an offense is so severe as to warrant a higher level of discipline."

Clearly, Western Sugar argued, Shaw committed a gross offense in failing to oversee the man who suffocated inside the sugar bin. The court agreed.

Western Sugar escaped a net of its own weaving because it had the foresight to plan for extraordinary events and grasped the fact that detailed policies can hamstring the enterprise.

"Any process can work well when it's handled by a great manager," says the owner of a mid-size California manufacturing company. "But not every manager is great. So your hiring and firing process has got to allow for situations that you can't anticipate."

Many managers consider promoting from within a

safe alternative to hiring from the outside, mostly on the theory that workers already in the company have proved themselves.

But don't take too much for granted. The same rules apply to promoting from within as apply to hiring from the outside. And you can't expect to hide from the consequences of poorly written or nonexistent policies by promoting from within.

Sexual Discrimination

In the 1992 case *Stukey v. USAF* the Air Force turned out to have such sloppy and unfocused hiring procedures that it got in trouble — even when promoting from within — because it neglected to abide by the simple rules against sexual discrimination.

Linda Stukey worked as an attorney with the judge advocate office at Wright Patterson AFB near Dayton, Ohio. In 1985 Stukey applied for one of two positions as a professor of contract law at Wright Patterson's Institute of Technology.

Out of 16 applicants, Stukey ranked among the final eight. But a selection committee passed over Stukey in recommending two candidates, both men, for the positions. It made a big mistake in asking Stukey questions it didn't ask the men — about her marital status, her ability to work and travel with men, and her child care arrangements.

Making the final cut, the committee scored Stukey the lowest among the eight finalists. Stukey got no offer; each of the two positions went to a man.

Stukey sued, alleging sexual discrimination, and won the first go-round in federal court. The court ruled the committee's questions improper and ordered the case to go before a jury.

That, however, was the last thing the Air Force wanted. It settled for an undisclosed sum.

Still, promoting from within is preferable to hiring from outside. Aptitude and skills tests work most effectively when evaluating candidates for promotion, for one thing. For another, you don't have to repeat certain background checks (assuming, of

Written contracts limit claims

course, that your candidate really is a known quantity). For yet another, promoting from within bolsters employee morale.

But the smart manager follows the same procedures whether promoting from within or hiring from without. Treat the two efforts as one; promote your employees with the same caution you use in hiring them.

Contracts, Written or Otherwise

In many ways, detailed personnel policies can begin to resemble written contracts; and written contracts can make hiring and firing much easier. They limit the claims that an employee can make after being fired because, carefully written, they make the terms of employment explicit and allow the employer to sidestep many of the pitfalls of the implied contract.

But most workers never have employment contracts, and most employers prefer things this way because they know that employment contracts restrict their freedom to hire and — especially — fire as they please.

The 1992 standoff between Bo Schembechler and the owner of the Detroit Tigers reached almost comic proportions and shows how badly structured contracts can do more harm than good.

Schembechler, for years the football coach at the University of Michigan, left in January 1990 to become president of the Detroit Tigers. In negotiating the move, Tigers owner Tom Monaghan jotted down some salary figures on a napkin. Schembechler kept the napkin.

In 1992, in the midst of a troubled attempt to sell the team, Monaghan fired Schembechler. Within the week, Schembechler went public with the napkin, claiming that it represented a 10-year employment contract.

His attorney elaborated: "We believe [Schembechler] has been wrongfully terminated. There were substantial promises and assurances made to him to entice him to leave the University of Michigan and accept the presidency of the Detroit Tigers. He was to

finish his working life with the Tigers, working until age 70."

The attorney insisted on calling the napkin evidence that Schembechler had a 10-year deal even though the coach had "no written contract per se." The napkin, he said, demonstrated the existence of an employer-employee relationship.

Some fans doubted Schembechler's claim, but he threatened to sue, and the strategy worked. The team settled out of court. Fans in the Motor City registered the settlement in the low seven figures.

"The simple fact is that employment contracts don't change much," says New York-based human resources consultant Mark Saunders. "The question of termination-for-cause will come up any time a fired employee wants to bring it up, contract or not. If anything, a contract situation just gives the employer more reason to be careful about what's said and done during hiring — and especially firing."

Manuals and Handbooks

It doesn't take much looking to see the risks in employee manuals and handbooks. Still, despite the risks — maybe because of the risks — manuals and handbooks make an effective tool for establishing policies respecting hiring and firing.

They are certainly the first place employees look when they lose their jobs. Any language that seems to promise permanent employment or protected status easily leads to a wrongful termination suit. And an angry employee may well prevail even if disclaimers warn that the manual isn't a contract.

Employers count on employee manuals as a valuable informational tool. Manuals also serve as a strong link in the paper trail establishing that the enterprise adheres to fair and consistent standards.

So you should use them — but carefully.

Different manuals cover different aspects of the enterprise. Employee handbooks outline company policies on everything from dress codes to maternity leave. Operations manuals outline company operations from crisis management to customer relations.

Stick to what your manual says

Job handbooks outline the duties and responsibilities of each position.

The smart employer uses these handbooks not only to train new employees, but to cross-train employees to cover for one another during vacations or other absences.

"We are in such a litigious society that any employer who doesn't have an employee handbook is just asking for trouble," says California-based labor consultant Linda Reitman. "A good manual is going to save an employer a lot of time and money because it documents everything an employee needs to know and establishes a company's policies and procedures. A good manual makes a manager's job easier by contributing to a more accurate performance appraisal."

Above all, be sure to make your handbook accurate and easy to understand. Translate it into other languages for employees not proficient in English.

And — most important — once you've circulated the manual, stick to what it says.

"One of the quickest ways for you to get in trouble with an employee is to put out a policy handbook and then not follow it," says Edgar Ellman, a veteran personnel consultant with offices in Chicago.

Ellman writes hundreds of policy handbooks every year for companies of all shapes and sizes. He recommends against hiring an attorney to write a handbook but urges clients to pass his products by their attorneys and, if necessary, add information about state and local regulations. You want your handbook to be clear, he says, because it could play a key role in court.

As Conditions Change

Sometimes this works in unexpected ways. In *Berube v. Fashion Centre*, the Utah Supreme Court ruled that an employee manual doesn't fix the terms of employment forever. Specifically, it wrote:

> *[When] an at-will employee retains employment with knowledge of new or changed conditions, the new or changed conditions may become a*

contractual obligation. In this manner, an original employment contract may be modified or replaced by a subsequent unilateral contract. The employee's retention of employment constitutes acceptance of the offer of a unilateral contract; by continuing to stay on the job, although free to leave, the employment supplies the necessary consideration for the offer.

In most cases, the basics of contract formation — offer, acceptance and consideration — must occur to establish that an employment manual binds both parties, or conversely to show that the terms of employment have changed.

This assumed, it often becomes important to determine just why the employer issues an employee manual or handbook. The courts may find a de facto contract if an employer "creates an atmosphere" of job security or promises specific treatment under specific conditions and thus induces an employee to remain on the job.

This theory came to a point in the 1972 case *Perry v. Sindermann*, in which the U.S. Supreme Court ruled that an employer's actual practices gave an employee the right to be discharged for just cause only, despite a statement to the contrary in an employee manual. The case made it clear that an employer doesn't always preserve the right to at-will discharge if the policies in a manual don't match the employer's actual practices.

On the whole, however, the courts remain disturbingly inconsistent on the issue of whether a disclaimer in the front of an employee manual limits its contractual implications.

Words and Deeds

The 1991 decision *Johnson v. Morton Thiokol* illustrates the connection between words in a manual and deeds in the workplace. In this case the Utah Supreme Court ruled for the employer because it had fulfilled the commitments it made in the manual — even though the employee didn't like what ensued.

Billy Johnson went to work for Morton Thiokol as a process inspector in 1979, remaining until his termi-

Practices often prevail over policies

Reserve your right to change policy

nation in 1988. Throughout his tenure, Thiokol maintained an employee handbook prescribing company policy concerning disciplinary, review and grievance procedures. The handbook's introduction stated in clear and conspicuous language that the company did not intend the manual to operate as an employment contract:

This book is provided for general guidance only. The policies and procedures expressed in this book, as well as those in any other personnel materials which may be issued from time to time, do not create a binding contract or any other obligation or liability on the company. Your employment is for no set period and may be terminated without notice and at will at any time by you or the company. The company reserves the right to change these policies and procedures at any time for any reason.

Elsewhere the handbook detailed the company's elaborate policies with respect to discipline and termination. It also said:

Like most people, you are probably looking forward to increased responsibility and promotion, and Morton Thiokol recognizes this as a natural and worthy desire.

Performance evaluations provide a guide for improvement of your work and a basis for your promotions and merit increases in pay.

Testing for Leaks

In July 1988, Thiokol implemented a procedure to test for leaks and to verify the proper placement of certain O-rings used in the rocket motors of NASA's space shuttle. The company assigned Johnson, who would later claim he hadn't received adequate training regarding the new process, to oversee the procedure.

It had become common practice to perform numerous operations simultaneously, even though only one inspector worked a particular area. The company required an inspector to witness each operation — an impossible task, given the simultaneous "setups."

At one point, Johnson glanced at a setup but did not complete the 39-step inspection checklist required to verify the procedure. Thus he failed to notice that certain hoses had been improperly installed.

But he did write that he had completed the appropriate inspection.

A NASA Inquiry

The next day, during a routine test, pressure caused by the improperly-installed hoses unseated the O-rings and damaged the motor. The incident caused significant delays and prompted NASA to investigate.

Thiokol fired Johnson and the employee who installed the hoses. Johnson filed a union grievance, but Thiokol prevailed on the argument that it had fired Johnson for "careless or inefficient performance of duty" — grounds for immediate termination, according to its handbook.

So Johnson went to court, claiming that Thiokol had breached an implied-in-fact contract by firing him without sufficient cause. He lost again. The trial court found no such contract and dismissed Johnson's case. Johnson appealed to the Utah Supreme Court and lost once again.

The Utah Supreme Court wrote:

> *The terms of employee manuals may raise triable issues concerning the existence of an implied-in-fact contract. However, Thiokol's manual contained clear language disclaiming any contractual liability and stating Thiokol's intent to maintain an at-will relationship with its employees.*

Federal and state courts in Illinois, Kansas, Maryland, Michigan, South Carolina, Washington and Wisconsin have upheld clear and conspicuous disclaimers as well.

Johnson shows just how far the employer must go to avoid turning an employee manual into an implied contract. Here are some detailed items to look for in your own employee manual:

- The manual must make no promises to dismiss only for "just cause."

Things to avoid in your employee manual

Manual must change as your policies change

- It must avoid such subjective terms as "fair" and "equitable," which stimulate litigation.

- It should state, in boldface, that it is not a contract and that you reserve the right to modify or amend any personnel policy at any time, without notice.

- It should state that only designated company officials can enter into oral or written contracts with employees.[1]

- It should state that, if there is any inconsistency between a statement in the handbook and actual practice, the handbook governs.

- It shouldn't even imply that the employee can expect promotions regularly or as a matter of course.

- If the handbook specifies a probationary period for new employees, it should also state that such employees can be fired before probation ends and that successfully completing probation does not guarantee continued employment.

- It should change as policies change; when you alter policy regarding conduct (for example, to comply with laws barring sexual harassment) change your manual accordingly.[2]

Staking Our Your Territory

What all this boils down to is that you must be careful in these matters, but you don't have to despair. Not everything in your employee manual works against you. As the South Dakota Supreme Court has written, employee manuals do not a contact make — at least, not all the time, and certainly not if the em-

[1]Such a disclaimer, though not airtight, helps prevent a judge from finding that the statements of supervisory personnel have modified the terms of the handbook.

[2]Recent court decisions leave some points unsettled: As the employer you can change wages and benefits at any time (assuming that you don't have union contracts to worry about) but it's not clear just what happens when you change policies and procedures relating to job security. You may not gain the right to fire an employee at will after the fact, so to speak; if you hire someone under a policy not asserting your right to fire at will, you may not gain the right to do so simply by rewriting your policy.

ployer stakes out his or her own territory clearly. Disgruntled workers can't just accuse the employer of going against certain notions of "fair play and just and equitable dealings" and expect to prevail, as the South Dakota court put it. They must show that the employer has failed to live up to promises made — explicitly or otherwise — in the employee handbook.

That makes the lesson very clear for the employer: Don't make promises you don't intend to keep.

The Bottom Line

If you want to leave yourself free to fire an unsatisfactory employee simply and without complications, start off on the right foot. Be forthright about what you want before you bring the employee onto your payroll. Put things in writing, particularly your policies for hiring and firing. Make them clear and unambiguous.

Use job skills profiles to allow managers to analyze the jobs they have and the people they need to do these jobs.

Take special care in writing your employee handbook. The last thing you want is to give your employees grounds to argue that your manual constitutes an employment contract.

Take just as much care in crafting all statements of company policy. You go a long way toward preserving your right to fire at will if you put all policies in writing — and if you carry them out with the same attention to detail. The courts stand ready to chip away at your right to fire unsatisfactory workers at any time and for any reason, or for no reason at all. But you strip them of their ammunition if you think clearly and act forcefully — essentially, if you take matters in hand from the beginning. Never forget that you're the employer and that you're in charge. You decide what you want your employees to do for you, and under what conditions.

You set the workplace rules, so set them carefully.

Set your workplace rules carefully

CHAPTER 3: CASTING YOUR NET

Recruiting applicants is one of the least predictable steps in the hiring process. Even the best testing and screening procedures can't help you hire good people if you don't attract good candidates in the first place.

Many employers rely on word of mouth to bring people in the door. Others choose the first person an agency sends over, or they raid the staffs of their vendors or their customers.

Sometimes they get lucky. Sometimes they don't.

According to risk management theory, you minimize your risks by broadening your choices. You don't, in other words, put all your eggs in one basket.

When it comes to hiring people, this means that you put together the biggest practicable pool of applicants.

Personnel experts encourage employers to place help-wanted ads in newspapers, trade magazines and newsletters to attract a big pool of applicants. Professional and industry groups promote their own networking mechanisms for members.

Staffing consultants hang around almost any crossroads with more than two mid-rise office buildings. You can spend a lot of money on these people, but they can be useful. The good ones know the local — and national, if relevant — labor pool.

But if you want a more aggressive approach, you consider other methods.

Ways and Means

In the fall of 1989, the city councils in Pasadena and Pomona, two suburban southern California towns, began simultaneous searches to find new city man-

How to attract good applicants

Different means to the same end

agers. The towns took different approaches but met with similar success.

Pasadena brought in a team of consultants who drew a profile of the ideal city manager and launched a nationwide search for applicants, culling them for five or six finalists.

City Director Rick Cole defended the policy on the grounds that the city couldn't know in advance how far it would have to go to fill a specific job. "Maybe the next city manager already knows about the job and we're wasting a lot of time and money on recruitment," Cole admitted. Maybe, on the other hand, the best candidate lived far away and would prove "the last guy called" by recruiters.

The city invited 500 community leaders to participate in a discussion of the skills and characteristics needed in a city manager. It hired two different consulting firms to bring the fruits of these discussions into focus and undertake the recruiting.

The city budgeted more than $30,000 and several months to find the right one. The search took nine months.

In May of 1990, the city hired Philip Hawkey, the city manager of Toledo, Ohio. Hawkey survived a rocky beginning, but three years later, he was still city manager and had seen the Pasadena city government through a difficult downsizing.

City leaders pronounced him a success.

Do-It-Yourself Approach

In Pomona, which had fired its city administrator only to lose the interim replacement — who quit after five weeks on the job — the city council took a do-it-yourself approach. It spent only $3,000 on help-wanted ads in local newspapers, several trade journals and some magazines.

The ads sounded much like those for any mid-level corporate position. They sought an individual with "a strong background in local government, knowledge of fiscal and community development issues, a bachelor's degree in business or public adminis-

tration, a stable employment history and recent employment in city administration."

Council members knew the administrator would also have to be adept at working in a volatile political climate. "It can't be some wimp who can't take a little bit of heat," said one.

Pomona received more than 100 applications — more than the council expected. Of these, at least a dozen applicants met the city's basic requirements.

Pomona council members had hoped to make the appointment in six to eight weeks. And they did.

Six weeks after they began, they chose Julio Fuentes, the administrator of a smaller nearby city.

Fuentes took up his new duties with energy and skill. He improved Pomona's credit rating and recruited experienced people to head up city departments. Local political volatility remained a problem; some officials, even Fuentes' supporters, didn't expect him to last a year.

As it turned out, Fuentes became a calming influence. In June 1992, after three years in Pomona, Fuentes took a higher paying job with another Southern California city.

Politics comes into play when any governmental entity goes after a high executive. When California State University at Fullerton, for example, went looking for a new head basketball coach in 1992, it opened its efforts up to scrutiny. People knew everything the school did at every turn.

The Best Decision

This did more than just assuage the alumni. According to the school's athletic director, it helped the search committee make the best decision.

The search committee consisted of other coaches, a student and several teachers. The members worked hard, knowing that a lot of things rode on their decision: the money that college sports attracts, the egos, impassioned alumni. They culled a field of 53 candidates to seven finalists who went through a series of interviews.

Helping recruiters make the right choice

It pays to keep your ears open

Cal State Fullerton finally hired Brad Holland, who had assistant coaching experience at nearby UCLA and had played professionally. In his first year on the job, Holland guided the Fullerton team — projected to finish ninth in its conference — to a tie for fifth place. Soon after that, the school extended Holland's contract to keep him at the school through the mid-1990s.

"We're obviously pleased with the direction of the program," said Bill Shumard, Fullerton's athletic director. "It is in keeping with what our thoughts were when we hired him."

You probably don't worry about alumni and big-money egos when you make a hire. But you do have to make good choices, and it pays to listen to those who want to have a voice in the affairs of your enterprise — your line managers, your personnel types, the people with whom the new hire will work.

Effective Publicity

A big applicant pool is like the Constitution; it works because it gives you checks and balances in the system. This doesn't mean that you let everybody vote whether to hire this or that candidate. It means that you set up a system designed to present the best candidates for a specific job and keep you well within the bounds of the law, and that you allow that system to guide what you do throughout the process.

It also means that you use every means available to attract good candidates.

The downside, of course, is that you give yourself some work to do in following the system you devise. Depending on the job, you may have to sort through dozens or hundreds or even thousands of applicants — a time consuming task and sometimes very boring.[1]

The upside is that, like Cal State Fullerton, you take the edge off of complaints about your hiring and firing procedures.

To be sure, you can't guarantee to find your next marketing genius no matter how long a list of candi-

[1] We look at policies for weeding the applicants down quickly and effectively in the next chapter.

dates you compile. But a long list surely helps.

Your biggest challenge is to publicize your effort well enough to generate interest in the job. This may seem a simple proposition, but it proves the undoing of many employers. You want to reach the widest array of applicants as quickly as possible—and use the process of elimination from there.

The Dangers of Improvising

Doing anything else—especially improvising—can create more trouble than you need. The 1991 federal case *Blaine v. Onondaga Community College* shows just how much trouble improvising can generate.

In 1981, Catherine Blaine went to work as a part-time instructor in the respiratory therapy department at Onondaga Community College in Syracuse, New York. In June 1983, OCC advertised for one full time assistant professor and one part time professor in the respiratory therapy department.

For the full time position the school wanted a registered therapist with a master's degree and at least three years of clinical experience, plus teaching experience.

Six people applied for the part time position and three for the full time post, among them Blaine. Her two competitors — both women — withdrew their applications early on.

The search committee decided to advertise again and to ask those who had applied for the part time job whether they had an interest in the full time position. The committee chairman contacted Blaine to explain and to say that he had kept her application.

In the second ad, the committee eased off on its requirements. The school preferred a candidate with a master's but would take one with a bachelor's.

The ad drew no responses, but one candidate for the part time position, Daniel Cleveland, joined Blaine in seeking the full time job. Cleveland had no independent teaching experience and only a bachelor's degree.

A standard to judge your actions

The search committee unanimously recommended him.

Blaine stayed at OCC until May 1984. Two years later she learned how Cleveland had been chosen. She sued OCC in federal court, alleging that the school had discriminated against her on the basis of her gender.

Five years later, in 1991, the court ruled that OCC's entire hiring process was "conducted and geared to hire a male." Blaine met or exceeded the requirements in OCC's first ad, the court noted. Cleveland didn't meet the requirements of the first ad and barely met those in the second.

The court awarded Blaine $20,000 in lost wages, $6,500 for emotional distress and loss of professional reputation, plus legal fees.

Like so many other employers, OCC made its mistake in not following its own policies. To be sure, the policies didn't produce the result the school wanted; the school had to choose between a candidate it didn't want to hire and another who didn't meet the school's criteria. So the school improvised — and lost.

The Results You Want

The smart employer resists the temptation to improvise. It isn't easy to follow the procedures you set up, but they set the standard by which others — namely the courts — judge what you do. So be careful. Don't run roughshod over your own procedures when they don't produce the results you want.

If you set up your procedures intelligently in the first place, they should help the search for good candidates, not hinder it. They make the haphazard into the systematic, so it pays to think about what the position demands and how those demands will shape the kind of people you're likely to see.

Make your ads specific and reflective of the needs of managers and supervisors, as well as the position itself. Remember that getting too many applicants is a problem; so is getting too few. Getting the wrong applicants is worst of all.

Often you hire someone and then, when things don't work out, replace the individual—only to find that the replacement seems very much like the one you just let go. When this gets to be a habit, revolving-door turnover is in the making.

Bob Muhlenburg, a corporate recruiter for a big fast food chain, knows the perils of high turnover. He spends several days a month in Pittsburgh and other rust-belt cities recruiting management trainees to relocate to Philadelphia and other East Coast cities at company expense.

Muhlenburg hires a lot of people this way, but he loses a lot, too. He continues to recruit because, like many others in service businesses, he desperately needs people to fill entry-level management ranks. The labor pool in Philadelphia (and big cities like it) has fragmented, and it's hard to find reliable service workers.

One reason lies in the nature of the service business, a labor-intensive industry. Manufacturers move overseas to take advantage of cheap labor, and banks and insurers rely on automation to handle many tasks once done by people. Service businesses don't have these options. They need people, and the people they hire must work hard.

They have no choice but to hire locally. As a result, convenience stores, retail chains, and fast food restaurants fall victim to high turnover.

More Than One Cook

The solution here is to get more than one cook into the kitchen to stir the stew. Let your personnel people and your line managers know what you think of their candidates for a job, but don't make your thinking dominate the process. You want information to flow from all directions—from the personnel offices, from the field or shop floor, and from your own office. The impressions of line managers don't always square with those of personnel types, and the contrasts may be as instructive as the agreements.

Whatever the nature of your business, it makes sense to market your positions in the same way that you market a new product. Call on people who know

Train the local talent or move

the field to help you define what you need in your applicants. Then test your findings just as you test-market your products, adjusting your needs as you go along so as to draw a large field of qualified candidates.

In this way you don't tempt yourself into panicked, slapdash efforts to fill the job. You also don't just rationalize a gut decision. You keep an eye out for those likely to apply for a job you might need to fill, and you know what to expect once you hire.

Other Common Problems

The country's labor pool has shifted significantly in the last twenty — and especially in the last ten — years. This presents the employer with real problems to overcome.

Once drawn to well-paying blue collar jobs, young workers now find the trade occupations neither as plentiful nor as lucrative as they were. They feel trapped in a labor pool limited to low-paying service jobs.

But you can't conclude from this that, as money is the problem, so is it the solution. Even the most callow of youths would flip burgers for a million dollars. But McDonald's can't afford to pay that much, and you probably can't, either.

"Entry-level employees aren't like professionals, whom you can attract from all over the country," says John Soto, who handles job development for the city of Denver. "They are drawn from the group of people who are living around you. Take a look at who lives in your city, because that's who your workers are going to be."

In Denver, that means a lot of women, immigrants and minorities. Some need special job training. Some need to learn the language. Some need basic math.

Wherever you are, if you face the same circumstances, you have two choices: Train the local talent or move elsewhere.

The first is the more likely response. When the country had an economy based on manufacturing,

employers invested huge sums of money in adapting equipment to meet particular needs. Now that the economy relies more on service, employers invest in adapting people — in training them. This costs money, but it allows you to search among a greater number of people in filling a particular job.

In this vein, many employers look to older workers —many of them retired or semiretired—to fill staffing needs. Older workers pose special challenges, since they are a protected labor class under certain federal laws. But older workers offer some definite advantages. For one thing, there are more of them relative to the number of younger people. For another, in an increasingly under-educated labor force, they come well equipped to work. They know how. They have spent years thinking and working with others.

Summing It Up

One Chicago personnel consultant sums it up this way: "Retired workers make great role models for younger [employees]. And they make better employees right off the bat. They are prompt. They show up to work. They show up on time. They don't mind working weekends, and they are less likely to steal from an employer. We'd all like to see a lot more of that kind of employee."

But older workers don't solve all of your staffing needs. You have to hire young people, too, and even if you spend money to train them, lowering your standards can be a tricky business. The experience of Virginia-based data processing giant DynCorp proves the point.

In 1988, DynCorp decided that — in an effort to increase its applicant pools — it would relax its requirements for data-entry positions. Previously, the company had insisted that applicants type 24 words per minute.

The company was desperate to fill several hundred positions within a few months. It had a contract with the U.S. Postal Service to process certain kinds of mail, and a little more than a month before the

Retired workers make great role models

'Dumbing down' your standards

contract took effect, DynCorp had hired only 75 percent of the people it needed.

The company tried to put the best possible spin on the change: "We have not been convinced all along that 24 words per minute is a good way of selecting people," a spokeswoman said. So DynCorp decided to take a second look at people who typed 15 to 23 words per minute. It tested the applicants on their knowledge of state abbreviations, the parts of an address, their recognition of foreign countries, and their ability to read handwritten mail.

They could opt out of the test if they could verify — through an accredited program such as a high school class or a civil service test — that they had been able to type 24 words per minute at some point within the previous year.

A Looming Deadline

The failure rate on the original typing test had been so high — averaging 50 percent, including repeat takers — that DynCorp stood no chance of hiring enough people by the time the postal contract started.

By lowering its standards, the company filled all the necessary positions in time to start processing mail. But it didn't solve the problem permanently. Five years later, when the Postal Service contract came up for renewal, DynCorp ran into staffing problems again. Originally scheduled to have a full work force by November of 1992, it requested two extensions — first until February 1993 and then until April — to fill almost 300 vacancies.

The company's difficulties attracted the attention of the media, especially when Dyncorp complained that the low-skill workforce might force it to pull out of Pennsylvania and Virginia.

Once again, nonetheless, the company squeaked by, but it didn't make many friends.

"DynCorp treats its personnel problems like a hurdle it has to clear each time [its government contracts] come up for renewal," complained a resident of a Pennsylvania city that's home to one facility.

"They just barely fatten the goose up every couple of years to pass muster. I guess that's — like they say — good enough for government work."

If your employees have to work harder than that, you probably don't have the option of lowering your standards.

Third Parties

Employers turn to outside experts when their own publicity doesn't attract the right candidates — or enough of them.

In late 1990, the Los Angeles-based Bowers Museum set about hiring a new director, hoping to get the job done within six months. It had been without a permanent director since 1989, and its acting director planned to leave by mid-1991.

The Bowers worked with a Los Angeles search firm, Spencer Stuart, which has a nonprofit-institution division. Bowers officials praised the firm for "helping us maintain a proper sense of procedure and protocol."

By March of 1991, the museum had a short list of six people, all "currently employed in positions of responsibility at credible museums," a museum spokesman said.

The museum finally hired Peter Keller of the Natural History Museum of Los Angeles County as its new executive director. He had overseen permanent and temporary exhibitions, educational programs and publications. He had worked in the museum field since 1970, including a stint at the Smithsonian Institute.

Arthur Strock, chairman of the Bowers' board of directors, said Keller had several virtues that boosted him above the other finalists: "He's local; he knows and is known by the cultural arts community of Southern California. And he had very strong experience in three areas. One, he is a scholar, with a lot of experience as a curator. Two, he has a great deal of experience in administration; he understands that museums, to some degree, have to run as businesses, and he is both confident and comfortable

A new way to look before you buy

doing that. Three, he is very comfortable meeting the public, promoting the goals of the museum, and he is a confident and experienced fund-raiser."

The search firm's fee — said to be over $10,000 — seemed worth the price for such a good fit.

Job Fairs

The Bowers Museum got its man at a price too high for most small employers. But you don't have to call in experts and shell out money every time you want to fill a job. Employers use job fairs as recruitment tools with increasing success.

A simple idea lies behind the job fair: A third party — often consultants, but sometimes industry groups or chambers of commerce — organizes a meeting at which employers and employees exchange information and resumes. It allows employer and employees alike to look without committing themselves.

The best job fairs have the feel of a trade convention (and sometimes last as long). Job fairs organized by individual companies become increasingly common.

Pharmaceutical giant Rhone-Poulenc Rorer organized one such fair for itself in 1992 at corporate headquarters outside of Philadelphia. It looked as much like a reception to launch some new product as it did a job fair. Almost 900 people turned up to check out 100 openings for research scientists, clinicians, and support services.

"It's a very cost-effective way of hiring," says the Rhone manager who supervised the fair. "We can take what it would cost to relocate two people from outside the region and put on one of these. There is a lot of talent in the area."

Applicants received paperwork at the door. After filling out the forms, job-seekers handed them to "runners," employees who took them upstairs to a conference rooms where company scientists and executives conducted 10-minute screening interviews.

If the interviewers liked what they saw, they asked applicants to return later for a more in-depth evaluation.

Do It Yourself

If you're too small to stage a job fair for yourself, third parties organize industry-focused fairs in most metropolitan areas. Some consulting groups specialize in matching employers with engineers and consultants in the environmental industry, for example. Career Connection, a California-based consulting group, arranges job fairs for environmental engineers and consultants. Christos Richards, one of the firm's principles, says that the recent wave of tough anti-pollution laws on both the federal and state levels has caused his business to grow quickly.

As aerospace and defense firms cut their work forces in California, Richards and his partners noticed a surge in help-wanted ads for environmental specialists. Particularly in demand were engineers with expertise in air quality management and in the testing and cleaning of contaminated ground water. So they decided to focus on the environmental industry.

Job candidates attend Career Connection fairs for free; employers pay fees averaging $2,500. Career Connection advertises upcoming fairs in trade publications and local newspapers, rents the hotel space and checks applicants to make sure they have the right qualifications.

Career Connection turns away those who lack the qualifications. The rest receive printed invitations which they must present at the door for admittance; employers get the names of these candidates several weeks in advance. Several hundred job-seekers typically show up without invitations. Career Connection staffers screen their resumes on the spot before admitting them.

Employers review the resumes and interview applicants in private hotel suites. They stand a good chance of finding qualified applicants because only people with environmental credentials get in. They

Some job fairs focus on specific industries

55

Helping hand from public agencies

average two to three hires per fair, so they spend $1,250 to $833 per applicant — compared with the $10,000 to $15,000 that big employers spend on consultants.

If a privately-managed job fair threatens your recruiting budget, some government agencies provide similar services, though less successfully.

In 1983, for example, the city of Philadelphia accepted applications for 600 of the 1,350 jobs to be created by the opening of Gallery II, a new shopping mall. But the assistance came with strings attached. The city wanted to place minority workers in half of all the retail, food service, security and maintenance jobs at the new mall. It did the initial interviews and screening, but the results didn't fare well under the merchants' later interviews.

The city did place several hundred workers in the mall, but employers complained that the hires performed erratically. Within two years, the stream of applicants directed to the mall from the city had dwindled to a trickle.

The Race Factor

Race plays a bigger role in hiring and firing than it does anywhere else in business. And it has more to do with hiring than with firing.

It's not hard to know what government wants you to do with respect to racial matters in hiring and firing: It wants you to give everybody a fair chance at landing a job with your enterprise. But sometimes it's hard indeed to figure out how government wants you to go about achieving that end.

To prove yourself fair, government wants you to show no preferences based on race. But it requires that you pay a great deal of attention to race in order to prove that you show no preferences. It wants you to be colorblind — and in order to prove that you are, it requires that you be anything but.

You avoid discrimination claims later on — even after you fire someone — by the way you put together your applicant pools. Take care here and you earn

dividends down the road. Do things sloppily and you pay the price.

Some employers learn this lesson the hard way.

In August of 1990, the U.S. Department of Labor accused the University of Maryland of discriminating against black and Asian job applicants. The complaint threatened some $15 million in federal contracts, mostly research grants.

The Labor Department filed the complaint after negotiating long and hard to settle the dispute. The university agreed to reform its policies for future hirings but refused to shell out more than $1 million in back pay or to offer jobs to anyone found to have been discriminated against.

A Pattern of Discrimination

The complaint stemmed from the campus' hiring practices for clerical and secretarial workers. The Labor Department said it uncovered a pattern of discrimination during a routine investigation that began in March 1987. The government alleged that the number of blacks and Asians hired for clerical work was smaller than it ought to have been, given the number of minority applicants.

By implication, at least, the government thought the proportions should be roughly equal.

The university acknowledged that the racial mix of its clerks and secretaries did not match that of the applicant pool, but it denied that the disparities showed any racial discrimination. The school's attorney argued that federal investigators had turned up no instances in which individual applicants had been treated unfairly.

Furthermore, the school argued, the U.S. Supreme Court had outlawed the method of statistical analysis used by the Labor Department to substantiate its allegation. The analysis relied on the ill-defined concept of "significant disparity" to make its case.

The government skated around this difficulty by resorting to a technicality. It argued that the Supreme Court decision didn't apply because the Labor De

The racial mix of the applicant pool

The payoff

center increased by 75 percent between December 1988 and May 1991. By 1992 the test scores and resumes of the technicians who applied for jobs at the blood center had improved noticeably.

Clearly, the center made its efforts pay off. It took an active role in cultivating its local labor pool, with the result that it headed off a growing problem.

And it showed that, if creating jobs remains one of the most rewarding aspects of being an employer, the creative process doesn't stop when you place an ad in the newspaper.

CHAPTER 4:
PICKING AND CHOOSING

Once you assemble a strong applicant pool, you face the task of choosing the workers you want from among them. No matter how you go about this, it's hard to avoid the dilemma of the kids who choose teams on a playground. They don't always love the team they pick, and the kids they pick — or don't pick — sometimes feel insulted by the whole process.

It's hard to be politically correct, in other words, when you pick your workers. But you have to try.

You also have to hire everybody with an eye toward firing everybody. No one likes to admit that this makes for good hiring. But it does.

Finally, you have to spend money, because before you pick, you must check and test. Personnel types check references, educational background and previous job performance. They oversee drug testing and medical screenings as they become more common. Somebody needs to check immigration and residence status, to conform with federal and sometimes state law.

The Price Tag

These add to costs dramatically. In 1985, the American Society for Personnel Administration and the Bureau of National Affairs studied the total costs of 423 personnel departments in firms employing 800,000 people. They found median expenditures at $500,000. In 1986, the median hit $525,000. By 1990, with testing for blood diseases like AIDS and hepatitis increasingly common, the median passed $600,000.

What does all this give the employer? A headache.

It sometimes seems that in picking your employees you spend money only to gain the opportunity to

Always hire with an eye toward firing

You remain in control

lose more money later on in messy lawsuits. But it pays to resist this kind of thinking. The selection process is the last step in the hiring and firing process that you can completely control by yourself. Do it carefully and you give yourself employees who contribute to the enterprise. Do it sloppily and you give yourself headaches indeed.

The Challenge

In late 1992, the U.S. District Court in Washington, DC issued a ruling that brought to a head one of the largest and most complicated lawsuits in American legal history involving a company's applicant screening process. The case never reached trial, but it stands out as an important signpost for employers everywhere.

The dispute involved black and female applicants turned down for jobs with Potomac Electric Power Company — PEPCO, in local parlance. The rejected applicants argued that PEPCO hired far fewer black people than would have been statistically probable, given its applicant pool.

PEPCO used a standard application form for all job applicants. Its employment office screened the applications and sent them on to those departments with openings. The departments picked out those applicants whom it wished to interview in person, and hired from that group.

This, the plaintiffs argued, made for too much subjectivity in PEPCO's hiring. The company allowed its departments to make the final selection for its jobs with little supervision of the techniques of the individual interviewers, the plaintiffs said.

In the pretrial maneuvering, the court sorted through a lot of ill-will between the rejected applicants and PEPCO, stressing that it didn't want to judge the merits of the rejected applicants' claims.

PEPCO argued that no grounds existed for a trial for two reasons. The first was that the company required that interviewers identify the race and sex of each applicant interviewed and summarize the successful candidate's background. Its employment department reviewed these reports before extend-

ing an offer to the successful applicant.

This precaution had teeth, PEPCO argued, and prevented the interviewers from acting arbitrarily.

The court didn't think so. "Such precautions are a step in the right direction," it said, "but they hardly preclude discriminatory decisions."

PEPCO's second argument was that its skills tests worked objectively and fairly, whatever the merits of the company's willingness to let its individual departments decide whom to hire.

But the court didn't care about the tests. It cared only about the laxity of the oversight. It put an end to the pretrial maneuvering by siding with the plaintiffs and ordering that the case go to a jury.

At this point PEPCO gave up the fight. The court appeared to have validated the anger of the plaintiffs, and PEPCO had no choice but to settle. The utility agreed to pay $38.4 million to the plaintiffs and to train all of its nearly 5,100 employees in cultural diversity. It also agreed to hire consultants to study its personnel practices, including the skills tests, which the company promised to adapt to allow more minorities to pass — although PEPCO denied that any "race norming" would result.

Too Much Credence

Among other things, *PEPCO* shows the hazard of putting too much credence in tests on which members of different groups score differently on the average.

It also shows the hazard of letting line managers and supervisors do their own picking and choosing with little supervision from senior management. The plaintiffs in *PEPCO* made a telling point in arguing that the practice allowed too much subjectivity to creep into the hiring process.

The answer, however, isn't to do everything yourself; that takes too much time. Instead, set out the guidelines by which you expect your managers to make their decisions in hiring people, and make sure they follow them. In addition, make sure that your enterprise communicates clearly with the peo-

A step in the right direction

Fair treatment for everyone

ple you consider for employment. Let them know how you ensure that everybody gets fair treatment. Doing anything less tells outsiders that your company operates in an ineffective and inconsiderate manner.

Even so, as *PEPCO* shows, there's no such thing as a completely objective hiring process. You can pay consultants tens of thousands of dollars to develop screening tests. You can (and should) use objective criteria to compare your candidates. You can assemble committees to review your selection process against company standards.

But in the end, you have to pray that you don't get somebody — or a group of somebodies — angry enough to take you to court. The courts want you to treat people fairly, but they don't judge your efforts by consistent standards. So you can't know in advance whether your standards for measuring candidates will pass muster.

In the end, fighting discrimination claims in court is like the battle of Leningrad. A winner eventually emerges, but only at great cost.

And only the lawyers come out whole. In *PEPCO*, $10 million went to lawyers for the applicants.

What Really Matters

Keep in mind that outcomes count for a lot here. The court sided with the plaintiffs in *PEPCO* because the company's procedures didn't assure that it would hire people of different races and genders in rough proportion to their presence in the applicant pool. It didn't matter, in other words, that the company sought to assure fairness going into the hiring process. What mattered was what came out of that process.

Continuity counts for a lot, too. It establishes patterns that can debunk accusations of unfair — meaning inconsistent — treatment.

None of this makes the hiring process objective. Hiring one person over another always involves subjective values and preferences. As the employer, you still have that prerogative, believe it or not. But you

must defend it. You must assume the worst — namely that in choosing one person over another, sooner or later you will offend the losing candidate and face a lawsuit.

The Interview

The Americans with Disabilities Act and the Civil Rights Act of 1991 make hiring "a potential nightmare," one East Coast consultant says. "Some specialists gave us 15 questions you must not ask during the hiring process — basic things like, 'Where have you lived?' 'Are you married?' 'Have you ever had any illnesses?' 'Have you ever filed a workers' compensation claim?'"

The list of pitfalls will grow over the years as the courts seek to gauge the meaning of these vaguely worded laws.

Notwithstanding this turmoil, the interview remains the most efficient method of evaluating a job candidate and of controlling your legal exposure at the same time.

So how do you handle the interview?

Start with what hiring experts call structured questions. Ask them of every candidate and base your comparisons on what your candidates say. Use a standard worksheet to do this, checking off each applicant's strengths against the job skills profile for the position.

Make sure, of course, that you adjust your questions to reflect each applicant's background. The interview must leave room for give and take — unstructured questions, in the parlance of the business — and the interviewer must know how and when to pursue such questions to clarify things left uncertain by the structured questions.

Experienced interviewers tend to avoid questions that encourage yes and no responses or pat answers.

The structured questions should cover five areas:

1) *Ability/suitability*. These questions probe skills and mechanical abilities of an applicant

Answers show initiative — or the opposite

tive and skills to solve problems.

II. *Communications skills*

Question:

Please describe times you communicated effectively and ineffectively. Describe the results in each case.

Answers:

1) "I left the meeting without fully understanding the instructions, then returned shortly to my supervisor with a sample of the work and asked, 'Is this what you wanted?'"

2) "My supervisor was telling me how to do something and I didn't understand one of the instructions. She wasn't good at explaining things. So I interrupted her and asked her to repeat what she said."

Both answers are acceptable. The second is the better one, though. It suggests an applicant self-confident enough to admit that she didn't understand the instruction.

III. *Decision-making skills*

Question:

Tell us about one or two tough decisions you made at work in the last year or two. In each case, describe the situation, the process, and the end results.

Answer:

"I had to buy a new car, so I researched it thoroughly. I read reports on different models. I comparison shopped. I spoke with people who had bought the model I was interested in. I took time to think out the decision."

This is a good answer. Most employers look for people who think out decisions before they make them. Answers to this point often overlap those in the next.

IV. *Stress tolerance*

Question:

Give us some examples of the kinds of conditions that cause you to lose your temper. How did you handle those situations?

Answers:

1) "There's too much work when a machine breaks down."

2) "Six people were supposed to work one weekend and three called in sick. I worked hard but also called my supervisor and told her I needed help."

The first response is understandable, perhaps, but suggests immaturity. The second answer demonstrates that the applicant will work hard but knows the limits of response to a given situation. It suggests someone who — even if frustrated — will work toward a solution.

UCSF has four supervisors interview job candidates together. As the candidate answers each question, the interviewers register their impressions on a scoring form. Scores range from a low of 0 to a high of 3.

Other employers use scoring systems ranging from simple pass/fail models to elaborate ten-point systems. The scoring mechanism matters less than the fact that the questions remain varied, relevant and asked of each applicant.

Common Mistakes

Rarely does an interview cover everything of importance about any given applicant. But the following guidelines help interviewers in any field cover the basic points.

- *Focus on goal-orientation.*

Ask what goals your candidate set in his or her last job or project. Did the candidate set those goals alone or with direction from superiors? Did he or she meet the goals and, if so, in what time frame? In answering these questions, an applicant must be quite specific about his or her experience and work history.

Look for people who think through problems

Uncover gaps in work history

If the applicant can't take you through the steps required to set and meet goals, or remains sketchy about the details, you can conclude that he or she probably required a lot of supervision.

- *Look for the right kind of stability.*

Many employers see a stable work history as a major indicator of an applicant's promise, but it's not always true.

A history of job-jumping in a short period of time sometimes means trouble. Look behind the history for reasons. Your candidate may have jumped jobs often in a search for something creative, for example. If so, do you need that quality for the job you want to fill?

Ask the applicant to review his or her resume and discuss the good and bad aspects of each position listed. This uncovers gaps in a work history that might not be so obvious at first. It also offers you a glimpse into how your candidate thinks about work in general, and of how he or she may think of the position you want to fill.

- *When possible, interview your candidate more than once.*

This is a given when hiring managers, salespeople or executives, who expect as many as three interviews. It can pay off with other people in your organization chart, too. The second and third interviews give both the interviewer and the applicant every opportunity to test compatibility.

- *Ask applicants to assess their performance at previous jobs.*

Often, people equate working hard with achievement. They're not the same thing. Achievers tell you not only what they did, but why they set certain goals and why they performed well or badly in attaining those goals.

Take it as a bad sign if your candidate recites a litany of ills against old bosses. Take it as a good sign if the applicant looks at past performance in honest, critical terms.

"Most striking in the entire employment process is

the willingness of applicants to falsify education credentials and experience," says a Northwestern University survey of companies assessing the 1993 job market.

The survey found that employers verify education and past employment much more than they did five years before. Also more widely-used: Checks of credit reports and police and court records.

A small industry has sprung up to do nothing more than check into the backgrounds of employment prospects. For example, the Credit Managers Association of California, a nonprofit credit reporting agency, checks a job applicant's employment history and credit record as well as any criminal convictions for a fee of $110.

The Candidate's Help

Most employers don't go so far as to bring in an outsider, however; they do the work themselves. They contact references provided by their candidates, and they tell their candidates ahead of time that they intend to so so. This enlists the candidate's help in getting references to be forthcoming. If possible, they get the candidate to sign a release protecting those who give references.

When you call the references, give them:

- Your name and that of your company;

- An explanation of the position being offered, the industry, and how you intend to use the interview;

- An assurance of confidentiality so as to jeopardize neither the applicant's nor the reference's current position.

Once you get the reference's cooperation, the key to a successful check is to ask open-ended but relevant questions that give the reference freedom to be expansive in answering.

Some of these include:

- How would you rate the candidate against other similar employees? Top third? Middle third? Bottom third?

Check credit report, court records

When silence speaks volumes

- Why did you choose this ranking for the candidate?

- If the candidate worked for a vendor to your firm, did he or she appear well prepared to deal with your account?

Old headhunters start at the bottom of a list of references on the theory that marginal references sometimes have the most interesting things to say about a candidate.

Getting the reluctant references to talk is an art — but even silence can speak volumes. Generally, employers give positive references for past employees who deserve them but only confirm specific information for those for whom they would give a negative reference.

Candid conversation sometimes blossoms when the person doing the check talks to a counterpart at the previous employer — for example, controller to controller, marketing chief to marketing chief.

The Scarlet Letter

In the past, bad references pinned a job seeker with a scarlet letter for life. Former employers didn't hesitate to speak freely, and new employers wouldn't hire someone with a bad reference. These days, the rules go the other way because past employers fear being sued if they speak ill of anyone. This makes it difficult to uncover the past of those who have things to hide.

Employers accustom themselves to having little information about their applicants' work histories, but they don't like it. Making reference checks occupies less time in the hiring process than it did even ten years ago.

But remember that the exposure goes to the former employer who answers a question, not to the employer who asks it. You can't get in trouble for asking a question, only for answering it. In fact, you build a solid defense if you know certain things about your candidate going in.

Not all managers understand the risks involved in giving out a negative reference. This leaves you, the

potential employer, free to concentrate on getting information any way you can. You don't face really major legal exposure until you make the hire, so make every effort beforehand.

Testing Applicants

In a 1990 survey on pre-employment testing, the Pennsylvania-based Center for Workplace Issues and Trends found that more than 60 percent of the 500-plus companies polled used skills testing as a condition of employment. Another 29 percent used personality/aptitude testing or considered doing so.

Eighty-one percent verified educational achievements and 79 percent verified past employment. Fifty-seven percent required a physical exam, 33 percent drug testing, 17 percent personality or psychological testing. Seven percent required their applicants to undergo psychological testing. Two percent tested for the HIV virus.

For many employers, testing proves the most important source of information they have about their job candidate.

Unfortunately, some labor groups and activists argue that testing only confirms that American business discriminates in hiring practices. The critics charge that testing screens out excellent prospects, discriminates against minority candidates and actually adds to the costs of hiring in the long run because it can prolong the search and adds to the costs.

In all of this, a key question emerges: To what extent is pre-employment testing a cost-effective way to find the right person for the job?

The federal government uses somewhat loose standards to judge written tests.

"The Equal Employment Opportunity Commission has established clear guidelines to make it a fair and legal hiring practice, when used as *another selection — not screening* — tool and in conjunction with the interview and reference checks,"[1] says Donnie Perkins, associate director in the Office of Educational

[1] Emphasis added.

The employer as social engineer

schoolchildren everywhere, one step farther.

The system weights the scores of pre-employment tests so that proportionate numbers of each racial and ethnic group pass. It scores white, black and Hispanic people separately and converts the results into percentile ranks. Naturally enough, those with low scores in one group often stand higher in the final ratings than those with high scores from another group.

The proponents of race norming justify it on the grounds that it seeks to give opportunity to those who might not otherwise find it, but employers have good reason to react against the practice. Race norming effectively makes the original tests meaningless by skewing the results so as to affect the outcome. The tests no longer measure one individual against another without respect to race, gender or any other factor. Instead, they mask performance by measuring the individual only against others of the same race, gender or ethnic background. Thus race norming makes race the central feature of the hiring process. It does unique violence to the ideal of America as a colorblind society.

The employer, meanwhile, wants only to hire those people who appear most likely to help the enterprise make a profit. Indeed, the employer sees the enterprise itself primarily as a profit-making venture and only secondarily as a vehicle for providing others with an opportunity to get ahead in the world. To the employer, race norming makes it impossible to pick the candidate best qualified for the job. It forces the employer to pick the candidate most likely to make the workforce resemble the racial and ethnic mix of the population — a different proposition altogether. It forces the employer to become social engineer first and employer second.

Employers should be wary of consultants who offer their services in the administration of these tests, because they practically choke the process. "Tests purchased and used without professional guidance can be risky and subject to legal challenge," says one New York-based consultant.

He makes his living offering said guidance.

Employers should be equally wary of those who coach job applicants how to take the tests. They advise applicants to play roles when taking psychological tests in a deliberate effort to skew the results.

One headhunter explains her advice plainly: "The person who is being tested is the professional 'you,' not the personal 'you.' Suppose on a psychological test you are to answer this question: 'On weekends, would you prefer to go out to a party or stay home and read a book?' If you're applying for a sales job, you wouldn't want to appear too introspective, though personally you might prefer to stay home."

Testing Skills and Aptitude

Toyota U.S.A. uses a rigorous selection system at its Kentucky plant to find people who accept responsibility and work effectively with others. The company recruits aggressively, and it assesses technical and interpersonal skills with equal rigor. It also requires that the employee undergo drug-and-alcohol testing and a physical. It hires only those who pass muster without respect to race, gender or ethnic background.

The carmaker touts the Kentucky plant as the highest-quality automobile plant in the United States.

"I see this as an exact reflection of our pre-employment testing," says spokesman Jim Wiseman. "We believe that every hire is a million-dollar decision [based on a 30-year employment projection] and should be given the same kind of attention that we give to any million-dollar investment."

Other employers do well when they follow similar practices, but it isn't easy.

For one thing, it takes time and patience; you have to commit yourself to the task as an ongoing process. For another, most employers see a broad decline in the abilities of the people who come looking for work in the skilled trades. Metalworking shops, for example, have trouble finding people with the skills for journeyman positions.

"The flow of skilled workers into our sector of indus-

Flow of skilled workers slows

try is drying up," says Donald Nicholson, who coordinates training programs for the National Tooling and Machining Association. The group provides employers with standard tests that can protect shop owners against lawsuits alleging discriminatory hiring practices.

"For years," Nicholson explains, "we've been scared of testing because a lot of our tests were based on achievement and, therefore, were declared to be illegal."

The NTMA's tests seek to measure aptitude — the probability of job success in the tooling and machining industry. In addition to three standardized tests, the screening package includes a new test geared specifically to machine-shop math.

The organization customizes the tests for other industries, and other trade groups provide similar materials for their own members.

Drug Testing

Drugs cost American employers more than $20 billion every year in lost productivity, according to the best estimates.

In response, an increasing number of employers use pre-hire drug tests to screen out potential problems. A 1987 Northwestern University report found that 33 percent of responding employers used some form of drug testing to screen all applicants, an increase of 136 percent from 1985. An additional 19 percent of the firms planned to start drug testing within two years.

But this solution raises problems of its own — including everything from civil rights difficulties to high implementation costs.

"The cost of verifying applicants' backgrounds, giving physical examinations and testing for drugs is tremendously expensive," said Victor Lindquist, an author of the report. "But companies cannot afford not to conduct extensive screening, because it will cost them more in the long run."

By his estimate, the extra cost of hiring a drug user averages at least $7,000 in the first year of

employment.

A Harvard University study, published in 1992, considered the costs and benefits of pre-employment drug screening.

The Harvard researchers studied 2,500 prospective postal workers in the Boston area. The applicants took drug tests, but the Postal Service didn't use the results in deciding whom to hire; neither supervisors nor employees knew the results.

The applicants registered as drug-positive if their urine samples showed signs of marijuana, cocaine, barbiturates, amphetamines, or several other drugs not prescribed by a physician.

The results showed 7.8 percent positive for marijuana, 2.2 percent positive for cocaine, and 2.2 percent positive for other drugs.

The study correlated the test results with absenteeism and injuries, finding lower rates among employees not testing positive for drugs. The Postal Service, meanwhile, realized substantial savings in employing the same people. The savings in absenteeism, accidents, injuries, and turnover came to $271 per applicant hired in the study. The drug testing cost $108 per applicant, leaving a net benefit of $163.

Two thirds of the savings resulted from the lower absenteeism among those workers not testing positive, and one quarter resulted from lower injury rates.

Other Industries

The Harvard results don't automatically apply to other industries, however. For one thing, because of economies of scale, the Postal Service probably spent less on the drug tests than most companies would.

For another, rates of absenteeism, accidents, injuries, and turnover among drug users differ in different industries and in different parts of the country. So do the costs. For example, in the air transport industry, the average cost per accident might be much higher than in a white-collar industry like insurance.

Some software already exists

Finally, many users have mastered the tricks of evading positive results. Diet Mountain Dew is the bogus urine look-alike of choice, says one New Jersey-based specialist. The person who puts a small container of the soft drink under his arm to bring it to body temperature will pass 98 percent of federal drug tests. Cheaters add Visine eye drops to urine to test negative for marijuana. They add bleach to pass a cocaine test.

Nonetheless, the Harvard researchers concluded that drug screening saves money for employers who show high rates of injury, absences, and turnover, and who attract job applicants with a high prevalence of drug use.

Automated Screening

Human resource types wax enthusiastic about the revolution in job interviewing and screening promised by the computer. Some interview software already exists, but employers have mixed opinions about its usefulness.

One program, Computer Employment Applications, uses a personal computer as the initial interviewer of job applicants. The applicants read questions on the computer screen and type multiple-choice and short essay answers. After the interview, the computer prints out a summary of the information.

The program's designers claim that applicants tend to be more truthful about their resumes and experience with computers than they are with human interviewers. They even claim that applicants admit illegal drug use more readily in the computer program than in face-to-face interviews.

But screening programs like this don't truly automate the decision process. They are simply tools of convenience.

Interviews range from good to bad depending on a number of factors. Some interviewers are better than others. They work in effective or ineffective set-

tings, and they use good or bad formats. Some questions apply more broadly than others.

Taboo Subjects

Whatever the variables, the skilled interviewer must avoid certain subjects in talking with job applicants.

Chief among these:

- *Anything asked of women — but not men — about children or family circumstances.*

In the 1991 case *Bruno v. City of Crown Point, Indiana,* a woman applied for a position as a paramedic with the Crown Point Emergency Medical Services Department. Her interviewer asked about her plans to have children and about her husband's reaction to the necessity that she work twenty-four hour shifts. Crown Point eventually hired a less-experienced man and Bruno sued for sex discrimination.

Crown Point won the case, but it was a close call. In analyzing the facts, the court ruled: "An employer may ask applicants questions regarding family circumstances. . . . However, the questions should be asked of all applicants, regardless of sex, who appear to present family circumstances that might [affect] their ability to do certain jobs."

The interviewer showed sexual bias in asking only female applicants questions concerning child care and family matters, the court said. But "[m]erely showing the questions were asked . . . is not sufficient to prove intentional discrimination," it added.

- *Anything that implies promises of permanent employment.*

The employer's vulnerability to a wrongful-discharge suit begins in the very early stages of the relationship. The courts sometimes find a contractual relationship in the exaggerated statements made by recruiters or managers about job security or advancement opportunities.

Even an oral promise of a salary review after a specified length of time should be avoided; the courts

Avoid questions on race, religion, age

may find a contract of employment for that length of time in any such promise.

- *Anything about the applicant's race.*

Several federal laws prohibit these questions, including Title VII of the Civil Rights Act of 1964 and the Civil Rights Act of 1991.[2]

- *Anything about the applicant's religion.*

Even if religion has some bearing on the business, the employer still can't ask what religion applicants keep or how they keep it.

- *Anything about the applicant's age.*

The Age Discrimination in Employment Act allows some circumstances under which the employer may discuss age, but they are very specific. Do nothing to make it appear that age is a factor in your decision.

- *Anything about arrest records or military service.*

You can't ask if someone has an arrest record or has served in the military.

You may finesse this point to some degree — by asking whether your candidate has been convicted of a felony or acquired any skills needed for the job in the military.

- *Anything about the applicant's physical or psychological handicaps.*

The Americans with Disabilities Act even prohibits asking recovering drug abusers about their problems. Most state workers' comp laws prohibit asking about prior claims.

Caution is the rule of thumb here.

If your applicant offers information regarding a disability, you may ask about it. If not, you can broach the subject only if the disability might interfere directly with job performance. You can ask questions regarding essential job functions, but take care not

[2]See Chapter Five.

Questions specific to the job

to speculate on that information — for instance, by asking doubtfully whether the applicant could perform the necessary tasks.

You may need legal help here. The ADA gives you the right to ask about what it calls "bona fide occupational qualifications" — questions specific to the job made in good faith and in accordance with a vaguely defined standard of relevance.

If that sounds vague, it is; that's the problem with ADA. Congress rose to new levels of obscurity in writing this law, and it did so intentionally. The courts will spend many years plumbing the depths of the act before a concensus emerges respecting its mandates.

In the meantime, the worst that can befall you is to give your name to one of the lawsuits by which the meaning of the ADA will emerge. If you have any doubt at all about the wisdom of what you do in interviewing, hiring or firing someone protected by the ADA, get yourself to a lawyer.

CHAPTER 5: UNCLE SAM'S INFLUENCE

You may suspect that the federal government works against your business interests more often than for them. Conditioned by years of dealing with agencies ranging from the IRS to the EPA, most employers do. But nowhere does federal law undermine the common sense of the employer more completely than it does with respect to hiring and firing.

What began as a handful of good and useful rules has mutated into a compliance bureaucracy that— as often as not — causes the opposite results from what it intends.

Federal laws that influence hiring and firing include the Americans with Disabilities Act, the Age Discrimination in Employment Act, the Civil Rights Acts of 1964 and 1991, the Occupational Safety and Health Act, the Employee Retirement Income Security Act, the Labor Management Relations Act, the Fair Labor Standards Act, the Vocational Rehabilitation Act, and the Vietnam Era Veterans Readjustment Assistance Act, to name a few.

We don't consider all of these laws in this book, but the issues we discuss apply to virtually all federal workplace enforcement.

A Reversal

Federal employment laws generally mean to stop discrimination in hiring. But the government spends most of its time fighting discrimination in *firing* instead. According to a study done by the New York law firm Jones, Day, Reavis & Pogue, in 1966, the number of claims charging discrimination in hiring filed with the Equal Employment Opportunity Commission outnumbered those dealing with termination by 50 percent. But by 1985, things had reversed themselves: Firing claims outnumbered hiring claims by 6-to-1.

Working against your interests

Bias complaints increase

What lies behind this startling turnaround? It's not just the law of unintended consequences, which has bedeviled those who make law since time immemorial. Instead, a number of factors stand out, among them corporate layoffs and a greater public awareness of sexual harassment prompted by the televised hearings of Supreme Court nominee Clarence Thomas in which a former employee, Anita Hill, accused Thomas of sexual harassment. Then there is the very visible mission of the federal government to position itself as the guarantor of civil rights, not to mention the civil rights laws themselves.

All of these factors contribute to a sharp increase in the number of federal workplace complaints filed each year.

During the first quarter of 1992, total job discrimination complaints filed with the EEOC jumped 14 percent. Sexual harassment charges rose some 60 percent during the first six months following the Thomas hearings — and have kept up that pace.

EEOC officials expect that the Americans with Disabilities Act, meanwhile, will generate 12,000 new job discrimination charges each year through the 1990s.

Other polling data suggest equally disturbing conclusions. An astonishing 78 percent of Americans believe that most employers practice some form of discrimination in hiring and promotion practices, while 25 percent say they personally have experienced job-related discrimination.

The Attentive Ear

Congress pays attention to such things. Washington insiders consider it likely that Congress will shift its focus to protect employees from unfair and discriminatory dismissals and firings. Organized labor argues that the United States remains one of the few industrialized countries with no uniform code for determining what constitutes a just-cause job termination. As is usually the case with any uncertainty involving money, the resulting uncertainty generates more lawsuits.

Don't bypass your own rules

What can you do about all this?

First, use common sense and a basic knowledge of the law to keep your hiring and management processes free of discriminatory biases. Second, shape your paper trail so that it shows legitimate cause for any termination involving an employee who falls into a federally protected group.

Third, never assume that the at-will presumption will hold up against federal anti-discrimination law.

The Challenge

A 1991 case from Pennsylvania federal court shows how complex and far-reaching federal employment lawsuits can be. *Taylor v. USAir* entailed a major corporation for almost a decade, ultimately forcing the company to change the way it hires and fires workers.

Larry Curtis Taylor, a black man, began to apply for a position as a pilot with USAir in 1978.

Taylor met USAir's qualifications as published in its Flight Operations Manual. But after more than six years and several different applications, he never received a job interview. Citing federal civil rights law, Taylor sued.

He claimed that the airline had two channels to hiring: the official channel, which followed objective qualifications published in the USAir Flight Operations Manual and other sources, and an unofficial channel — the "Vice President's List" — which bypassed announced standards. Taylor alleged that every pilot hired through the unofficial channel was white, and that many failed to meet the qualifications in the flight manual.

USAir answered that it hired the best available applicants and had the "pick of the crop" because it was one of the few airlines hiring pilots in early 1980s.

The USAir executive in charge of evaluating applicants said he didn't interview Taylor because Taylor didn't show 60 college credits. USAir's flight manual required "some college," but the company didn't

Avoid undefined standards

consider anybody with fewer than 60 credits, this executive said.

USAir also argued that the percentage of black pilots hired exceeded the percentage suggested by census statistics about the overall population.

But it was to no avail; the court sided with Taylor.

"In assessing the qualifications of these applicants, the vice president of flying used undefined and reduced standards which were unknown to anyone else," the court said. "This channel, with its reduced subjective standards, was not open to qualified black applicants and thus provided white applicants with enhanced employment opportunities."

The court awarded Taylor unspecified monetary damages and attorneys fees. It ordered that he receive the next available position as pilot with USAir and, once hired, seniority retroactive to the date of his 1981 application.

The simplest way to avoid a problem like USAir's: Don't tolerate policies that appear to discriminate.

A Standard of Behavior

Taylor lays out an important standard of behavior that stands as a guideline for employers.

It required that USAir:

- Stop using the "Vice President's List" to recruit, screen and hire pilots as discriminatory on the basis of race;

- Eliminate any quota for the hiring of any relative or friend of an influential USAir employee;

- Notify all persons involved in the recruiting and hiring of flight officers that the company would not countenance discrimination;

- Route all flight officer applications through the Human Resources Department;

- Publish standards setting minimum qualifications and interview only applicants who met or exceeded the qualifications;

- Make available to all interested persons the criteria by which the company used subjective scoring;

- Take "appropriate measures" to guarantee Taylor and other black employees a work environment free of harassment or discrimination; and

- Inform all flight officers of the company's procedures for handling allegations of harassment or discrimination.

The Americans with Disabilities Act

The ADA, signed into law in 1991, casts a longer shadow over hiring and firing than any law passed since the 1960s. One reason is that, in the ADA, Congress wrote one of the vaguest laws on the books, leaving much of its meaning for the courts to decide.

Congress seems to have thought that the law would have greater impact on hiring, but that hasn't proved so. Most ADA litigation focuses on firing and lost benefits.

The ADA aims to move some 10 million disabled Americans into the mainstream of the working world. It bans discrimination against the blind, the deaf, the mentally retarded, the HIV positive, and the physically impaired. It protects people afflicted with cancer or epilepsy, and individuals recovering from substance abuse.

The law also protects workers with disabled spouses or children. You can't turn them down for a job or promotion simply because you think the relatives' impairments could cause the employee to miss work.

The ADA compels you to offer "reasonable accommodations" — for example, ramps for wheelchairs or sound amplifiers on a phone — to disabled people who seek to apply for employment. The law presumes most accommodations to be "readily achievable"; you have prove they aren't.

Not surprisingly, in ADA's early going, most disputes hinged on the meaning of "reasonable" and "readily achievable."

The disabled make good employees

"It's hard to understand exactly what we are supposed to do," says Cindy Eid, director of government affairs for the Massachusetts Restaurant Association. "Business people fear that a single accommodation might never be enough."

Much of the law's language is prospective. For example, you have to set up policies for offering modified jobs to disabled job applicants *before* they apply for positions. Otherwise, you risk being found in violation of the act — even if you adjust your policies after a disabled person has applied.

A Silver Lining

A 1987 Harris Poll of more than 900 managers showed that 64 percent considered the disabled good employees and another 24 percent considered them excellent employees. Forty-six percent rated disabled employees as harder workers than their peers with no disabilities.

A 1991 Harris Poll showed that Americans in general recognize this potential advantage. Eight out of 10 said that people with disabilities have underused potential to contribute by working and producing. Only one out of 10 disagreed.

Clearly, the polls showed that Americans do not resist the attempt to mainstream the disabled worker.

And employers found that they spent less than expected in accommodating the disabled. You don't have to rush out to hire experts or consultants. The disabled usually know more than anyone else about their needs.

For example, one person with a disability suggested putting a paper cup dispenser next to a water fountain rather than lowering the whole machine. A blind computer programmer showed his manager how to set up his computer with Braille output at minimum expense.

The President's Committee on Employment of People with Disabilities publishes a fact sheet that describes job accommodation problems and proposes low-cost solutions. Some examples:

- Problem: A person with a learning disability worked in the mail room and had trouble remembering which streets belonged in which zip codes.

 Solution: A rolodex card system listed the street names alphabetically with their corresponding zip codes, at a cost of $150. The rolodex helped the worker increase his output to acceptable levels.

- Problem: A hearing impairment made it difficult for a plant worker to use the telephone.

 Solution: Rather than assign the man to a lower-paying job elsewhere, the company bought a $48 amplifier that worked in conjunction with the employee's hearing aids.

- Problem: A file clerk had only limited use of her hands and couldn't reach across her work table to access files.

 Solution: Her employer provided an $85 "lazy Susan" file holder that allowed her to reach all necessary files.

- Problem: An applicant for a kitchen position could do everything the job required except open cans, because he had lost a hand.

 Solution: The President's Committee supplied the employer with a list of one-handed can openers and their manufacturers. The employer installed one at a cost of $35.

The President's Committee provides information on job accommodation, including free consultation on particular issues. It also serves as a central clearinghouse of basic information and refers people to other organizations as necessary.

AIDS and ADA

One of the most controversial elements of the ADA is its inclusion of AIDS and HIV as protected disabilities. As a result, AIDS patients enjoy protection from discrimination in areas such as hiring and firing, rates of pay, job assignments, fringe benefits including health insurance, and employment terms.

The law defines AIDS as a disability

You can't reject applicants solely because of HIV test

Opinions vary widely on the wisdom of listing AIDS — a communicable disease — as a disability. Critics hope the courts will limit the protections; supporters argue that the law should stand as written. In the middle, employers must understand that it is illegal to reject a job applicant solely because he or she tests positive for HIV or suffers from AIDS.

The First Test

Given the touchiness of this issue, it's no surprise that the first major ADA case to reach trial involved a claim of AIDS-related discrimination.

In March 1993, the estate of Mark Kadinger sued the International Brotherhood of Electrical Workers alleging that the union violated the ADA by limiting AIDS coverage under its health plan to $50,000. Before filing the civil suit, Kadinger's estate obtained a right-to-sue letter from the EEOC, as required by the ADA.

Kadinger had exhausted his medical benefits under the IBEW plan several months before he died from AIDS in 1992. His lawyers argued that, if he'd contracted another disease, Kadinger would have had $500,000 in coverage.

According to Gayle Dixon, legal coordinator for the Minneapolis-based Minnesota AIDS Project and an adviser to the Kadinger estate, the ADA allows AIDS victims to pierce the protective shield that the Employee Retirement Income Security Act (ERISA) affords self-insured plans.[1] AIDS activists focus on the ADA because it offers a course of action not available under state insurance and anti-discrimination laws.

Thirteen months after Kadinger died, the union settled the litigation by offering $100,000 to Kadinger's estate and the hospital where he received treatment.

In another case, an AIDS-positive employee who had been fired by a supervisor won a state court case. The employee won reinstatement plus $195,000 in damages. The only condition was that

[1] See page 94.

the employee supply his employer periodically with a certificate from his doctor stating that he posed no threat to other workers.

Most employment law experts expect the use of the ADA to become common in AIDS cases. "To some degree that was the intent [of the law]," says Mike Rosenblum, a partner in the Chicago law firm of Mayer Brown and Platt. "The ADA not only protects individuals in terms of hiring and firing, but also in terms of benefits."

The EEOC denies that it makes any special issue of AIDS coverage, but it did take part in a high-profile New York case establishing that the ADA prevents an employer-sponsored health care from excluding coverage for AIDS.

Increase Likely

Jacques Chambers, manager of the benefits program at AIDS Project Los Angeles and a former insurance agent, also predicts an increase in AIDS-related ADA suits. "The [affected employee] feels personally discriminated against just because he got the wrong disease," he says. ERISA has not protected health benefits for such people, but "the ADA is going to provide some relief," Chambers says.

Some tips for handling this well:

- AIDS doesn't guarantee an employee's position in your company. If the worker cannot for any reason — including debilitation as the result of the disease — perform the duties required by the job, you can justify dismissal.

- An employer may fire or refuse to hire an employee whose handicap directly threatens the lives and safety of others in the company.

- You can use education to calm the fears of healthy employees and customers who come into contact with an AIDS-afflicted employee. Do this regularly and often and make sure that your people understand that they can get AIDS only by sexual contact or from infected blood.[2]

The intent of ADA

[2]An infected mother may pass the disease to an unborn child.

Make sure you show fair treatment

- You can meet the act's requirements for "reasonable accommodations" by restructuring jobs, modifying work schedules, or reassigning HIV-positive or AIDS-afflicted workers. Doing so sometimes allows you to remove such workers from potentially volatile situations.

These points remain true for all employees protected under the ADA. If you fire them, make sure that you can prove you have:

1) made reasonable accommodations;

2) established justifiable reasons for termination (so as to satisfy what ADA calls "bona fide occupational qualifications"); and

3) treated the protected employee in exactly the same manner that you treat other workers.

ADA and ERISA

The Employee Income Security Act preempts state laws governing employee benefit plans, but it expressly preserves state laws regulating insurance.

This causes no shortage of confusion—and of litigation. Employers would much prefer that ERISA govern the benefits they offer to employees, including those with disabilities, because it gives them greater flexibility.

Many try to control costs by limiting employee benefits, often by limiting benefits for disabilities caused by mental or emotional disorders, alcoholism or drug addiction.

ERISA permits these kinds of limits. But the ADA contains a far-reaching ban on discriminatory behavior, raising the question whether employers, in limiting benefits, engage in discrimination.

The courts have yet to figure out what to do about this conflict, and Congress didn't give them much to go on in the ADA. The legislative history of the ADA is confusing, and the law itself doesn't explicitly say whether employers may impose disability-specific limitations on employee benefits.

One section of the law expressly protects ERISA from preemption by any state law offering "greater

or equal protection" to people with disabilities. But the very next section upholds those state laws that govern health insurers and self-insured employers.

Further clouding the situation, the EEOC hasn't provided any consistent guidance concerning what limits ADA allows employers to place on fringe benefits. This ambiguity is the pivotal point of conflict between ADA and ERISA.

A 'Safe Harbor'

Applying the U.S. Supreme Court's interpretation of other civil rights law to ADA, employers operating bona fide benefit plans should have a so-called "safe harbor" for disability-specific limitations adopted before the ADA. Put simply, you should be able to keep disability-specific limitations as long as you don't intend to discriminate on the basis of disability in non-fringe-benefit aspects of employment (such as hiring, wages, or promotion).

Your paper trail will help you here. It can establish the specific business and legal reasons that justify any limitations in benefits you offer employees. Documentation from current benefit providers, consultants, and administrators about the rationale for any limitations should be a part of this record.

Of course, disability rights advocates will continue to argue that ADA's definition of discrimination extends to fringe benefits. They'll likely refer to the federal Rehabilitation Act of 1973 (an ADA predecessor), which covers fringe benefits.

Other precedents work for employers. In the 1992 case *Greater Washington Board of Trade vs. District of Columbia*, the U.S. Supreme Court supported ERISA's occasional conflicts with other workplace law. It decided that ERISA preempted a District of Columbia law that tried to require employers to provide additional health benefits to employees collecting workers' comp.

In the case, Justice Clarence Thomas wrote:

> *ERISA sets out a comprehensive system for the federal regulation of private employee benefit*

plans, including both pension plans and welfare plans. A "welfare plan" is defined in ERISA to include . . . any "plan, fund, or program" maintained for the purpose of providing medical or other health benefits for employees or their beneficiaries "through the purchase of insurance or otherwise."

Subject to certain exemptions, ERISA applies generally to all employee benefit plans sponsored by an employer or employee organization.

To date, this analysis remains intact. But disability rights advocates and greedy labor lawyers will surely continue to argue that ADA controls fringe benefits.

The Age Discrimination in Employment Act

Age discrimination has become a hot topic in post-termination lawsuits, particularly as companies downsize and cut staff. The Age Discrimination in Employment Act protects job applicants and existing workers over the age of 40 from any discriminatory job action based on their age alone.

"Over 40" covers a majority of the work force. Partly for this reason, the courts tend to side with employers who can reasonably account for why the disputed firings (or lack of hirings) took place.

This can sometimes prove tricky, because the burden of proof shifts around in ADEA cases — as it does in all civil rights cases. (The prohibitory language of ADEA is nearly identical to that of Title VII of the 1964 Civil Rights Act. Thus the courts routinely rely on Title VII decisions in interpreting the comparable ADEA provisions.)

The 1991 case *Berlett v. Cargill,* tried in Illinois federal court, illustrates the complexity. It involves claims of discriminatory non-hiring.

From 1975 to 1984 Betty Jo Berlett, born in 1929, worked as a grain merchant for the Pillsbury Company at its Central Illinois grain merchandising plant. In September 1984, Pillsbury sold the plant to Cargill, which owns and operates plants throughout the Midwest.

Cargill agreed to consider former Pillsbury employees for a limited number of positions. Cargill staffers screened them to find those who qualified.

Cargill hired several former Pillsbury employees holding lower-paying jobs (bookkeepers, clerks, grain weighers and graders). It didn't hire several higher-salary workers, including Berlett. She felt Cargill rejected her because of her age.

In deposition, Berlett offered one piece of direct evidence that Cargill took her age into account. She said: "Nearing the close of the interview [the Cargill staffer] said, 'I know I'm not supposed to ask you this, but how old are you?' . . . I was so taken aback by the question, and the gentleman had been very cordial during the interview, that I just blurted out 55."

A Different Account

The Cargill interviewer admitted to having discussed Berlett's age but portrayed the scene somewhat differently:

"[Berlett] seemed quite nervous, quite ill-at-ease . . . I read her employment application [and] noticed that we were somewhat in the same age group. I made some statement that we graduated approximately in the same era . . . and I said something to the effect that we must be close to the same age."

The court ruled for Cargill. It found the discussion of Berlett's age "incidental" and concluded: "[T]he fact an employer fails to find a way of retaining an older employee is not evidence of a discriminatory motive."

In arguing her case, Berlett used the so-called "mixed-motives analysis" first outlined in the 1989 Supreme Court decision *Price Waterhouse v. Hopkins.* In this approach, if the employee can show direct evidence of discrimination, the burden of proof shifts to — and stays with — you.

But an unlawful motive must be the "motivating part" of an adverse action, not just one of many influences. And as *Berlett* shows, stray comments or questions regarding a plaintiff's age don't prove

'Incidental' discussion of a taboo subject

A lawsuit waiting to happen

that age has played a "motivating part" in an employment decision.

The ADEA remains important in hiring and firing for one main reason: It protects experienced, affluent and well-connected people. Firing a worker who has a career's worth of friends and connections in a city or industry can make for trouble if you don't watch what you do.

As one angry oldster wrote to *New York Newsday:* "I am convinced that 'ageism' is the most pervasive form of unfair discrimination in our society. It transcends all barriers of race, ethnicity and gender. Yet practicing it doesn't seem to be even remotely incorrect politically!"

What Not to Say

This attitude is a lawsuit waiting to happen. Some tips for avoiding the summons:

- Despite *Berlett,* avoid any comments about an applicant's age, especially if you are younger than your applicant or employee.

- Make no comments about the company's wanting to project a "youthful image."

- Avoid all code words. Some interviewers use phrases like "you're overqualified" and "you won't be challenged" when dealing with an older job applicant. To date, this jargon has held up to court scrutiny, but it may not last much longer.

- Check the impact of layoffs or terminations on pension plans and other benefits. If older workers lose a disproportionate number of benefits, you should adjust severance packages to compensate for the losses.

- Handle older workers honestly and even generously. As in many disputes stemming from federal civil rights law, emotions tend to determine whether people file ADEA charges in the first place. A few thousand dollars of prevention can save tens of thousands of dollars in court-enforced cures.

The Civil Rights Acts

No other federal law influences hiring and firing as much as Title VII of the Civil Rights Act of 1964. Most employers know that Title VII makes it illegal to refuse to hire or promote anyone because of race, gender, creed or national origin. You can't fire people for these reasons, either.

Specifically, Title VII makes it unlawful "to fail or refuse to hire or to discharge any individual, or otherwise discriminate against any individual with respect to his compensation, terms, conditions or privileges of employment, because of such individual's race [or] color. . . ."

Title VII also makes it illegal to limit, segregate, or classify employees in ways that adversely affect any employee because of his or her race, color, religion, sex, or national origin.

Griggs v. Duke Power Co., considered in the previous chapter, construed Title VII to proscribe "not only overt discrimination but also practices that are fair in form but discriminatory in practice."

In plain English, *Griggs* focuses on the outcome of your practices, whether intentionally discriminatory or not. Under this "disparate impact" (as opposed to "disparate treatment") theory, a court may find a neutral employment practice in violation of Title VII even without evidence of any intent to discriminate on your part.

The language of Title VII prohibits punitive damages and concentrates on compensatory relief, including back pay and reinstatement. But an underlying presumption of the law presses up awards: In cases of intentional racial discrimination, a "court has not merely the power but the duty to render a decree which will so far as possible eliminate the discriminatory effects of the past as well as bar like discrimination in the future."

It's a widely cited section of the law.

The Burden of Proof

Two frequently cited Supreme Court cases address the burden of proof in employment discrimination:

Widely cited section of the law

Burden shifts to the employer

Price Waterhouse v. Hopkins, mentioned before, and *Texas Department of Community Affairs v. Burdine.*

In *Burdine,* the Supreme Court ruled that after the employee proves disparate impact or disparate treatment, the burden shifts to the employer to produce a clear explanation of a nondiscriminatory reason for its actions.

A key point: *Burdine* doesn't require that you prove that you hired a person with better qualifications than your accuser — only that your decision didn't directly discriminate. The burden of proving discrimination remains with the accuser.

In the 1991 Texas case *Miles v. J.C. Penney,* the plaintiff complained to the EEOC that J.C. Penney discriminated against her by denying her proper training and supervision, by unfairly evaluating her performance and by excluding her from management meetings, all because she was black. Valerie Miles also charged that the company fired her in retaliation for her complaint.

The Elements

Miles had sought a position as a merchandise manager. As required by *Burdine,* she established the elements of prima facie discrimination:

1) She was a member of protected class;

2) She possessed the minimum qualifications to perform her job;

3) Despite her qualifications, she suffered adverse treatment; and

4) After J.C. Penney fired her, it sought applicants with similar qualifications.

J.C. Penney successfully defended itself by producing evidence that it decided not to choose Miles for permanent employment for legitimate, nondiscriminatory reasons. Penney management testified that although Miles was sufficiently educated, she lacked the interpersonal skills, initiative, and follow-through necessary to serve as a manager.

Also, soon after she resigned from Penney and start-

ed her lawsuit, two other black trainees completed the same program under the same supervisors and won managerial positions.

The Texas court ruled against Miles:

> *The fact a court may think that the employer misjudged the qualifications of the applicant does not in itself result in Title VII liability, though it may be probative of whether the employer's reasons are pretexts for discrimination. . . . Civil rights statutes, such as Title VII, were not intended as a vehicle for judicial second-guessing of business decisions, nor were they intended to transform courts into personnel managers.*

You might want to copy that quote and hang it on your wall.

Miles offered no evidence to suggest that J.C. Penney's reasons amounted to pretext. She failed to carry her burden of persuasion.

Business Judgment

The "business judgment" rule that the *Miles* decision mentions has held up in other jurisdictions, too. In the California case *Sanchez v. Philip Morris*, the tobacco giant argued that its stated reason for not hiring an Hispanic job applicant — specifically, that it always hired the best qualified applicant — invoked the business judgment rule. It argued that this precluded the court from comparing the relative qualifications of the accuser and other applicants.

The trial court rejected Philip Morris's argument "because it would . . . divest courts of their power to determine if a defendant who offers this business justification is trying to cover up a gross disparity. . . . The reality of the entire situation must be examined."

A higher court rejected this reasoning: "We are not in the business of determining whether an employer acted prudently or imprudently in its hiring decisions."

As a rule, the courts show more interest in changing hiring and firing practices than in handing out huge

'Special master' determines back pay

piles of cash. When they do award damages, they do so conservatively, usually limiting them to back-pay.

But if the plaintiff establishes your Title VII liability, the court may appoint a "special master" to determine the back pay owed to the plaintiff or to each member of a plaintiff class. The special master operates under guidelines set by the court, and the process can turn very expensive.

Angry workers and defensive employers alike use statistics in arguing their Title VII cases. Numerous court decisions stress that numbers matter less in questions of discrimination than intentions.

Important Precedent

As tricky as numbers can be, motivations are even tougher to establish. The most important precedent in this regard is the 1989 Supreme Court decision *Wards Cove Packing v. Antonio.*

The Wards Cove canneries operated only during the salmon runs in the summer months. In May or June of each year, a few weeks before the runs began, workers prepared the equipment for the season.

During the off-season, the companies employed only a small number of individuals at headquarters in Seattle and Astoria, Oregon plus some employees at the winter shipyard in Seattle.

The company divided cannery jobs into two general categories: unskilled jobs on the cannery production lines, filled predominantly by nonwhites; and noncannery jobs, filled predominantly by white workers. Virtually all of the noncannery workers earned more than cannery workers.

A class of nonwhite workers sued in federal court in Washington state, alleging that the hiring and promotion practices of Wards Cove caused racial stratification.

After some wrangling, the court ruled for the workers. The Court of Appeals agreed.

The U.S. Supreme Court, however, ruled (with notable dissent) that statistical evidence showing a high

percentage of nonwhite workers in the employer's cannery jobs, and a low percentage of such workers in noncannery positions, did not establish a prima facie case of disparate impact.

Specifically, the Supreme Court wrote:

> *The Court of Appeals erred in ruling that a comparison of the percentage of cannery workers who are nonwhite and the percentage of noncannery workers who are nonwhite makes out a prima facie disparate-impact case. . . . [T]he proper comparison is generally between the racial composition of the at-issue jobs and the racial composition of the qualified population in the relevant labor market.*

Wards Cove's employment practices could not have a disparate impact on nonwhites — the first requisite in a Title VII claim — if the absence of minorities holding skilled jobs "reflects a dearth of qualified nonwhite applicants for reasons that are not petitioners' fault."

The Supreme Court upheld, in this context, your right to make business judgments. It called allegations of discrimination that compared a skilled work force to an unskilled work force "nonsensical."

Title VII and Reverse Discrimination

Some angry applicants and former employees try to use Title VII to support reverse discrimination claims.

Title VII prohibits racial discrimination against all groups, but the federal courts consistently rule that majority plaintiffs must establish reverse discrimination by showing:

- That background circumstances support the suspicion that the defendant is that unusual employer who discriminates against the majority and

- That the employer treated differently employees who were similarly situated but not members of the protected group.

The courts generally don't have much sympathy for these claims.

Statistics aren't always conclusive

A good example is the 1992 federal case *Lemnitzer and Green v. Philippine Airlines*. In this case, two former employees alleged wrongful termination on the basis of age and national origin.

Fred Lemnitzer worked for PAL from 1969 until 1988, Ken Green from 1976 until 1988. Both men were white and American citizens.

In August 1988, PAL announced that it would close all of its district sales offices in the United States outside of California and Hawaii due to financial losses. Ultimately, this cost 114 people their jobs.

PAL informed Lemnitzer in June 1988 that it would abolish his position. It informed Green two months later.

In their suit, Lemnitzer and Green alleged that PAL discriminated against non-Filipinos. They offered statistical evidence that PAL's managers were largely Filipino or U.S. citizens of Filipino origin. They alleged that PAL president Roman Cruz announced at a 1982 sales meeting that PAL intended to implement a company-wide policy of "Filipinizing" its management.

The court ruled that Cruz's 1982 remark didn't constitute sufficient evidence to demonstrate discrimination six years later.

The Second Element

Lemnitzer and Green couldn't produce the second element of the shifting burden process — to show that PAL treated employees differently. They argued that, as of 1976, fifty percent of PAL's managers in the United States were either U.S. citizens of Filipino origin or Filipino citizens. By June 1988, 28 of 34 managers in the United States (82 percent) were either Filipino citizens or U.S. citizens of Filipino origin. After the August 1988 layoffs, only one manager of 24 wasn't a Filipino citizen or a U.S. citizen of Filipino origin.

No deal, said the court. "Even assuming that these statistics are accurate," the unimpressed court concluded, "they do not supply evidence of PAL's discrimination."

Failing to meet the shifting burden of persuasion, Lemnitzer and Green failed to make their case. The court concluded that PAL's reasons for laying them off couldn't be proved pretextual.

The Civil Rights Act of 1991

This act, passed around the same time as the ADA, doesn't so much overhaul previous civil rights law as it fine tunes it. It extends the right to jury trial and allows punitive and compensatory damages to victims of intentional job discrimination. Beyond this, the courts have yet to resolve major questions on how the act applies in specific cases.

But one thing is clear: The law gives disgruntled people significant incentives to sue you. The act doesn't apply to firms with fewer than 15 employees. But for larger employers, it allows a jury to award compensatory damages for "future pecuniary losses, emotional pain, suffering, inconvenience, mental anguish, loss of enjoyment of life, and other non-pecuniary losses," plus punitive damages.

The act caps these other damages at $50,000 for firms with 15 to 100 employees, $100,000 for those with 101 to 200 employees, $200,000 for those with 102 to 500, and $300,000 for those with more than 500. If five employees bring suit and win, each would be eligible for the maximum damages allowed.

So much for the incentives.

The act also offers some tips for protecting yourself against frivolous complaints. Chief among them:

- Obviously, you shouldn't tolerate discrimination. "Take any possible infraction seriously," says one Washington, DC civil rights lawyer. "Addressing complaints seriously can help discourage frivolous suits."

- Enforce your policies scrupulously, so that allegations of discrimination run against everything anyone knows about your company. This moral line of defense can have greater impact than the most expensive legal wrangling.

Major questions remain

Take every complaint seriously

- Even if an employee feels strange about voicing a discrimination concern and doesn't want you to act, follow your procedures. The same employee could later file a discrimination suit and claim that he or she notified you about the problem.

- Review and update written policies. They should designate specific people to investigate complaints and outline how you handle complaints. Some consultants advise mid-size to larger firms to name a "termination czar," responsible for conducting internal investigations. This person becomes your major witness in any post-termination litigation.

- Maintain your paper trail. This means keeping a record of work-related problems and their solutions. Justified for-cause actions make the best defense.

- Don't try to manage your work force by paying attention only when you hire people. For example, if absenteeism poses a problem, you may feel tempted not to hire women with young children — clearly not the right thing to do. Your policies must work on their own. If you enforce them fairly and well, problems should subside.

- As soon as an employee raises any concern about discrimination, ask him or her to complete a written questionnaire, and keep the questionnaire on file.

Questions to consider:

- When did the alleged incident occur?

- How many people were involved? How many witness saw or heard it?

- Was the act subtle or blatant, an isolated incident or part of a pattern?

- Does the alleged victim know the company's policies on discriminatory behavior? Does the alleged perpetrator?

- What does the alleged victim want you to do about the complaint?

The object of the questionnaire is to establish the mind set of the accuser as well as the facts of the accusation. Since discrimination cases rely heavily on inference and interpretation, you need to know the context of the allegation as well as the context of the action.

These points come back to the central issue of moral authority. If your policies prohibit discrimination and everybody knows it, you stand a much better chance of getting the benefit of doubt from disgruntled employees, not to mention the courts.

Other Federal Law: The FLSA

In July 1992, a former technical support rep at California-based Ingram Micro filed suit against the computer distributor. John Zanudo charged that Ingram violated the Fair Labor Standards Act of 1938 by failing to pay him more than $2,000 in overtime and forcing him to resign when he complained.

The FSLA governs wage and hour issues, especially those distinguishing workers who are exempt (generally, salaried workers and managers) and nonexempt (generally, hourly workers) from overtime rules.

Zanudo argued that Ingram violated the act by reclassifying him from an hourly to a salaried employee. He also charged that the firm discriminated against him for speaking out about the alleged abuses.

In addition to back pay, Zanudo asked for damages of at least $40 million, and he wanted his job back — a constant cry in wage-and-hour cases.

Zanudo began working at Ingram Micro in October 1989. Less than a year later the company reclassified all the employees in his department as salaried personnel. The change did not alter duties but included modest salary increases; the company hoped to reduce the costs of overtime and after-hours employee training.

Federal labor law, however, allows employers to convert hourly-wage technicians into salaried

personnel only if they have supervisory responsibilities.

Zanudo claimed that the company forced him to resign after he spoke out against the changes. He claimed that he was unable to find new work because Ingram defamed his reputation.

His complaints prompted a Labor Department investigation.

In its defense, Ingram produced written warnings given to Zanudo, citing him for studying at work, poor attendance, insubordination, and poor performance.

Zanudo admitted that he was a less-than-exemplary employee and called the charges in the warnings misleading.

Substantial Evidence

In an administrative proceeding, the California Employment Development Department ruled that Zanudo could collect unemployment benefits because of "substantial evidence" that the company had forced him to resign. Ingram appealed the decision but later withdrew its objections.

At the same time, the Labor Department audited the company's wage schedules and policies. The audit proved Zanudo substantially correct.

In December 1991, Ingram agreed to pay back wages to 30 employees. Zanudo received $4,859 but claimed himself entitled to $7,047—so he sued. Ingram eventually settled.

The lesson of the Ingram case: Don't count on controlling your overtime costs by making hourly workers' into salaried workers. You want to avoid the FLSA and the Labor Department audits it authorizes.

Employers need to pay scrupulous attention to this process. The Department of Labor rules against employers more readily than even a civil court.

Federal personnel laws cover most of the legal issues you're likely to face in lawsuits based on hiring or firing decisions.

As a general strategy, the best plan entails putting policies in place that eliminate any suspicion of illegal discrimination — and then enforcing them carefully.

Pre-empting bad behavior doesn't necessarily cost a great deal, though it can be difficult to manage. But the effort is well worth making. The alternative can cost a great deal more.

The best plan

Chapter 6:
Setting Up The Rules

Setting ground rules when you hire an employee establishes good communication, which benefits both parties.

Often, you're as happy as you'll ever be with an employee when you hire him or her. You've chosen the one candidate you want from a pool of applicants, and your expectations are high. You and your new employee have struck a bargain, each in the hope that it will bear fruit.

The Tools at Hand

The employee, meanwhile, has chosen to work for you. That's when he or she is most amenable to your terms.

It's important to use every tool at hand to get off to a good start, for your own sake as well as for your new employee's. Chief among the tools at hand: a training program that gives workers the chance to meet your expectations or, at least, to learn what happens if they don't.

A good training program accomplishes two other worthy goals. First, it sets standards of workplace behavior that can head off personnel problems before they get out of hand. Second, it lays down the ever important paper trail.

It accomplishes each goal by establishing a pattern of clear and disciplined communication between employer and employee. The absence of strong communication creates risks that can ruin companies. At the very least, the lack of good communication probably influences hiring and firing more strongly than anything else.

Ground rules benefit all parties

Poor training breeds trouble

One of these exposures, sexual harassment, has become a hiring and firing theme unto itself. You might not think of it as a problem to be solved by good communication. You should.

The Challenge

Bad (or nonexistent) training breeds bad communication and hence trouble down the road. Bad communication causes trouble post-termination, in particular. The 1991 California case *Flait v. North American Watch Corp.* proves just how troublesome this chain of failure can be.

Stuart Flait went to work as a sales manager for North American Watch in 1984. He signed an employment agreement stating that it was "not a contract of employment for a definite period."

Despite strong performance ratings, Flait began having problems by 1987. His superiors grew increasingly dissatisfied with his work; they thought he showed more allegiance to certain customers than to the company. CEO James Reilly and Flait's immediate superior, vice president of sales John Pistner, called Flait into several meetings through 1986 and 1987 to discuss what they called his "attitude problem."

In March 1987, the trouble came to a point. Flait supervised a NAWC marketing rep named Pamela Berger who complained to Flait that, during a sales meeting a few days earlier, Pistner had called her "a vulgar slang expression for female genitals" in front of other employees.

In a telephone conversation, Flait told Pistner it was improper to speak to a female employee in that manner. Pistner hung up on him.

A few weeks later, Berger complained to Flait that Pistner had made comments to her "regarding his oral sex habits" at least once since her first complaint. She also said that Pistner had telephoned her and "asked, in crude terms, whether she had had sexual relations the previous evening."

Flait called Pistner and insisted that he stop harassing Berger.

Berger never used the term "sexual harassment," but Flait believed that Berger felt harassed because she continued to report the incidents.

As 1988 began, Berger left the company.

In January of the same year Pistner summoned Flait to NAWC's main office. Flait went expecting a promotion to regional manager. Instead, Pistner fired him for "not being a company man."

No written warnings or other paper trail supported Pistner's complaints.

Flait told CEO Reilly about Pistner's alleged abuse of Berger. He believed Pistner wanted to fire him in retaliation for his complaints.

Pistner denied making the statements to Berger, so Reilly didn't look any further into the matter. But that didn't save Flait's job; he was out.

Supporting Evidence

Shortly afterward, Berger, now employed elsewhere, gave Flait a written statement regarding Pistner's behavior. She stated that Pistner had used vulgar epithets and comments to her, that she had reported these incidents to Flait, and that she had resigned from NAWC because she couldn't tolerate the harassment.

Flait filed a complaint with the California Department of Fair Employment and Housing. He sued in March 1988, alleging that NAWC had fired him in retaliation for his efforts to stop Pistner's improper behavior.

A trial court issued a summary judgment for NAWC.

Three months later, an Appeals Court decisively rejected the lower court, ruling harshly against NAWC.

On the key issue — whether Flait reasonably believed he was opposing unlawful harassment — the court ruled that he need not prove the harassment sufficiently severe to alter Berger's work environment.

The court rejected NAWC's argument that Flait

No policy in place

should have waited to take action until the alleged harassment became pervasive — any such delay being "antithetical to the legal requirement that a supervisor take immediate action," the court said.

Because NAWC had no policy to handle complaints of sexual harassment, it was appropriate for Flait to go directly to the source of the alleged harassment, Pistner, in an attempt to resolve it.

Moreover, sufficient circumstantial evidence existed for a jury to find a causal link between Flait's complaints and his termination, the court said, thus making it a good bet that a jury could find NAWC's defense pretextual.

A jury might also find that "by saying Flait was not a company man, NAWC meant that it wanted salesmen who did not complain about sexual remarks directed at female employees by a senior vice-president," the court said.

It was a stinging rebuke to NAWC.

NAWC had not communicated to its employees that it considered sexual harassment improper. It hadn't told employees how to react to harassment. It didn't keep good records of anything.

It could substantiate none of its claims against Flait. When asked about the meeting in which Flait was fired, none of the executives — including Pistner — could recall looking at Flait's sales or any other records.

Nothing makes a judge or jury suspect pretext more than outrageous claims not substantiated by evidence. NAWC cooked its own goose.

Training

Employee training is a big business. Anyone who's ever cut a check to a human resources consultant can attest to this fact.

One large industry group estimates that it costs employers more than $50,000, on the average, when a management-level employee takes a new job, undergoes training, and then leaves. Overall, the American Society for Training and Development

says training in the workplace is a $200 billion industry.

Kenneth Teel, a labor specialist at California State University, has estimated that the cost of replacing hourly employees ranges from 7 to 20 percent of the first year's pay. Replacing nonsupervisory salaried personnel costs from 18 to 31 percent, and replacing managers costs from 23 to 175 percent, he believes.

Like so much else in good hiring and firing, training is a matter of investing money to limit your exposure to loss. The solution may seem expensive and difficult, but the alternative can be a hundred times more costly and much more difficult — so much so that it breaks your company.

The following list excerpts a 1992 study (done by staffing consultants the Dartnell Group) that considered how long various industry groups keep their workers in training programs or on probationary status:

Industry Group	Average Training Period (in months)
Agriculture	5.7
Amusement & recreation	2.0
Business services	4.1
Chemicals	4.5
Communications	4.2
Construction	5.0
Electronic components	1.5
Electronics	3.4
Fabricated metals	3.5
Food products	2.8
Instruments	2.7
Insurance	5.5
Lumber & wood products	2.7
Machinery	5.6
Manufacturing	3.3
Office equipment	2.8
Paper & allied products	6.0
Primary metal products	4.5
Printing & publishing	5.5
Rubber & plastics	6.5
Wholesale (consumer)	1.5
Wholesale (industrial)	3.9

Invest money to limit your risk

The basics of a good program

Obviously, the varying lengths of these training periods correspond to particular technical requirements. But there are a few basic subjects that every good program should cover.

Most urgently, you need to educate employees in your personnel policies and in general employment law. In educating your people you inform them with the facts — and so blunt the emotion that distorts perception in hiring and firing and such related issues as promotions and discrimination.

You benefit the most by telling your workers exactly what you expect from them and what they can expect from you. What you say should emerge logically from the skills profiles and job descriptions you've used before.

Make sure that employees have a clear understanding of performance and behavior standards that lead to advancement or warning or, ultimately, termination. Some employers include these standards in their employee handbooks. Others worry that delineating too much in a handbook suggests an employment contract.

In most contexts, you can state employment policies in the employee handbook. Standards of performance and behavior — at least, minimum acceptable standards — don't usually constitute a contract.

Another important subject: the employee review.[1] Workers should know that they can be fired or laid off at any time. This said, you can describe the review process and how it leads — if it does — to promotion, demotion or firing.

Two Goals

You have two goals in training your workers: to encourage and shake out new employees, and to establish clear lines of communication.

Worker trust is an important asset — and workers tend to trust employers who state their policies

[1]See Chapter 9.

clearly and follow them fairly.

This goes for policies respecting termination as it does with those respecting promotion. Keep your termination process secret and you leave your employees open to shock and outrage — and yourself open to a lawsuit.

Worker trust also measures your policies and your success in articulating them. High trust exists alongside good policy well articulated, and vice versa.

You should periodically review the ways in which you communicate with workers. Among the questions to consider:

- Formal communication lines. Does your company's hierarchy lend itself to the free flow of information top-to-bottom and bottom-to-top? Do your middle level managers keep you informed as to issues on the floor and on the road? Or do they get in the way?

- Mechanics of distribution. How do workers get information best? Memoranda and written instructions avoid confusion, but they take too much time in some situations. What's the best way to get information out to all employees?

- Informal communication lines. News — good or bad — travels fast in a small universe like your business. Trying to stamp out informal channels is a fruitless effort; people talk. The better question: How can you best use informal channels? Many managers like to nip gossip in the bud by making important announcements as soon as feasible. Others let the whispers pave the way for official memos.

A Lesson from the Inner City

A Philadelphia-based social program called Project Transition illustrates in extreme terms how important it can be to make your policies clear and reasonable.

Project Transition sought to help chronically unemployed and poor inner city residents find and keep

Learning to take orders in stride

jobs. The program offered classes in everything from reading and writing to personal hygiene. It included counselling and advice on handling the unfamiliar pressures of the daily grind.

The big problem: People who had never had a job didn't know how to take orders. Once hired into an environment with a hectic work pace (for example, in a fast food outlet), they often failed to perform.

Worse, they felt unjustly treated and singled out for abuse if a supervisor criticized them or barked commands harshly. Many quit on the spot when this happened.

Mainstream employees, who've been around working people most of their lives, take orders — even panicky, yelled orders—in stride. They may not like them, but they handle the situation. Project Transition's participants frequently couldn't.

Basic Communication

Project Transition volunteers (an altruistic mix of psychologists, social workers and business consultants) traced the problems to basic communications skills.

Because Project Transition participants lacked preparation in controlling inappropriate feelings, they tended to exhibit negative feelings in unproductive ways. They became remote or sullen, withdrawn and suspicious of their managers. Some committed petty theft, loafed, and engaged in minor acts of rebellion with similarly disenchanted coworkers.

One employee created a difficult but not impossible problem when her own cultural ignorance collided with her manager's inability to communicate clearly.

Eve, hired into a restaurant chain as an assistant manager, dealt frequently with the district manager — her boss's boss. As the relationship developed, Eve's manager objected that she was going around him.

At the same time, the district manager interpreted Eve's regular contact as a sign of weakness in the manager.

This pattern of communication aroused bad feelings all around. The manager assumed problems existed where none did and disciplined Eve for vague misdeeds. She felt picked on.

Eve had no idea that she broke the chain of command because she didn't know what a chain of command was. A Project Transition volunteer improved things dramatically by explaining business hierarchy and lines of communication to Eve.

Thereafter, Eve directed her communications through her manager, who stopped finding fault with her over petty matters.

Project Transition was a volunteer social program; your company isn't. But the importance of understanding social conditions is important to both. Eve was a good employee who lacked knowledge that her employer assumed she had. Her manager needed only to communicate clearly, giving her information she lacked. Eve, meanwhile, needed to communicate with the right person.

The Best Training

New employees feel a great amount of uncertainty; workplaces — even progressive ones — have languages and mores of their own. For these reasons, the best training programs explain not just how the company does things a certain way, but why.

"This gets back to the point about explaining how personnel decisions are made," says California-based human resources consultant George Meyer. "It's not enough to say that a job has management potential or is on an advancement track. You have to do two things at once: Talk in specifics and discuss corporate culture. You'd be surprised how often doing the first also accomplishes the second."

This puts a great deal of responsibility on the shoulders of your line managers. But that can be a good thing. Any effective training program relies heavily on line managers to participate — communications certainly does.

Organizations with high turnover often stabilize the problem with broad training programs that assume

Building trust pays off

as little as possible about employee professional and social skills. And stability is the key to avoiding hiring and firing problems.

Exhausting Administrative Remedies

The logical extension of having strong, clear lines of communication is having strong, clear avenues for solving workplace problems. It's not enough to tell your people to go to their supervisors with their complaints. The supervisors must respond.

Besides, effective administrative remedies are cheap. Satisfying a sexual harassment or discrimination claimant with internal action can save millions of dollars in legal bills and bad publicity.

Of course, it takes a lot of effort to build the level of trust that convinces workers they can get a fair shake from you without going to the EEOC.

"There are more institutions that have this kind of trust than you may think," says consultant William Bell. "The military is an obvious example; they always prefer to handle problems on their own. Police departments are like that. But there are companies, too. When the Federal Trade Commission poked around Microsoft Corp., looking for proof of antitrust violations, the investigators thought they'd be able to get a few employees to talk. They didn't."

The best way to achieve this level of trust (even better than paying big salaries) is to prove that you give employees a fair shake before firing or demoting them for doing something wrong or laying them off the minute revenues fall off: Prove, in other words, that you and they really have the same goals.

The more established your administrative remedies — and the better — the less likely lawsuits become. Again, it's a matter of winning workers' trust.

Your workers aren't the only ones whose trust you need. Courts put a lot of trust in internal administrative remedies. Sometimes, they do more to enforce remedies than you can yourself.

The 1991 federal case *Chube v. Exxon Chemical Americas* encouraged the use of arbitration procedures to resolve employment disputes.

Donald Chube was fired in September 1989 for testing positive on a random drug urinalysis test administrated at his job site. He'd worked at the Exxon plant in Baton Rouge, Louisiana as a wage roll employee since 1973.

Immediately after his firing, Chube sued Exxon for wrongful termination, intentional infliction of emotional distress, defamation and violation of Consumer Credit Reporting Act.

The Baton Rouge Oil & Chemical Workers' Union represented Exxon wage roll employees. The union's collective bargaining agreement established a grievance process for resolving disputes over terminations, requiring that any dispute go to binding arbitration.

The Preferred Method

Exxon argued that Chube could not sue in civil court but had to follow the grievance procedures set forth in the agreement. It cited the Labor Management Relations Act, which holds up collective bargaining agreements, where they exist, as the preferred method of resolving disputes.

Exxon also argued that LMRA preempted Chube's state-law claims for intentional infliction of emotional distress and defamation, and that Chube failed to make a coherent case involving the Fair Credit Reporting Act.

The Louisiana court agreed that the union contract governed Chube as an Exxon wage roll employee.

It wrote: "If the arbitration and grievance procedure is the exclusive and final remedy for breach of the collective bargaining agreement, an employee may not sue his or her employer under the LMRA until he or she has exhausted the procedure."

The court angrily noted that "an arbitration proceeding, filed in accordance with the agreement, is currently pending between the plaintiff and Exxon concerning the termination issue" Chube had prematurely brought to court.

It dismissed his claims without prejudice.

Employee must exhaust grievance procedure

Lawyers like broad definition

The Supreme Court has supported the Louisiana court's ruling in *Chube*, ruling that "Congress intended [LMRA] to preempt this kind of claim . . . [because] only that result preserves the central role of arbitration in our 'system of industrial self-government.'"

The U.S. Circuit Courts of Appeals, following the lead of the Supreme Court, give strong support to arbitration procedures.

Taking this argument even further, the Supreme Court has prohibited attempts by individual employees which would "completely sidestep available grievance procedures in favor of a lawsuit . . . [because such suits] would deprive the employer and union of the ability to establish a uniform and exclusive method for orderly settlement of employee grievances."

In short, the federal courts have jurisdiction to enforce collective-bargaining contracts, and they want labor and management to do everything they can to settle their differences within their own grievance procedures first.

Sexual Harassment

Nothing highlights the efficacy of good procedure more than the thorny issue of sexual harassment.

Some federal courts have defined harassment as "verbal, physical, or sexual behavior directed at an individual because of her, or his, gender." This includes verbal conduct such as epithets, derogatory comments, slurs, and physical and visual insults. Lawyers like the courts' definition; it covers a lot of ground.

In the year after the Clarence Thomas confirmation hearings — in which law school professor Anita Hill accused him of sexually harassing her a decade earlier — the number of sex discrimination claims filed by American women went up nearly 15 percent over the year before. The number of sexual harassment filings went up 53 percent.

Charges of sexual harassment have become a famil-

iar add-on to wrongful termination lawsuits and other post-firing actions.

Which doesn't mean they're bunk, whether the complaints come from women or men.

To be sure, as the number of women in the workplace rises, so does the number of sexual harassment cases. Between 1987 and 1992, more than 3 million women entered the work force; over the same period the number of sexual harassment cases went up 91 percent each year.

But you can't say that claims go up because more and more women join men in the workplace. Claims go up because women feel themselves harassed, and they have the law to back them up.

Awards Climb

Employers pay a price for such claims if they don't respond to them. In courtrooms across the country, jury awards to victims of sexual harassment climb past the $1 million mark. In April 1992, State Farm Insurance agreed to pay $157 million to settle a 13-year sex-discrimination class action lawsuit brought by women employees. It was the largest such award ever.

Some legal crusaders believe that rampant sexual harassment exists everywhere in the workplace, proving the impotence of the internal administrative procedures of most companies. Neither assertion is true.

For one thing, these days few men work with men only. Most men work side by side with women. Many work *for* women. The presence of women in the workplace means that the day passed long ago when men could engage in sexual harassment while working, and most men know it.

For another, the crusade against sexual harassment in the workplace appeals to the American sense of fair play. Women consider sexual harassment unjust, and they're right.

If anything, the employer should worry about the power, not the impotence, of the administrative apparatus dealing with sexual harassment. The topic

The largest sex bias award

A tough but fair remedy

occupies a place of such importance in the workplace that the mere accusation often carries so much weight as to make appearance into reality.

Some courts understand these dangers. Several recent rulings suggest that administrative remedies can be too harsh, punishing accused harassers with no allowance for due process of law.

With a heavily political and financial liability burden hanging in the balance, some employers try to ignore the issue of sexual harassment. That's a mistake — and an unnecessary one.

Human Relations

Most employers rely on a good human relations department to fix their problems before they get to court.

A hard but fair administrative remedy for sexual harassment can put you in a strong position in regard to this exposure. And if you can set up a system to handle sexual harassment, other problems will seem easy.

If you don't have a good system for handling sexual harassment, all kinds of problems can arise.

In early June 1993, Newport Beach city officials added a final twist to a confusing and expensive chain of events. They reinstated — and then immediately retired — Police Chief Arb Campbell and Captain Anthony Villa.

The city had fired Campbell the previous December and Villa three months later, in the wake of a sexual harassment lawsuit filed by ten female employees.

The lawsuit described the Newport Beach Police Department as "a hotbed of sexually offensive conduct." It accused Villa of making lewd remarks and fondling women, and Campbell of condoning Villa's behavior.

More damning, a police dispatcher accused the two men of raping her during a drunken police party in 1981.

The city had little chance of prevailing in the litigation filed by the women because it had no procedure

in place to address accusations of sexual harassment.

This left the city with no defense.

Worse, without guidelines to follow, it overreacted in firing Campbell and Villa. The men sued, forcing the city to fight a two-front war.

Kevin Murphy, the city manager, admitted that the lack of a procedure made a bad situation worse. He quickly set about establishing city policies denouncing sexual harassment and standardizing response mechanisms.

A Heavy Price

But the cat was out of the bag, and Newport Beach paid heavily. The city agreed to pay for Campbell and Villa's legal bills. In turn the men agreed to drop their wrongful termination suit, to waive their rights to civil service hearings to clear their names, and to forego seeking reinstatement.

The city agreed to pay any punitive damages assessed against Campbell and Villa in the sexual harassment suit unless a jury found that they had acted with malice.

The city also removed all references to its own investigation into allegations of sexual harassment, as well as any mention of Campbell's and Villa's terminations, from their personnel files. The settlement stated that the city's investigation produced "no corroborated evidence that Campbell sexually harassed any female employee of the department . . . (or) that Campbell condoned any specific act of misconduct on the part of any of his peers or subordinates." It didn't say the same about Villa.

The city had already spent more than $200,000 to pay lawyers and provide cash settlements to six women who did not sue but claimed to have been sexually harassed by Villa.

It offered the women who did sue another $400,000, but the women — who originally asked for $5.5 million — rejected the offer. The settlement with Campbell and Villa only inflamed their anger.

Costly confusion

Key points to remember

"It just makes me sick what they did," said Margaret McInnis, a police communications supervisor and a plaintiff in the harassment suit. "It's just reinforcing the same old thing that there's this one little network that sticks together."

The Crucial Thing

Human resources consultants like to talk in generalities about clear communications and well-defined complaint mechanisms. It's harder to come by specifics, especially in such a heavily-litigated context as sexual harassment. But the specifics are crucial. You must set up mechanisms to handle complaints of sexual harassment with enough detail to ensure that your company responds effectively to any such complaint.

Key points to remember:

- It's hard to fight the "hostile atmosphere" charge, so you must make every effort to see that no such atmosphere exists anywhere in your company. This means paying scrupulous attention to every allegation; the courts construe any sign of laziness or inattention as contributory.

- It counts for nothing if an accused harasser tries to beg out of trouble by assuring the victim that he or she meant no offense. Intentions mean little here, only perceptions; it doesn't matter whether the accused harasser wanted to *give* offense, only whether the alleged victim *took* it.

- The courts use the "reasonable woman" standard in judging sexual harassment complaints. This gives an accuser some latitude to interpret neutral or circumstantial evidence as supporting the claim.

- Some managers set up committees consisting equally of women and men to review all sexual harassment charges. It's probably a good idea.

- Beware of so-called "sensitivity" training and consultants. They cost money, and their effectiveness is the topic of much debate.

- The employer who responds rapidly and effectively to complaints goes a long way toward defusing them. Conversely, the employer who does not respond merely creates a lawsuit waiting to happen. Often, a stiff reprimand averts legal action. So does separating accuser and accused, if possible, by transfer.

But beware of reacting too quickly and too harshly against accused harassers. These days, you're as likely to find yourself sued by an employee wrongly accused of sexual harassment as by his or her victim. Make sure that you offer both accused and accuser due process, whatever the final disposition of the complaint. This is where preset punishments and time frames come into play, as they do with so much we talk about: Set your procedures up carefully, and stick to them.

A Hasty Response

The city of Kent, Ohio found itself in trouble for acting hastily in response to allegations against an administrator.

The city made its first mistake in ignoring a complaint of sexual harassment against Carson Barnes, the city's grants administrator. It made its second mistake in firing Barnes — an action later deemed "an abrupt and excessive response" by the city's Civil Service Commission.

Barnes denied the sexual harassment allegations and announced that he would sue the city.

After an eight-hour hearing, the Civil Service Commission decided to reinstate Barnes but to suspend him for 90 days without pay, retroactive to the date of his termination.

The commission noted that Kent's community development coordinator had ignored a sexual harassment complaint against Barnes from Jamella Hadden, but that the city had then fired Barnes, in part, because of Hadden's allegations.

Hadden testified that she had been sexually harassed by Barnes since 1988. Barnes moved office furniture so she would have to pass by him, and she

Mixed reactions under scrutiny

feared having Barnes walk behind her.

"When Ms. Hadden reported Mr. Barnes' workplace behavior to her supervisor in the spring of 1992, the city failed to reprimand Mr. Barnes for sanctionable actions," the commission wrote. "Later, the city found these same actions a basis for termination. When an employee's wrongful actions go unsanctioned, that employee may conclude that such actions are permissible."

Sex and Culture

Some global employers defend themselves by claiming that cultural differences cloud the question of sexual harassment. This defense has some relevance in an international workplace, but don't push things; it perpetuates cultural stereotypes.

The question comes up among American women who work for Asian companies. Cultural differences sometimes strain relations between American and Asian women working side by side. American women often expect to earn more and wield greater responsibility. But some Asian managers don't hesitate to ask American women — even executives — to make tea or do other housekeeping chores.

Debra Douglas, an employee of Hyundai Motor America's sales subsidiary, felt honored and excited to receive an invitation to dinner with the company's Korean chairman during a 1991 business trip to Seoul.

During dinner, the chairman addressed only two questions at Douglas: Did she wash her husband's hands and feet? Did she believe in the equality of men and women?

He didn't seem inclined to talk seriously about anything — particularly not business.

Two years later, in a sexual harassment and discrimination lawsuit filed against Hyundai, Douglas claimed that the chairman's questioning reflected a company-wide attitude respecting female employees. Hyandai simply didn't take women seriously as professionals.

Experts on Asian culture see awkward attempts to establish personal relationships in such behavior. That may be so, but American women, accustomed to having the law on their side in such matters, take offense.

She complained about a 1988 incident in which her immediate supervisor said at a business meeting that she had a "nice rack." Hyundai pointed out that it had disciplined the supervisor for the incident.

Douglas hadn't reported later incidents, though. Hyundai alleged that she kept these secrets in order to gather ammunition for her harassment case.

If so, her gathering didn't work.

After just an hour of deliberation, a jury found that Douglas had failed to prove her case.

Ironically, Douglas had remained at Hyundai throughout the lawsuit.

If you do business in other parts of the world, stay alert to miscues. Beyond this point, the cultural defense may have shrinking value.

In all of this it remains unclear just what sexual harassment means. The U.S. Supreme Court has the question under consideration as this book goes to press. In the meantime, the lawsuits proliferate, and as they do, many employers consider buying insurance to cover employment claims.

Allegations Against Clients

It's hard enough to set up and follow policy to deal with sexual harassment. But in the last couple of years, an even more difficult claim has begun to appear: Sexual harassment charges against clients and customers.

Like traditional sexual harassment cases, these charges tend to crop up after a termination has taken place. The accusers — usually women — occupy professional and sales positions in which two things come with the territory: pleasing the customer and taking rudeness in stride. This makes the cases particularly costly and difficult to fight.

Taking rudeness in stride

Confronting a customer or client can mean losing money, which is why some employers opt to fire or ease out the employee. Other employers plead that they can't control their customers' actions. But the courts frown on these defenses.

In 1991 a California jury awarded Teresa Vineyard $226,000 after determining that a client of her employer had sexually harassed her.

Vineyard worked as a home health care nurse. The elderly father of a patient grabbed her, kissed her and made sexual advances, she alleged.

She complained to her employer, Ultimate Health Care Agency of Orange, California. But the company did nothing, she said, because it feared losing the account.

"I should have been warned or something because he'd done it before to other nurses," said Vineyard. "The company just wanted to sweep it under the rug."

Ultimate Health Care subsequently filed for bankruptcy court protection.

"People before me put up with being harassed because they just didn't want to fight," Vineyard said at the time of the judgment. "Someone needed to say something or it would still be going on."

The Employer's Responsibility

Federal law requires employers to provide a workplace free of harassment.

This makes the employer equally liable whether the harasser is an employee or someone outside the company — assuming that the employer knew of the incident or should have.

Good training fosters strong communication, which in turn leads to policies which can avoid behavioral problems like sexual harassment.

Progressive managers think of these elements as parts of a single process. They control the workplace

by using training and communication as tools for setting the parameters for acceptable and unacceptable behavior.

Simply said, by laying the ground rules strongly and clearly from the worker's first day on the job, you position yourself and your company against the fuzzy standards that breed workplace lawsuits — and wrongful termination claims.

Strong and clear rules

CHAPTER 7:
THE DAILY GRIND

In a given day at the office, you probably focus on achieving long-term goals or handling the crises that come up along the way. Like most employers, you probably include employment hassles under the heading of crises.

They can make for lingering problems, though.

If you don't enforce clear and consistent policies, you find even your good workers at the center of hiring and firing problems.

In this context, every worker you hire poses a risk. And as a rule, your biggest firing problems don't come from dramatic confrontations. They develop gradually in the daily routine, where memories function subjectively and frustrations smolder.

The Paper Trail

Once again, a complete paper trail emerges as your best defense. It serves you in several simultaneous capacities: as a discipline for maintaining consistent good-faith practices, as a deterrent to litigation, and as a standard for measuring your own performance as a manager.

In this chapter we look at the review process in relation to terminations. In fact, it applies just as closely to less drastic actions, like transfers or promotions.

In all cases, the questions you ask and the strengths and weaknesses you evaluate remain much the same.

The smart employer uses the review to instill in workers a constant sense of responsibility and accountability.

Solve problems in the daily routine

A measure of conduct

Employees and employers both make commitments in the hiring process. Employees have a legal system that serves as their avenue for enforcing these commitments.

You have daily management.

The Challenge

Good policy gives you an outline of how you should treat your employees; a strong paper trail shows you whether you live up to that outline. Taken together, they can make a formidable defense in court — or on the courthouse steps.

Katressia Smith went to work for Union Labor Life Insurance, in Washington, D.C., as a cost analyst in January 1984. Two years later, she rose to the company's management ranks as a referral analyst.

In August 1988, Smith suffered injuries from an automobile accident that occurred on personal time but kept her from doing her job.

Following company policy, Union Labor Life insisted that she complete a disability form by September 30 or face termination.

Smith went back to work September 19 and submitted the disability form the same day. But her prescription medication made her feel groggy and tired. After several days, she went back home again.

On October 13, the company fired her because she had been absent for more than five days without submitting evidence of good reason and had failed to contact her immediate supervisor.

Smith sued, alleging "extreme and outrageous conduct" in connection with her termination.

The trial court issued a summary judgment in favor of Union Labor Life, ruling that "it was beyond dispute" that the company had treated Smith fairly and within its legal prerogative as an at-will employer.

The Court of Appeals agreed. "It is well settled in the District of Columbia that an employment contract, absent evidence to the contrary, is terminable at the will of either party," the court ruled. "Thus her em-

ployment at Union Labor Life was terminable at-will."

The key evidence: The insurer's employee handbook, which outlined the disability-report policy and stated in clear language that the company hired all employees on an at-will basis.

Union Labor Life did a good job of managing its paper trail in regard to Katressia Smith. Its actions might seem harsh — the woman had been in a serious car accident, after all — but they comply with the law.

Policies and Schedules

Union Labor Life avoided trouble by establishing in advance, in its employee handbook, what it meant by justified termination. In doing so, it avoided any hint that it had resorted to some pretext for firing Katressia Smith.

This is crucial. Lawyers love to accuse employers of using some pretext for firing a worker they don't like, and when they make the charge stick, the employer pays dearly.

Thus when you fire someone justifiably or for cause, you avoid making pretextual excuses. A strong paper trail establishes a cause-and-effect equation: The employee engaged in some prohibited behavior, causing you to fire him or her.

You probably have more material in place than you think to establish this cause-and-effect equation. The keys to completing it: Don't set policy in a void, and be specific as to your causes and effects. Don't follow the example of a mid-sized sales-driven company in the Southeast whose employee handbook sets out policies that read like so many platitudes. Among them:

> Because we value customer service very highly, we require that all employees arrive to work by 8:30 a.m. each weekday.

It is, of course, a good idea to promote punctuality in your employees. But it's also a good idea to spell out just what happens to the tardy employee. Nowhere does the policy statement quoted above say

Leave yourself room to maneuver

what happens to an employee who arrives at, say, 8:35 a.m. one morning. Does one such incident result in termination? In an oral rebuke? In a written warning? Or does discipline begin only if the employee's tardiness becomes habitual?

Note who suffers confusion here: everybody. You and your employees know the rule but not the consequences. Nobody knows what to expect from an infraction.

To avoid this confusion, make sure to state clearly what violations of policy result in what repercussions. The repercussions can range from simple disciplinary measures to immediate termination.

But you needn't specify just one response to a given infraction of the rules. You needn't, in other words, say that tardiness will result in written warning; such a policy forces you, without fail, to issue a written warning to every employee who arrives late — a practical impossibility, and in any event not a good idea.

Instead you can say that tardiness *may* result in 1) an oral rebuke, 2) a written warning, or 3) termination if habitual.

Cause and Effect

What matters most is that you link specific cause with specific effect — or effects, so as not to hem yourself in.

In this way you preserve your prerogatives as an employer. Some employees may deserve slack that others don't, and you need room to maneuver for those who do — without acting unfairly.

Whatever you do, keep an eye on the practicalities of life in business. Don't make things so rigid that you must become inconsistent just to make it through the day. A better strategy builds your prerogatives into the system. Enforce all policies evenly — even if you reserve the right to think subjectively in deciding whether to fire someone.

Above all, be clear as to what you demand and what you prohibit. Don't modulate the do's and don't's. Modulate only your responses to the do's and don't's.

In the 1993 California decision *Sequoia Insurance v. Norden,* the employer's management process turned ragged, but its policies—and the paper trail they created—still held.

Sequoia Insurance hired Robert Norden as a claims manager in 1976 and made him a vice president in 1979. In 1987, QBE Insurance Ltd., an Australian insurance and reinsurance group, acquired Sequoia.

As ownership transferred, Norden and other executives acknowledged in writing that Sequoia could terminate their employment at will.

Soon after assuming the presidency of Sequoia in 1990, Michael Moody told Norden that Sequoia's reserve policies reflected an improper management assessment of the risk the insurer faced. Norden disagreed.

Written Criticism

Moody never directly ordered Norden to increase the reserves against pending claims, but he criticized—in writing—the claims department's practice of keeping low reserves.

In September 1990, Moody called a meeting of managers and explained the severity of Sequoia's financial distress. The meeting produced a long list of recommended cost-cutting measures.

In October Moody informed Norden, now litigation director, that Sequoia would eliminate his position.

In May 1991, Norden filed suit, alleging that the company had fired him "for his refusal to inflate claim reserves." By "creat[ing] the illusion of loss," he said, Sequoia intended to increase its premiums illegally.

The trial court ruled against Sequoia and supported Norden's case. Sequoia appealed and prevailed.

The California Court of Appeal ruled that Norden exaggerated the significance of the loss-reserve data. As a result, since Sequoia's firing hadn't explicitly violated any state statute, the firing could stand.

The paper trail holds

"We grant a writ . . . to obviate an expensive and complex trial of a legal issue which, as a matter of law, must be resolved in the employer's favor."

Sequoia could have been more consistent in reviewing and terminating employees. And Moody made mistakes — for example, by claiming that he fired Norden for purely financial reasons after fighting over the claims reserves, thus exposing the company to the strong likelihood that Norden would sue.

But the paper trail prevailed. Norden's claims didn't hold up to legal scrutiny and — his convoluted argument respecting loss reserves rejected — Sequoia justified its actions.

Zombies and Other Nightmares

Many large companies transfer troublesome employees to remote cities or promote them to meaningless administrative jobs. At one East Coast department store chain, employees call the place for misfits "the vault," an isolated outpost never visited by customers or other workers. "Once they're in there, they can't hurt anybody," a former manager told one newspaper.

In human resource parlance, these employees are zombies.

Companies think it easier to pay someone a salary than to spend several times that amount in legal fees and, in addition, hazard the negative publicity of a lawsuit.

Unfortunately, this kind of passivity only leads to more problems. "The problem is that a zombie can be contagious," says Jennifer Young, a California-based human resources consultant. "Not every one might be a complete basket case. But before you know it, you've got ten percent of your work force working at sub par efficiency."

Frequently, turnaround experts and management consultants earn their exorbitant fees by finding the zombies and firing them.

Consultants use other devices to resolve personnel problems, usually by documenting unacceptable behavior. Some of these devices can be quite subtle.

The better ideas include:

- "Coupons" to tame an abrasive employee whose complaints push managers and co-workers to the edge. In one case, every time the man complained, he had to redeem a coupon. As his allotment dwindled, he learned to parcel out his grumblings.

- Role playing exercises that put problem workers in a manager's position for a few hours. More often than not, employees have no idea what managers do in a given day.

- Employee review panels — similar to employee safety committees — that meet to consider specific problems and recommend solutions. "You want to keep this as a kind of low-key arbitration," says Young. "[The panels] can turn into the Inquisition if you don't keep their missions focused tightly."

A Common Method

These techniques share a common method: They review and enforce workplace policies for problem workers.

"You want to be as sympathetic as you can and work with a problem person," says the human resources director for a Virginia-based housing products manufacturer. "But at some point, you have to call the problem worker in and say, 'These are the terms under which you were hired. You really have to live up to them. We're going to keep a close eye on you for the next couple of weeks and we have to see some improvement.'

"You can point people in the right direction — you've always got the option to fire them, and they know it — but workers really have to sink or swim on their own."

Doing so sounds harsh, but the truth also liberates. The best motivation your employees have for solving a problem is the knowledge that you can fire them if you choose, whatever the hoops you must jump through.

Taming the abrasive employee

Punitive damages

"The last thing you want is to be an employer who never fires anyone," says Young. "Firing is like a doomsday machine. You don't want to use it, but you want to establish that you can and you will — if you have to."

This brings up the bottom line on zombies: The best reason not to create zombies is that their presence undermines the threat of termination.

Good Faith, Bad Faith

Bad faith claims stem from an assumption in contract law that all parties to an agreement tell the truth going in: who they are, what they want, and what they promise to do in order to get what they want. Civil courts allow these assumptions to apply — in limited ways — to the employer/employee relationship.

They impute the covenant of good faith and fair dealing when the employee is a long-term one, most particularly. Most courts find such employees entitled to added benefits, including fair dealing from the employer, even if they don't have a written employment contract.

But there are some limits.

California courts rule (and most others agree) that, although the implied covenant of good faith exists in every contract, the courts can't construe this covenant to establish rights or duties not agreed upon by the parties. Judges can't go hog wild, in other words, even when they see a good faith covenant.

This rule is important because angry workers who lose their jobs tend to tack charges of bad faith onto their other complaints. The reason: They must show bad faith to collect punitive damages. Thus their attorneys fill their complaints with emotion-charged references to betrayed good faith and corrupted dealing. This accomplishes two things. It builds the stereotype of the unfeeling employer and, sometimes, makes a case against at-will presumption.

The good faith argument generally goes like this: Management practices lead a reasonable employee, operating in good faith, to believe that his or her employment will last for a given (read: long) time.

The fired employee claims that the ordinary course of business implies a covenant of good faith and fair dealing, which means that he or she can't be fired at will.

In November 1992, Los Angeles classical-music radio station KUSC-FM found itself embroiled in a bad faith termination lawsuit. Tom Deacon, former programming vice president, charged that he had been fired by Wallace Smith, the station president and his supervisor, without warning in late 1991.

Deacon and Smith had argued over the quality of morning personality Bonnie Grice's on-air performance.

Grice was Smith's wife.

Deacon alleged that Smith had fired him without "good or sufficient cause" and that Grice "interfered with the business and contractual relationship" he had with Smith.

'Economic Factors'

The University of Southern California, which operates KUSC, denied Deacon's charges and cited "economic factors requiring a reduction in force" as the reason for his dismissal.

"Tom was let go because we could not afford to retain him," Smith said publicly. "There have been serious budget restrictions. We had to reduce the size and scope of the organization."

Deacon's attorney disputed the economic explanation.

"We know that that's USC's position, but we don't buy it," Steven Kaplan said. "We don't question that KUSC, like probably every other nonprofit radio station, is facing a difficult financial world nowadays, but we think that in constructing its budget, USC targeted Tom for termination and then used the budget as an excuse."

That would make it a textbook case of pretextual firing.

Deacon's suit alleged that within a month of his bringing Grice to KUSC, she and Smith began a re-

The value of a contract

lationship that led to marriage. Deacon hosted a wedding reception at his home for them, according to the suit.

Deacon contended that USC policy forbade an employee "to initiate or participate in decisions involving hiring, promotion, salary increase or other subjective personnel considerations concerning immediate relatives." Smith, Deacon said, "continuously interfered with and played an active role with respect to personnel and employment decisions relating to Grice, thereby hindering [Deacon's] ability to effectively supervise her."

The suit stated that Deacon began to "develop concerns regarding the quality of Grice's job performance and the undermining of his own job responsibilities by Grice and Smith."

Around December 1991, Deacon's criticisms of Grice increased and, when he expressed his concerns to Smith, the KUSC president "responded that Grice was very upset and threatened to leave KUSC."

Deacon lost his job the following day, but was told he could work through June, 1992, which he did.

Limitations

His lawsuit remained unsettled as this book went to press.

But good faith and fair dealing apply only to at-will employment situations.

As the Wyoming Supreme Court pointed out in the 1991 decision *Hatfield v. Rochelle Coal Company*, "We have never applied the doctrine of good faith and fair dealing to a case in which there is . . . an employment contract. We have held that the covenant does not apply to employment which is not at-will."

Strip that sentence of the double negative and you see that you avoid the good-faith-and-fair-dealing covenant if you and your employee sign an employment contract.

Even so, the courts and legal scholars make the covenant of good faith and fair dealing the subject

of much debate. On the far-out fringe, some argue that the unequal bargaining status of employer and employee automatically makes a victim of the latter.

Politically Correct

In a dissent to *Hatfield,* the chief justice of the Wyoming Supreme Court joined the crowd, sounding more like a politically-correct college teacher than a judge:

> *Expanded job security created by imposition of the covenant may promote employee productivity and a more cooperative work environment. Several foreign countries, including Germany and Japan, have successfully abolished at-will discharges. The requirement of good faith does not operate to forbid terminations for cause and does not unduly restrict an employer engaged in his course of business.*

Referring to another case, the same jurist wrote:

> *Amid all of its incantations of good faith and promises of fair treatment, [the employer] surprisingly . . . asks me to grant summary judgment against [the former employee's] claim based on an implied covenant of good faith and fair dealing because plaintiff is a 'mere' at-will employee who is owed nothing — not even fair treatment — and can be fired at the whim of the employer. I shall do no such thing. Employers must realize that if they are going to reap the profits and rewards of employee loyalty and enhanced workmanship which are coaxed by implied promises made to the work force, then such employers must be held to their word.*

> *If we assume society something different than a pack of wolves tearing apart the carcass, supplemented by a flock of vultures devouring the remains, we should have no problem recognizing that it is of the essence of an implied-in-fact employment contract to include a duty of good faith and fair dealing in its performance and enforcement.*

The high road

This judge would carry employee rights a long way, given half a chance.

Meanwhile a 1988 article in the *Harvard Law Review* called "the relative bargaining power of [employers and employees] . . . so unequal that traditional contract assumptions are invalid."

You're probably right if you guess that those who make such arguments would like the courts to turn you into an employer for life, whether you like it or not.

The arguments rest in slipshod sociology, not in the law. But the American court system allows judges to concern themselves with righting social wrongs, even at the expense of the law. That makes it your problem, because as an employer you must conduct your relations with your workers so as to give no one any cause to haul you in front of such judges. Then you have to hope that no one will anyway.

Moral Leverage

Employers gain certain management advantages when they treat their workers with unfailing fairness and respect. You win a lot of credibility by taking the high road and playing fair.

In this context, the employee performance review becomes a key tool. Scheduling reviews on a frequent basis bears many fruits, especially if you use them to make sure the employee understands his or her responsibilities plus your policies and expectations.

Some supervisors tape-record their review meetings and give a copy to the employee to document their efforts. Others suggest that a problem employee recommend solutions.

"It's very important to have them think about it a couple of days," says San Diego psychiatrist Tom Rusk. "The power you gain is that you're being profoundly respectful."

The employee has little choice but "to join you on that high moral ground," Rusk believes.

Rusk concedes some limitations to his method. Not all companies behave consistently enough in the

course of business to exert credible moral leverage, as the following case study shows.

After the Euro Disney Resort opened in April 1992, Edoardo Leoncavallo — an architect and former executive at the $4-billion theme park — found himself in the midst of a lawsuit against Disney.

Leoncavallo claimed that he had been fired as an act of revenge by a supervisor who failed to brief him on Disney's grooming rules. Leoncavallo wore a mustache; Disney policy prohibited facial hair on employees in contact with the public at its theme parks.

According to the lawsuit, Disney promised Leoncavallo a three-year contract to work on Euro Disney and, afterward, a comparable job at its stateside Imagineering special effects division.

Shortly after his arrival in France, Leoncavallo claimed, a supervisor told him to shave his mustache or risk being fired. He shaved.

Later, he transferred to another division that permitted facial hair, though he kept the same supervisor. He grew his mustache again.

Poor Marks

When Leoncavallo's performance review came up shortly afterward, the supervisor gave him poor marks, writing that Leoncavallo was "challenging the Disney spirit, the company's culture, the people.

"(He) has a hard time accepting authority."

Given the rigid structure of the Disney ethos, this kind of review meant trouble for Leoncavallo. Soon after, the same supervisor fired Leoncavallo and sent him back to the United States.

Disney executives asserted that the supervisor based Leoncavallo's dismissal solely on his job performance.

In 1992, the Los Angeles Superior Court denied Disney's motion for a summary judgment and ordered the case to trial. Disney settled soon after. The company didn't disclose terms, but one human resources consultant said, "They probably paid him a

year or two of salary to go away. If they had the bad review in their paper trail, they were probably in good shape. But several high-level [Disney] executives have beards, so how much credibility would they have?

"Besides, who wants the embarrassment of a lawsuit over a moustache?"

As this case illustrates, every dispute involves the objective and the subjective — here the review and Disney's apparent reluctance to stage a public fight over a man's beard, respectively. Any given case can turn on either one, but if you have a choice, make yours turn on the objective: Focus your review on performance and, if necessary, on any infractions of your rules.

The Moral High Ground

It pays to put problem workers on an accelerated review schedule and to involve them in the process, so as to give you the moral high ground that psychologist Rusk emphasizes.

More importantly, using reviews puts time on your side. You don't have to rush your decision to fire someone, so you reduce your chances of making a mistake.

Some employers encourage their employees to stay current with the job market and aware of alternative positions. This makes getting fired a less frightening — if not a less likely — prospect.

California-based computer maker Sun Microsystems has an on-site career center that broadcasts its services and programs on the company E-mail. Sun assumes a high level of turnover. "Our human resources department tells us, 'Don't expect you're going to be at any company for life,'" boasted one employee in a 1993 interview.

The 1989 Utah Supreme Court case *Arnold v. B.J. Titan Services* shows the danger of acting without preparing the way first.

Raymond Arnold joined a corporate predecessor of B.J. Titan in 1975 and advanced to production manager of his plant by 1980.

Throughout Arnold's employment, the company used an operating manual which spelled out procedures for disciplining and terminating employees. Arnold followed these procedures with people under his supervision.

B.J. Titan experienced economic setbacks and reduced its work force in 1985 and 1986. In the fall of 1986, B.J. Titan fired Arnold over an alleged failure to maintain a plant to company standards.

A Written Warning

Arnold sued, alleging he'd been fired without the prior written warning as outlined in the employee handbook. The handbook required, among other things, that the employee sign a written reprimand which then went to the personnel department.

The manager who supervised Arnold admitted that he had never issued a written reprimand to Arnold, but testified that he had spoken with him informally about improving the appearance of the plant.

The manager also testified that he'd received a telephone call from corporate headquarters to issue a written reprimand to Arnold to clean the place up in ninety days or lose his job. Fifteen minutes later, another call instructed him to fire Arnold immediately.

Despite the haste, the trial court concluded that B.J. Titan had terminated Arnold for cause. It saw no "mutual assent" between Arnold and B.J. Titan regarding the procedures set forth in the operating manual. Arnold appealed, arguing that the trial court's findings and conclusions conflicted with previous state Supreme Court decisions.

The Utah high court agreed with Arnold. It had previously ruled that:

> An employee may demonstrate that his at-will termination breached an express or implied agreement with the employer to terminate him for cause alone. [The at-will] presumption can be overcome by an affirmative showing . . . that the parties expressly or impliedly intended a specified term or agreed to terminate the relationship for cause alone. Such evidence may be found in employment manuals.

Written statement of the facts

That tipped the scale in Arnold's favor.

The Handbook

B.J. Titan's haste to fire Arnold — never explained in court or since — ended up costing the company. The relevant sections of its handbook stated:

Oral Reprimand

When a policy or rule has been violated . . . the supervisor [may] initiate the oral reprimand. In taking this reprimand action, the supervisor will, after obtaining all the facts of the case, talk privately with the employee and indicate the seriousness of the situation. He will be firm and positive as to further possible action in the event of recurrence . . . Depending on the seriousness of the situation, the supervisor will determine the number of oral reprimands necessary and may . . . forward to the personnel department a written statement of the facts of the meeting(s) for inclusion in the employee's personnel file.

Written Reprimand

When one or more oral reprimands have failed to correct the situation, or when the initial action of the employee is of such serious consequence, the supervisor [may] initiate a written reprimand.

This written document will . . . contain a complete summary of the entire situation, showing all the facts related to the case and previous supervisory actions taken in the matter. The supervisor will then privately discuss the written reprimand with the employee . . . The reprimand will be forwarded to the personnel department where it will be included in the employee's personnel file.

Discharge

When the offense warrants immediate severe disciplinary action or the progressive disciplinary steps outlined above have failed to correct the situation, the employee is subject to discharge. Prior to discharging an employee the immediate supervisor must discuss the matter

*fully with his superior and prepare a written
statement of the need for discharge. In case of
discharge the final check must be available to
the employee at the time of termination.*

B.J. Titan didn't follow all these procedures, so Arnold prevailed.

Clearly, B.J. Arnold hamstrung itself with its own
procedures; their very detail severely limited the at-will prerogative. The company handbook should
have articulated B.J. Titan's right to fire employees
on the spot. Lacking that, the company had no
choice but to follow its rules closely — or lose a court
fight like the one brought by Arnold.

Using the Review to Your Advantage

We've put a lot of emphasis on accelerating and intensifying the worker review process as a means of
fixing problems and of paving a clear paper trail for
termination. Now let's step back from the tactical
planning and consider what constitutes a good, accelerated review.

Some companies simply don't do thorough performance reviews. Many mean to but don't follow their
intentions. Others conduct only cursory reviews.

In one 1992 survey, 70 percent of corporate managers reported that they faithfully reviewed subordinates annually. Yet in the same organizations,
less than 30 percent of the subordinates reported
that their superiors reviewed their performance annually. Clearly, what some employers see as a performance review, their subordinates see as informal discussion.

Better to operate from the same page.

After getting his pink slip and a referral to the outplacement department, one middle-level manager
complained to a trade magazine, "I got sacked for
failing to do a lot of things I never knew I was expected to do." Senior management never told him
what it expected of him in advance. Then, under
pressure, it didn't tell him how poorly he was doing.

Vagueness on your part can leave a former employee confused and frustrated — a litigious com-

Honesty is the best policy

bination. This erodes your moral persuasion and goodwill. And as we've seen before, it can make you vulnerable to the whimsy of the courts.

Honesty is the best policy in the performance review. Honesty makes it difficult to soften the blow or to use diluted language or to point to external factors to explain poor performance. Honesty addresses success and failure in a forthright manner, with an eye toward improving matters in the future. And the honest review leaves paper-trail evidence — always the key in any court fight.

"I'm amazed at how many [employers] fire someone who wasn't performing and then go back and look over the reviews — all raves! It makes the termination hard to defend," says a New York-based human resources consultant.

Two Approaches

Most employers take two approaches to the review. The first aims at making periodic judgments, the second at a continuous review of ongoing performance.

The first approach amounts to the traditional annual review. Its shortcomings breed interest in the second approach.

In a nutshell, the argument for the ongoing review reflects the country's broad move toward contractors and so-called "direct consideration." When you use contractors, you get immediate feedback on a short-term basis. You can apply corrections and adjustments on a continuous basis.

The most effective performance reviews make use of immediacy.

You let employees track how they're doing by defining basic terms — and areas of responsibility — in advance. These performance standards emerge naturally from the skills profile, job descriptions and training materials you use in the course of hiring a worker.

These terms should remain as exact and extensive as possible. Among topics you'll probably want to include:

- Workload in terms of unit output or volume;

- Schedules and deadlines;

- Allowable margins for error or tardiness;

- Managerial or administrative duties (especially paperwork and reports);

- Acceptable and unacceptable behavior;

- Attitude and "fit" with colleagues;

- Professional and trade activities;

- Communication skills;

- Management's expectations.

As with staffing and screening, you run into some legal limitations on the things that you can expect of employees, particularly as to behavioral standards and off-site activities. State and federal laws allow you to prohibit dangerous or outrageous behavior, but encouraging "acceptable" behavior can lead to civil rights problems.

As a rule of thumb, keep your requirements related to the job description as specifically as you can.

One East Coast personnel manager who has handled a number of difficult terminations suggests a three-stage process for performance reviews:

- First, state the performance failure, produce evidence that it's an issue, and compel the employee to agree that a problem exists. Use directed statements rather than accusations or questions—for example, "We're having a problem because you get in late."

- Next, with the employee, list as many options as you can for solving the problem. Then prioritize. Select short-term solutions and long-term ones.

- Last, agree to a plan for implementing the solutions.

The power of this approach is that the employee feels some involvement in the solution and tends to have a positive response.

Some employers find a less-structured approach

Tactic involves the employee

more useful. They ask the employee to talk about the job and then review the self-appraisal with the worker, seeking to understand the reasons behind the employee's frustrations.

This form of review cues you on how to counsel workers on a day-to-day basis. For instance, if a worker thinks he or she doesn't work fast enough — but actually works quickly and carelessly — you can reinforce the employee's commitment to speed while stressing the cost of carelessness.

Involving the Employee

Whatever your approach to the review, try to involve the employee in any solution. Encourage your employees to measure their own performance while they work. Under the best scenario, employees become self-rewarders and self-scrutinizers while they operate under managerial control.

"A lot of employers resist this kind of disclosure because they feel proprietary about who's responsible for what," says lawyer and consultant William Bell. "But performance is something everyone already knows. Secrecy in this regard is a myth. In most workplaces employees know a lot more than [you] probably think. If the plant manager's playing golf every day at three, the people in shipping know it. If the head of marketing doesn't know what he's doing, the sales assistants have already figured it out."

A caveat: Be careful about using probationary periods, a favorite tactic of management consultants. The employee who gets through probation may misinterpret the success to mean lifetime employment.

Instead, your employee manual should clearly identify the probationary period as a time of adjustment and growth, a period for matching employee capabilities with employer needs and for giving the employee an understanding of the job.

Remember that performance reviews relate closely to expectations—yours and your employees'. Some employees look forward to an annual performance review because it gives them an opportunity to talk

about the job, the company, themselves, and — if they have the gumption — even you. Other employees fervently hope you'll forget about it.

Resist the temptation to go along. Try to make every review fit the circumstances of the employee and manager involved:

- If you have a longtime employee lately fallen into a malaise, gear the review toward helping him or her back into high gear.

- If you have an employee who's reached the top of his or her grade without much prospect of promotion, gear the review toward setting new goals within the position or transferring elsewhere.

- If you have an employee whose position has become precarious, let him or her know that you expect improvement or disciplinary procedures will begin.

- If you have doubts about a person or a position, make them known but don't dwell on them. Not all employees — not even all senior employees — understand what they need to do to succeed. Make your expectations clear. But don't browbeat.

Peer Reviews

Even the most progressive and effective management practices don't have as much impact as self-directed discipline and peer pressure, however.

Interest in peer review systems has increased markedly since the late 1980s, particularly because the courts require workers to exhaust internal remedies before they file lawsuits.

In the typical procedure, if an employee can't solve a problem by talking to his or her boss and following the normal chain of command, the worker can elect to seek binding resolution before a peer review panel consisting of both employees and managers.

The panel members (usually three peers and two managers) ask questions, interview witnesses, and research precedents and policy. When the mem-

Give employees a chance to talk openly

bers feel sufficiently informed, each casts a secret ballot to grant or to deny the employee's grievance. Majority rules.

Peer review resolves many subtle issues, and management's initial fears about providing peer panelists with a majority vote have abated. In virtually every entity using peer review, employees volunteer to serve and complete an intensive training program before becoming eligible. Most demonstrate a sophisticated concern for making good decisions.

Playing by the Rules

Peer review panels act more like juries than legislatures. Management still makes policy; the peer panels simply decide whether both sides have played by the rules.

Thus peer review ensures greater compliance with personnel policies. It encourages supervisors to make good decisions to start with and to solve problems as soon as they arise.

As the systems demonstrate their commitment to fair dealing, employers discover additional benefits. Most of the time, peer review produces quick, efficient and inexpensive results. If they don't satisfy everybody, they do defuse many disputes.

The review programs have few complicated rules, no courtroom trappings and no lawyers. Meetings take a few hours at most. The intent is to solve problems.

Peer review also induces managers to act with restraint. A human resources manager can make a hasty supervisor think twice about a questionable decision by asking: "How do you think your decision will play out in front of the peer review panel?"

But peer review's biggest benefit is its ability to keep problems out of court. Especially on the state level, the courts show a surprising level of deference to peer review decisions. An employee whose complaint has been heard and rejected by his peers has a hard time making the same case in court—or finding a lawyer to make it for him or her.

Each company decides for itself what peer panels can consider, but most employers limit the panel's jurisdiction to those complaints subject to the grievance and arbitration procedures spelled out in standard union contracts. In most cases, this covers overtime assignments, upgrades and promotions, discipline, and terminations.

"We had a huge victory in a wrongful termination suit," said Richard L. Kellogg, director of employee relations for Adolph Coors Co. "A guy filed a multimillion-dollar suit against us after he had appealed his termination to a panel and was turned down. The court gave our process equal standing with outside binding arbitration and decided the case in our favor. We've now had seven major wrongful discharge cases. We've not lost one."

Some Limitations

But the courts don't give peer review panels carte blanche, and the trial bar has the panels in its sights.

Hospitals, for example, promote peer-review committees as a way to crack down on incompetent doctors, ward off malpractice lawsuits and improve health care. Staffed by doctors who work at the same hospital as the colleague under review, the panels may restrict a doctor's work and revoke lucrative privileges — for example, to perform surgery.

But the peer review committees provoke antitrust litigation brought by doctors who charge that bad reviews threaten their freedom to engage in business.

Censured doctors say that without the ability to take peer-review boards to court, doctors work at the mercy of rivals who may ruin their good names out of malice.

Until recently, hospital administrators argued that the federal Health Care Quality Improvement Act of 1986 protects review boards from court challenges in exchange for reporting incompetent doctors to a national data bank.

Final and binding decisions

But separate 1993 rulings by federal appeals courts in Cincinnati and Denver held that the 1986 law provides hospitals and committee members only limited immunity from liability. Lawyers for the hospitals in those cases planned to ask the U.S. Supreme Court to hear their appeals.

Whatever the result of these appeals, you increase the odds that the courts will uphold your peer review process if you:

- Describe your peer review system in your employee handbook;

- Stipulate in the handbook (and everywhere else) that no one shall resort to court suits before exhausting your internal remedies;

- Have your employees agree that the panel's decision will be final and binding; and

- Publicize your system widely and ensure fairness and due process.

Appeal Policy

You should devise some kind of appeal policy at the same time you set up a peer review panel. You need to get the problematic employee's side of the story, and the internal appeal allows the employee a second chance to articulate it. The appeal — like the peer review panel — also gives the employee the opportunity to refute any allegations of misconduct in front of witnesses, thus providing a record of importance to both sides.

Also like the peer review, the appeal hearing should be informal. Some employees want representation at such hearings; most employers don't object.

A good in-house procedure for handling complaints — including a forum for appeals from peer review — may prove your single most effective means of avoiding lawsuits. Employees go to lawyers if they feel unfairly treated. You deter the impulse if you give your employees every possible chance to voice their dissatisfaction within the company.

Remember that the appeal can't just *be* fair. It must

appear fair to your employees. Inform all employees, from the first day of employment, how they can use the appeal process. Keep detailed records of all such hearings. Make sure to document employee warnings, evaluations, attendance and tardiness records. Document all meetings at which you discuss career plans and promotions. Have the employee read and sign warnings and performance evaluations.

The Pretextual Firing

Avoiding pretext remains one of the hardest things to do in preparing to fire a problem employee — and one of the biggest exposures.

Some plaintiffs' attorneys use the suspicion of pretext as the sole reason for pursuing a wrongful termination case — and for good reason. Pretext can make a case, even where the actual facts don't amount to much.

The courts tend to favor employers in cases involving bad faith and pretextual firing, but you leave yourself open to attack if you go about things sloppily. The Bank of America prevailed in the following case, but it looked like a close race.

In late 1990, Michael Thomasson was fired from his job as a legal secretary at the Bank of America in San Francisco. "They called me into the office, told me I was fired for long-term problems at my job," Thomasson said. "Then they had a security guard escort me out into the rain."

In January 1991, Thomasson filed suit against the bank, claiming invasion of privacy, discrimination and wrongful termination. He argued that the complaints about job performance were nothing but pretext.

The real reason Thomasson thought he was being fired: He worked as a stripper at a San Francisco sex club.

Arguing that the bank had fired him on pretext, the ecdysiast sought more than $1 million in damages. Attorney Paul Wotman noted that Thomasson's personnel file showed him to be an exemplary legal secretary.

"Two months before he was fired, he even got the highest allowable raise for outstanding job performance," Wotman said. "He was fired for no other reason than for what he did in his private life. But it's illegal to fire someone because of a moral judgment about his lifestyle. One of these days, employers are going to start realizing this."

Thomasson charged that the bank had caused him severe emotional distress. Wotman claimed that Thomasson had spent "some pretty low, very lonely months. A lot of these people who ostracized [him] had been like family."

Though not mentioned in the lawsuit, issues of discrimination surrounded Thomasson's charges. Just before he lost his job, he had announced the fact that he was gay to friends and family members.

Even so, the court wasn't impressed. It ruled in favor of Bank of America.

Thomasson spent five months job hunting before finding another position as a legal secretary.

Win or lose, you often fight social issues when you fight allegations of pretext. As Thomasson's attorney suggested, angry plaintiffs read discrimination and deceit into any decision that negatively affects them.

Plaintiffs' attorneys won't hesitate to call you a liar — and worse. But don't let your worries about pretextual firing intimidate you. Pretext is a tough thing to prove in court — and judges often reject the allegations long before a trial ever starts.

The Careful Gardener

You plant the seeds of every lawsuit in the course of daily management. And you assert control of the threat in the same way — specifically, by anticipating and preventing claims, and by responding aggressively against them.

You should think of at-will terminations as luxuries — the easy way out of a personnel problem. But they cost more in terms of management attention and

money, and the odds are good they'll result in some kind of lawsuit.

It's smarter to manage things on a daily basis so as to substantiate a "just cause" termination. This takes time on the front end, but it saves money after the fact. The strategy assumes that retaliation will follow a termination. It let managers and workers know what to expect when behavior becomes a problem.

If you manage your business so as to let your people know everything going in, those who want revenge have a hard time proving their case in court—and doubly so when you have given them access to peer review and an appeal process, and when you have followed your own procedures fairly and consistently.

Following your own procedures remains crucial. You want to give the angry employee no way to argue that you somehow failed to follow your own procedures in his or her case. And you can do all this without giving away your right to terminate a problem worker immediately, as business or work conditions demand.

A Critical Element

The performance review stands out as a critical element in daily management. You and your employees benefit alike from honest and critical performance reviews. If you conduct your reviews frankly and candidly, you avoid posting an evaluation of a fired employee that looks suspiciously like that of a retained employee. And if you can't evaluate your people frankly and candidly, you probably shouldn't evaluate them at all. Fired employees use good evaluations in litigation.

Every time you fire an employee, ask yourself at least two questions: How will you explain the discharge to a jury? And how will you prove you're right?

Keep track of your reasons. Don't give away any of your prerogatives.

The easy way out

CHAPTER 8:
"ARISING OUT OF . . ."

You must take great care when firing an employee who has filed a workers' compensation claim.

State law prevents employers from firing employees in retaliation for workers' comp claims. The states also try — with less success — to protect employers from workers who file bogus claims after they lose their jobs.

But no matter what the laws say, terminated employees see the workers' comp system as a means of adding to their severance packages, or of exacting revenge. Some file workers' comp claims as a sort of preemptive measure once you put them on notice or under review.

Still, you can control this risk even if the states can't. This chapter shows you how.

The Retaliatory Worker

Angry workers and their lawyers like to allege that you terminated them because they made a workers' comp claim.

The 1990 Illinois case *Marin v. American Meat Packing* set a precedent for this kind of legal argument.

Javier Marin took a job at AMPAC, a Chicago hog slaughterhouse, in 1975. He worked steadily until 1981, doing general meat packing chores and some skilled butchering.

On September 3, 1981, Marin sprained his back while picking up some meat that had fallen to the shop floor. His supervisor referred him to a nearby clinic for treatment. Marin visited the clinic five times during the next month for lingering back pain.

Eventually, his doctor hospitalized him for several weeks of treatment. On November 13, he filed a

Take care, keep control

The awkward offhand comment

workers' comp claim with the Illinois Industrial Commission.

On December 3, he returned to work at AMPAC with a doctor's certificate. He continued to work until December 8, when he reinjured his back and went to the hospital again.

Marin left the hospital on January 16, 1982. He went to AMPAC several days later to pick up his compensation check from Cathleen Heffernan, AMPAC's industrial nurse. According to Marin, Heffernan said, "Don't you think that the firm is spending enough money with you at the hospital?" and threw the check at him.

A few days later, Marin saw Dr. S.P. Kaushal, who put him into a third hospital. Marin stayed three weeks.

On February 26, Marin received a certified letter from AMPAC saying that his doctor had released him for return to work on February 16 and that he had not yet reported to work. If he did not return by February 26, the letter said, AMPAC would assume that he had quit.

Marin was still under the care of Kaushal, who gave him a return-to-work permit on March 1.

Conversation Overhead

Marin arrived at work the next day at 7:30 a.m. and gave the permit to Richard Bachert, the plant superintendent. Marin overheard Bachert tell the nurse, "Look at this paper. This stupid doctor gives him light work." A few minutes later, Bachert fired Marin.

Marin sued AMPAC for retaliatory discharge, linking his termination and his workers' comp claim.

In deposition, Bachert's version of Marin's last day differed slightly from Marin's. Bachert said Marin reported for work wearing street clothes, showed the doctor's permit, and asked, "Do I still have a job?"

Bachert told him he did not, because he "didn't do what [he was] supposed to do by the date . . . [he was] supposed to do it."

The jury returned a verdict for Marin, finding that he had not abandoned his employment. It found AMPAC liable for $75,000 in compensatory damages and another $75,000 in punitive damages.

AMPAC appealed, arguing that the judge had instructed the jury in a manner that biased it against the company.

The appellate court agreed, holding that the verdict in favor of Marin went against the manifest weight of evidence. It ruled that the statements of the nurse Heffernan — a big part of Marin's case — proved nothing, since she had no power with respect to Marin's termination.

"Marin admitted that he received the letter on February 26, understood its implications, yet did nothing in response to it until March 2," the court said.

"The evidence showed that Marin was fired for not reporting to work on time as directed by his superiors. Under Illinois law, an employer may fire an employee for excessive absenteeism, even if the absenteeism is caused by an injury which is compensable under the [workers' comp] act."

Not in Retaliation

An important point, that last. You can fire a worker for excessive absenteeism — or, for that matter, for some other infraction of your workplace rules — but not in retaliation for a workers' comp claim.

AMPAC prevailed here, but it made mistakes in its treatment of Marin which, in another state, might have tipped the balance against the company. Win or lose, the company invited the litigation by treating Marin in a careless way, even though the law supported its position.

For many small employers, getting involved in litigation is like losing it no matter which way it finally goes, simply because litigation takes time and money.

The workers' comp system takes time and money, too, and it's extravagantly inefficient. Like most employers, you probably don't much like the system,

but you only cause more trouble for yourself if you mishandle a worker who makes a workers' comp claim.

You break the law if you fire a worker in retaliation for filing a workers' comp claim.

Absenteeism

Most big employers automatically terminate the employment of a worker absent for twenty-four weeks, even for the most compelling of reasons. Some cut employment at twelve weeks.

"But you really do have to set this up from the beginning," says the human resources director for a California financial services company. "Put it in the employee handbook, because if a workers' comp lawyer even suspects [a termination] is retaliatory, the lawsuit is guaranteed to get ugly."

The 1993 Texas case *Trevino v. Corrections Corp. of America* shows just how ugly these cases can get.

In September 1988, CCA contracted with the Reeves County, Texas Law Enforcement Center to manage its jail facility. Lisa Trevino was an employee first of Reeves County and then of CCA when it took over the facility.

In June 1989, Trevino injured her shoulder on the job. A month later, she went on disability leave. Her benefits covered lost wages and her medical bills through the end of November.

Trevino received a letter from CCA dated January 3, 1990, informing her that in accordance with CCA policy, she would be terminated effective January 1, 1990.

Trevino settled her workers' comp claim for a lump sum and then filed suit, claiming wrongful termination. The trial court granted CCA's motion for summary judgment against Trevino.

On appeal, Trevino alleged that CCA had fired her as a result of her injury and her subsequent treatment. The trial court, she added, had erred in accepting CCA's argument that it carried out a neutral policy of terminating any employee whose workers' comp period extended beyond six months.

Under Texas law — like that in most states — the burden of proof shifts in workers' comp/wrongful termination claims.[1]

First, the worker must establish a causal link between his or her discharge and the filing of the worker's comp claim. The worker must show only a causal connection, and need not establish the workers' comp claim as the sole cause of the termination.

That done, the burden then shifts to the employer to show a legitimate reason for the discharge.

Corporate Policy

Relying on this, CCA sought to show that the workers' comp claim was not a determining factor in Trevino's discharge. A CCA manual covering corporate policy stated that the company would carry employees receiving compensation benefits on leave-without-pay status for six months. Thereafter:

> If the workers' compensation period extends beyond six months, the employee will be terminated and dropped from the payroll. The employee will no longer be carried on the company's group insurance plan; however, the employee may apply for conversion. Preferential treatment will be given when, with a physician's approval, the employee is able to return to work, but the employee will not be guaranteed reinstatement.

But the company lost anyway.

In its termination letter CCA tried to make it clear that the company acted in accordance with corporate policy, but the Texas Court of Appeals didn't accept the premise. Specifically, it ruled:

> The fact that the policy applies to all employees with compensation claims of longer than six months duration does not make it any the less discriminatory. It penalizes the employee who has a serious injury and files a claim by telling

[1]This shifting burden resembles the same one applied by federal courts in Title VII discrimination cases.

Beware the civil claim

him that if he draws compensation for longer than six months, he is out of a job. It is not the six-month period that makes the policy bad (it could be for a much shorter period and pass muster). It is bad because the termination is tied directly to maintaining a compensation claim for longer than six months (or whatever the period). . . .

Although CCA may have had legitimate staffing and safety concerns requiring the termination of employees who were absent from work for longer than six months, such concerns are not sufficient to disprove the clear causal link between the compensation claim and the termination.

The court ruled for Trevino.

The Exclusionary Rule

Worker's comp lawyers look for civil claims like wrongful termination when pressing suit. The worker's compensation system limits damages; civil courts don't. So lawyers make more money from a wrongful termination lawsuit than from a simple comp claim.

Your best ally against them is the "exclusionary rule." This rule, slightly different in each state, essentially says that employers and employees must resolve work-related injury cases through the workers' comp system. Only the most extreme behavior on the part of the employer — for example, egregious fraud or abuse — moves a workers' comp claim into the civil tort arena.

Davaris v. Cubaleski, the 1993 case of a California employer who had a lot of problems with employees, shows the strength and weakness of the exclusionary rule.

Wendy Davaris went to work for Vasa Cubaleski, the owner of Continental Culture Specialists, Inc., in 1981 as a bookkeeper at an annual salary of $19,125 a year. By 1988, she had risen to office manager, earned more than $66,000 a year, and participated in the company's profit-sharing plan. Cubaleski repeatedly told Davaris, "Continental is your future," and "If Continental makes money, so will you."

In September 1987, Davaris told Cubaleski that she needed corrective surgery and would require six months to recuperate. At Cubaleski's request, she postponed the operation for about six months.

When she brought the matter up again in March 1988, he accused her of "ruining the company." She reminded him that she had postponed the operation at his request, and she told him that — in her opinion — she had a right to the time off.

He responded that she had "no right to an opinion."

Cubaleski immediately "began a course of conduct designed to harass and humiliate" Davaris, who interpreted his conduct as an attempt to force her to resign.

A Replacement

Davaris went ahead with the surgery, even though Cubaleski told her that he had hired someone to replace her.

After the surgery, Cubaleski threatened not to allow Davaris back to work. She eventually did return, but Cubaleski refused to speak directly with her.

He began to make disparaging remarks about Davaris to certain employees, telling one of them that she was a "Jew dictator." He told other employees and an outside accounting firm that Davaris was stealing money from the company and conspiring with an outside contractor to steal money. The accusations proved false.

He told other employees that Davaris had worked out a deal with the company's health insurer by which she received her health insurance benefits to the detriment of other employees — also false.

Cubaleski fired Davaris in August 1989. He asked her to sign a resignation letter implicitly conditioning her severance pay upon signing. She refused and received no severance pay.

Even after he'd fired Davaris, Cubaleski continued to criticize her. In September 1989, he told a number of employees that Davaris and two other employees had stolen $800,000, preventing Cubaleski from paying employee bonuses.

Conduct as evidence

'The gist of an action for slander'

In January 1990, Davaris filed a complaint against Cubaleski in civil court. She alleged five causes of action: intentional infliction of emotional distress, negligent infliction of emotional distress, retaliatory discharge, breach of contract, and defamation.

Exclusive Remedy

Cubaleski countered that workers' compensation provided Davaris' exclusive remedy — that, in essence, she had no right to sue him in civil court. The trial court agreed, ruling that "all of the conduct alleged by [Davaris] arose in a setting of the workplace and hence was within the normal part of the employment relationship."

Davaris took her case to the California Court of Appeal, asking it to decide whether the workers' comp system was, in fact, her sole remedy. It was, the court said, at least with respect to the emotional distress and retaliatory discharge claims.

Not satisfied, Davaris appealed to the California Supreme Court and at last found a receptive ear.

Reviewing the purpose of the California Workers' Compensation Act, the court concluded: "The conditions of [workers' comp] liability attach where the employee receives a personal injury arising out of and in the course of his employment . . . the act relates to medical and/or occupational injuries, i.e., those risks to which the fact of employment in the industry exposes the employee.

"The gist of an action for slander, however, is damage to reputation. The harm flowing therefrom is not a personal injury or a risk of employment within the purview of the workers' compensation law."

The court noted that some of the allegedly defamatory statements made by Cubaleski — for example, his accusation that Davaris had stolen $800,000 — came after Davaris lost her job, and so couldn't "be deemed to have occurred in the course and scope of Davaris's employment."

The court allowed Davaris to pursue her slander and defamation claims in the civil court system:

"Patently, defamatory statements which have no other purpose than to damage an employee's reputation are neither a normal part of the employment relationship nor a risk of employment within the exclusivity provision of the Workers' Compensation Act."

Civil Action

That left Cubaleski facing civil action in addition to the workers' comp claim. He settled the former out of court.

Cubaleski made his mistake in relying on the exclusionary rule to govern circumstances not within the purview of workers' comp law. He made an even bigger mistake in ignoring a central tenet of good workers' comp management: You avoid the workers' comp system altogether if you foster trust and goodwill in the workplace.[2] Instead, he created an atmosphere of ill will between himself and Davaris, making it certain that workers' comp hassles and post-termination claims followed. At least one other lawsuit against him by a former employee reached the California Court of Appeal within twelve months of *Davaris.*

It isn't easy to foster trust and goodwill — and even tougher to quantify it. It's easier to rely on the paper trail, which you can maintain irrespective of the trust and goodwill between you and your employees.

The 1993 Oregon case *Dawes v. EBI Cos. and Nevi Summers* shows how valuable the paper trail is. The employers in this case kept scrupulous records and successfully defended their actions.

Peggy Dawes, a housekeeper, took time off to recover from what she called a work-related injury. Her employer expressed doubt as to the link between the injury and her work — and began a file.

Dawes returned to work on a limited basis. Then she failed to report to work for two days and reported

The purview
of
workers'
comp
law

2See *Workers' Comp for Employers,* by James Walsh. (Santa Monica: Merritt Publishing, 1993)

169

The value of the paper trail

late for two more. She never contacted Nevi Summers about her situation, but instead had her son call on one of the days to announce that she would not come to work that day.

Failure to Show Up

The employer fired her, citing her failure to show up for work — and making note in the file that her termination had nothing to do with her injury.

The Oregon Compensation Board, refusing to pay benefits, agreed with the employer's doubt as to whether the injury was work-related.

Summers prevailed by arguing that Dawes lost her job because she failed to report for work, not because she was injured, and by producing the paper trail as evidence.

The board agreed that Dawes' failure to report to work gave Summers cause to fire her. It also found that the employer "had a legitimate doubt in regard to its duty to pay temporary total disability. . . ."

This was key. Oregon law allows an employer to refuse to pay if the employer has a legitimate doubt as to its liability. In this case, the employer established the existence of doubt by producing its file on Dawes.

The Compensation Board ruled that the employer acted not unreasonably in refusing to pay benefits. It cited the 1988 Oregon case *Safeway v. Owsley,* which set the precedent that an injured worker who returns to work and is terminated for reasons unrelated to a workers' comp claim has no right to disability benefits.

Dawes took her case to the Oregon Court of Appeals, to no avail. But one of the appeals judges dissented, arguing:

> *The unfortunate result of the majority's decision is that it relieves the employer of the responsibility to follow legislatively preferred claim closure procedures and permits the employer to unilaterally cut off benefits while the worker is partially disabled and suffering a wage loss. I cannot concur with that result.*

The law protects your right to fire workers who break your rules, but you should remember this dissenting opinion. Many judges—especially workers' comp judges — resist giving employers much discretion when it comes to employees with workers' comp claims on file. If you fire such a worker, make sure you can protect yourself against the claim that you acted in retaliation for the claim.

Focusing the Workers' Comp Claim

Claimants' lawyers like the payoff that looms if they take their workers' comp cases into the civil court system, and they do everything they can to turn a work-related injury into a tort claim.

It pays to resist them tooth and nail. Keep comp claims within the comp system and civil charges in the civil courts. The comp system assumes your liability but (in theory) limits damages — so its exposures tend to be smaller and more frequent. The civil court system assumes your innocence but hits hard if it finds you guilty — so it presents much larger but less frequent hazards.

The plaintiff's bar, meanwhile, wants to blend the exposures by confusing the workers' comp claim with the tort claim. All too often, judges cooperate.

In the 1990 Kansas case *Pilcher v. Wyandotte County*, a woman successfully wound her workers' comp claim in among other charges.

In an appeal of an earlier ruling, Wanda Pilcher attacked the trial court judge's instructions to the jury that had heard her case, which charged that her employer fired her in retaliation for a workers' comp claim. She argued that the trial court hadn't given the jury a clear definition of the various ways by which an employee who has filed a workers' comp claim might prove retaliatory discharge.

The appeals court agreed. "The instructions by the court did not go far enough in advising the jury as to the law of wrongful termination where workers' compensation is or may be involved," it said. "In Kansas it is not only wrongful to fire an employee because he or she has filed a workers' compensation

Linking a claim to the discharge

claim, it is equally wrongful to terminate an employee because of his or her absence due to a work-related injury."

In a 1988 case, the Kansas Supreme Court had set the relevant precedent by ruling that:

Allowing an employer to discharge an employee for being absent or failing to call in an anticipated absence as the result of a work-related injury would allow an employer to indirectly fire an employee for filing a workers' compensation claim, a practice contrary to the public policy of this state.

The appeals court ruled that the trial court should have instructed the jury that, even though Pilcher had filed no claim, the employer could not terminate her for absences due to a work-related injury which might form the basis for a workers' comp claim in the future.

A Direct Link

The appeals court found evidence to suggest that Pilcher's absence from work—directly linked to her work-related injuries — was a factor in her termination.

A termination on that basis would constitute a retaliatory discharge, the court said, entitling Pilcher to damages. The court ordered a new trial, complete with jury instructions that linked the workers' comp claim to the alleged retaliatory discharge.

Wyandotte County, Pilcher's employer, made a key mistake by giving the court enough leeway to link its termination decision to Pilcher's potential (though yet-unmade) workers' comp claim. It should have resolved the comp claim separately, through a settlement or even a simple release, before firing her.

Much debate centers around the usefulness of releases seeking to free employers of any liability to people either injured on the job or just plain fired. Lawyers sometimes nullify such releases, so some experts discount them altogether. But as often as not, the releases hold up in court.

The 1992 Texas Court of Appeals case *Sweeney v. Taco Bell* proves the point. The release in question arose out of an injury suffered by John Robert Sweeney when he worked at a Dallas Taco Bell in 1987.

Sweeney took several weeks to recuperate, then returned to work only to hear from his manager that he no longer had a job because, the manager said, he didn't like Sweeney's work.

Sweeney believed that the manager acted in retaliation for Sweeney's claim under workers' comp law.

In July 1988, the Texas Industrial Accident Board awarded Sweeney $7,800 for his injuries. Taco Bell's insurer, National Union Fire, got Sweeney's signature on a release that later proved his undoing.

'Any and All Claims'

In October 1989, Sweeney sued Taco Bell for wrongful termination. But National Union Fire's release provided that:

"It is further agreed that upon payment . . . the same shall be in full release of the said National Union Fire Insurance Company of Pittsburgh, Pennsylvania and Taco Bell Restaurants of any and all claims for alleged disability resulting from the described accident and damages, if any, allegedly resulting from John Robert Sweeney's termination at Taco Bell. . . ."

That cooked it for Sweeney. He tried to argue that the release settled only his workers' comp claim. He hadn't bargained, he said, for the settlement of his wrongful termination claim.

But the court didn't think much of this argument. "As a general rule, a written release cannot be voided on the ground that the releasor was ignorant of, or mistaken about, the contents of the release, or failed to read it before signing," it ruled. "A settlement agreement and release, valid on its face, will not be voided on the ground that the releasor was ignorant of or mistaken as to the contents of the release or failed to read it before signing."

A simple release holds up

The 'mutual mistake'

It recognized only fraud or other improper influences as exceptions to this rule, but Sweeney could show no evidence to that effect. On the contrary, he tried to make the legalistic argument of "mutual mistake" — that the release described a bargain never intended by employer and employee.

The appeals court rejected that argument, too: "Viewing the evidence in the light most favorable to Sweeney, we hold that his evidence of mutual mistake is not sufficient to raise a genuine issue of material fact as to the enforceability of the release."

Thus the release covered not only the workers' comp claim but his wrongful termination claim as well.

Taco Bell avoided Sweeney's wrongful termination claim by separating it from his workers' comp claim, and by confining its liability to the latter. But not every employer succeeds in doing the same.

In the 1992 North Carolina case *Abels v. Renfro Corp.*, a worker successfully pressed a retaliatory discharge claim even though the state Industrial Commission ruled that her injuries didn't qualify for workers' comp benefits.

Virginia Abels claimed that she injured her back and leg when she slipped and fell on some flat cardboard boxes while attempting to get a spool of yarn in June 1984. She reported her injury but did not file a workers' comp claim at the time.

She claimed that a second injury occurred three years later, when a co-worker struck her from behind, injuring the back of her head, her upper back, her neck, and her ribs.

Retaliatory Discharge

In August 1987, about eight weeks after the second injury, Renfro Corp. fired Abels. Six weeks later, Abels filed workers' comp claims for both the 1984 and 1987 injuries. Then she filed a civil suit alleging that Renfro Corp. had discharged her in retaliation for the workers' comp claim.

Renfro insisted that it had discharged Abels for poor work quality. It offered written evidence establish-

ing that Abels had received several warnings to improve her work or face termination.

In October 1988, the North Carolina Industrial Commission denied Abels' workers' comp claim. It ruled that the statute of limitations barred the 1984 claim and that the 1987 claim didn't arise out of a compensable injury. The state Court of Appeals affirmed the decision in August 1990.

A jury trial on the retaliatory discharge claim began the next January. The jury found for Abels, awarding her $82,200 in damages and ordering her reinstatement.

On appeal, Renfro's lawyers argued strenuously that the Industrial Commission's action in ruling Abels' 1987 injuries not compensable should have precluded the civil case.

They made another, more interesting argument: that wrongful or retaliatory termination cases should be tried in the same manner as "disparate treatment" employment discrimination cases are litigated under federal law. They argued that a "policy that is applied equally to all employees—even an unfair policy — does not constitute unlawful discrimination." In this regard, "[a]n action for retaliatory discharge is analogous to an action for employment discrimination under federal law."

Liberal Construction

The North Carolina Court of Appeals shot down all of Renfro's arguments. "The courts of this state have recognized that the Workers' Compensation Act should be liberally construed so that benefits will not be denied by technical, narrow, or strict interpretation," the court wrote. "Liberally construed, the statute encompasses acts by employers intending to prevent employees from exercising their rights under the Workers' Compensation Act."

So Renfro Corp. lost. Like Wyandotte County, it might have had a better chance had it rectified the workers' comp claim before it fired Virginia Abels.

Without a lawyer at their elbow, most employers

Policy must apply equally to all

Rectify the workers' comp claim first

don't realize the importance of giving an employee no room to accuse them of retaliatory discharge.

The 1993 case, *City of La Porte v. Prince*, shows a complete failure on the part of an employer to separate a workers' comp claim from a termination. You can spend hours studying this case before deciding whether the employer was more stupid than careless, or vice versa.

Allen Prince worked for the City of La Porte, Texas as a sewer lift-station operator. In June 1983, he reported an on-the-job injury to his foreman. A doctor diagnosed the injury as a hernia.

Prince had surgery later that month. His doctor told him that he should expect to be off work for six to eight weeks. Prince reported the same to his foreman and the city's personnel coordinator. He filed a claim for workers' comp benefits, but the city's insurer denied it. He then filed a claim with the Texas Industrial Accident Board.

A month after the surgery, Prince went to see his foreman to say that he could return to work in two or three weeks. The foreman told him to see Luther Maxey, the department superintendent. Maxey fired Prince on the spot.

Prince sued the city for wrongful termination.

Policy Timetable

In its defense, the city claimed to have a policy that physical incapacity would result in termination if an employee were incapable of returning to work within thirty days following the use of all accrued sick leave. It argued that the policy justified Prince's termination because of the length of his absence.

Prince argued that the city fired him because of his workers' comp claim. City employees feared filing such claims because many who did lost their jobs, he said.

The jury sided with Prince. It hit the city with $100,000 in actual damages and $1 million in exemplary damages.

The city appealed, making an elaborate ten-point argument, but couldn't budge the appeals court. Instead, the court concentrated on the city's systematic harassment and termination of employees who filed workers' comp claims.

Mayor Norman Malone had testified that the city council delegated the responsibility for personnel policies to the city manager. Jack Owen, city manager when Prince lost his job, in turn delegated authority for hiring and firing to his department heads. In Prince's case, authority rested in Luther Maxey.

The appeals court noted that Maxey knew when he fired Prince that Prince intended to return to work in two weeks. Furthermore, Maxey fired Prince immediately after asking him whether he had filed a workers' comp claim against the city — or as Maxey put it, "What's this BS I hear about you filing a lawsuit on the city?"

That was enough for the appeals court to rule against the city.

'Willful and Malicious'

"This evidence is both legally and factually sufficient," the court said, "to support findings that the city had an official, but unwritten, policy to terminate employees for filing a workers' compensation claim; that Maxey's conduct was willful and malicious and in furtherance of that policy; that he fired Prince for having pursued a workers' compensation claim against the city and not for physical incapacity; and that he acted with conscious indifference to Prince's rights and welfare."

These facts alone supported the $100,000 award for actual damages, the court said. And Luther Maxey's behavior — condoned and even subtly encouraged by the city — supported the award of $1,000,000 in exemplary damages, the court said.

You should profit from these losses. If you can avoid it, don't fire an employee in the midst of a workers' comp claim. If you can't avoid it, document everything you do with extreme care. Establish that you

'Official but unwritten policy'

Cheaper to pay the claim

have honored — and will honor — your workers' comp obligations. Make sure that you have cause to terminate the worker, and that you give the courts no room to find against you in a retaliatory discharge suit.

It's cheaper to pay a workers' comp claim than jury award for retaliatory discharge — or the lawyer's fees required to fight the claim.

Chapter 9:
The Turning Point

So far we have considered how to avoid the problems that crop up after you fire someone by studying what to do long before you get to that point.

But you still have to fire people. Sometimes firing them is the only solution to a problem. And sometimes you have to act even if you can't be sure that you do the right thing.

The best thing to do in these cases is to carry out the termination in such a way as to cause the least anguish for everyone involved. Take control early on, and prepare the way. Don't let things drift along; above all, don't let your unhappy employee — who probably knows, after all, what lies ahead — seize the initiative. Decide where you want to end up and what you want to come out with. Figure out what you must do to get yourself and your enterprise to that point. Then do it.

Keep four things in mind as you go along:

1)Consider your options. One may be to keep the problem employee on, perhaps in another job, so as to avert a messy termination. If you do transfer the worker, take the time to study the strengths and weaknesses of the individual; you may find more of the former than you think, and those strengths may play well in another job in your organization. If you can't transfer the worker, your efforts in having made the attempt may stand you in good stead if the employee takes you to court. One way or the other, give serious thought to putting the problem employee on an accelerated performance review. Let the employee know what you expect—and what you intend to do if the employee doesn't shape up.

*Cause
the least
anguish
possible*

The rumor mill never sleeps

2) Check your insurance coverage. Some general liability packages protect you against certain kinds of wrongful termination claims. If yours doesn't, think about buying new coverage. At the very least, study your insurance to see whether its provisions and exclusions give you a sort of map of the problems you must avoid or overcome in terminating a problem worker.

3) When you do act, act decisively and quickly. It takes time to prepare your way to firing someone, to be sure. Take care not to telegraph your intentions; the rumor mill never sleeps in any organization, and if it starts grinding away while you prepare to fire a problem worker, it may hurt morale and actually increase your exposure to litigation. Leave no grist for that mill lying around. Prepare yourself fully and then act.

4) Limit your exposure to bad faith charges. A good example of these: whistle-blower charges, in which a former employee claims that you fired him or her to cover up illegal or improper activity within the company. These charges don't always reflect actual circumstances, so they can be difficult to anticipate.

Note that in all of this, you take preventive action, just as you do with everything we discuss in this book. The steps noted above compress those precautions into a short, intense period of time. But if you keep your focus on a plan you've set up in advance, you minimize the pain everyone faces in a termination.

The Challenge

You must take as much care in firing your employees as you take in hiring them. Indeed, some employment experts argue that for every precaution you take in hiring people, you must take a roughly equal precaution in firing people. In *Liao vs. TVA*, a 1989 U.S. Court of Appeals case, the employer set up an affirmative action hiring plan but didn't make any special affirmative action firing plans — to its cost.

In 1977, the Tennessee Valley Authority hired Christina Fang-Hui Liao as a research chemist in the Soil and Fertilizer Research Branch of its National Fertilizer Development Center. Liao met or exceeded all requirements the TVA had for the position.

Liao counted as what employment cynics call a "twofer" — she was a woman and of Chinese descent, therefore also a racial minority.

Shortly before hiring Liao, the TVA had adopted an affirmative action plan governing the division in which Liao worked, in accordance with Title VII of the 1964 Civil Rights Act. The plan identified certain hiring and promotion goals and recognized the "limited participation" by women and blacks in management and in the scientific and engineering occupations.

Focus on Hiring

What the plan didn't do, however, was to specify what role affirmative action might play during any cutbacks. It focused only on hiring, not on firing.

In 1981, budget cuts forced the TVA to prepare to reduce its workforce. The federal government, which oversees the TVA, warned it to consider the impact of the cutback on minority and female employees.

Liao lost her job as a result of the reduction in force. Following procedure, she filed an official complaint alleging sex and racial discrimination with the TVA's internal equal employment opportunity office.

The TVA claimed business necessity. Its internal examiner found these claims legitimate and nondiscriminatory.

Liao took her case to federal court, claiming that the TVA's affirmative action plan covered firing as well as hiring — a novel theory, since Title VII devotes itself to hiring and says nothing about firing. As a woman and a minority, Liao enjoyed the protection of the affirmative action in hiring, and wanted to extend that protection to the process by which the TVA fired her, too.

A rough symmetry in hiring and firing

Liao found a sympathetic ear on the federal bench. In May 1987, a federal judge found that the TVA had violated its own affirmative action plan in dismissing Liao, even though the plan did not explicitly cover firing. "The allegedly legitimate non-discriminatory reason articulated by [TVA] is automatically and by definition pretextual," the judge wrote. "[Therefore] there is no need for this court to determine whether or not TVA's decision to terminate Dr. Liao was impermissibly or directly motivated by her race and/or her sex."

It was a lot of new law for one judge to make — as the U.S. Court of Appeals decided when it heard the TVA appeal. The higher court held that the TVA may have violated its own affirmative action plan, but this did not automatically violate Title VII of the Civil Rights Act.

Still, the Court of Appeals didn't completely reject Liao's claims.

Liao had argued that Title VII applies to both hiring and firing, and the appeals court didn't deny this claim. It sent Liao's case back to U.S. District Court to be tried on its merits.

The TVA ended up settling out of court.

Liao shows that you need a kind of symmetry in your procedures for hiring and those for firing: For every precaution you build into your hiring process, you should build a corresponding precaution into your procedures for firing. And in both cases, the procedures should assure that you don't discriminate against protected classes of people at either end of the employment pipeline.

Transferring the Problem Worker

You don't always have to fire problem employees. Sometimes you need only move them into a new department. This doesn't mean creating the zombies we considered earlier. It means finding a better spot for your problem employee.

Of course, this isn't always — or even often — a viable alternative, as the following cases show.

The 1991 U.S. Court of Appeals case *Boehm v. American Broadcasting* involved a wrongful discharge claim from an employee to whom ABC had offered an alternative position.

ABC fired Frank Boehm in November 1982. A vice president of sales at ABC radio and a fourteen-year employee, Boehm could have avoided his termination by accepting another job, a newly created position. The base salary of the new job was the same as that of the old, but total compensation — factoring in commissions — didn't come close. Boehm turned down the new job, and ABC fired him. The network didn't hire anybody else for the new job, either.

Boehm sued.

ABC argued that, under standards set by the Supreme Court,[1] its offer to reemploy Boehm in a new position cut off its liability for any further damages. It also argued that Boehm had voluntarily left the job market when he moved out of state in the fall of 1987. Any damages for lost compensation should stop at that point, ABC said.

A Question of Legitimacy

At trial Boehm questioned the new job's legitimacy, noting that it had not existed before ABC acted against him and, for all intents and purposes, didn't exist after he left, either. It was a phony job, Boehm said.

The jury awarded Boehm $1.34 million in lost compensation and $150,000 for negligent infliction of emotional distress. Implicit in the jury's verdict was the finding that the newly created position was not sufficiently similar to Boehm's old job.

An appellate court upheld the verdict.

"ABC fatally assumes that the necessary predicate to requiring a discharged employee to justify his failure to accept a new position — that the new position be substantially equivalent — was established," the appeals court wrote. "A jury, properly

[1]See Chapter 10.

A good alternative

instructed, found that ABC failed to establish the predicate fact [that it had offered a truly similar position] necessary to absolve itself of liability."

In plain English, the jury hadn't bought ABC's story any more than Boehm had.

The *Boehm* case shows that if you offer a troublesome worker a different job, it has to be really similar. Even so, transferring a worker to a new job remains a good alternative for most employers. A more recent case, the 1992 Alabama Court of Appeals decision *Watson v. Presbyterian Retirement Corp.*, proves the point.

In November 1989, Percilla Watson sued Presbyterian Retirement Corp. for wrongful termination. She alleged that she had slipped on a wet floor and suffered an injury to her knee while employed as a baker in PRC's Westminster Village retirement center. She received medical treatment, including arthroscopy, and planned to return to work without restrictions in May 1989.

But she found her former job filled when she went back. PRC offered her a different position on a different shift with equal pay; it held out a chance to change shifts when another position became available. Watson rejected the offer and found other employment.

Additional Benefits

Watson received workers' comp benefits for the knee injury but failed to win classification as permanently disabled, which would have given her additional benefits.

Meanwhile she sued the hospital for wrongful termination under a state law prohibiting employers from discharging employees in retaliation for workers' comp claims.

The trial jury, aware that she had failed to qualify for permanent disability benefits, ruled against her. Watson appealed, arguing that the workers' comp issue had improperly influenced the jury.

The appeals court went against Watson. It noted that PRC offered Watson a job with equal pay upon

her return to work, and that Watson rejected the position. "Such evidence clearly supports the trial court's finding," the appeals court decided. "Alabama law states: 'If an employee refuses employment suitable to his or her capacity offered to or procured for him or her, he or she shall not be entitled to any compensation at any time during the continuance of the refusal.'"

The workers' comp claim had nothing to do with the decision, in the end. The key in *Watson* was that the hospital offered her substantially the same work without a cut in pay.

Reviewing Your Insurance Coverage

As you prepare to fire an employee, check whether your general liability insurance coverage protects you against legal costs and damages related to post-termination lawsuits. If not — and most general liability policies don't — proceed carefully.

For the most part, general liability insurers began excluding coverage for employment-related practices (ERP in insurance jargon) in the late 1980s. Some D&O policies offer coverage — to directors and officers, naturally enough, but usually not for the enterprise as a whole.

Some insurers offer special ERP policies covering everything from wrongful termination to sexual harassment. But even these policies have their limits. Among the exclusions: losses stemming from violations of the Employee Retirement Income Security Act, the National Labor Relations Act or state workers' comp laws. Some policies exclude coverage for claims stemming from the Occupational Safety and Health Act or union contracts.

ERP insurers target large employers with professional human resources departments. Limits run to $1 million — a real possibility if you have sales of more than $10 million or pay salaries in the $100,000 range.

ERP carriers use strict underwriting. You must demonstrate a history free of employment claims and show written anti-discrimination policies and procedures, as a rule. The latter trip up small em-

ployers, who give only cursory attention to such things — to their cost.

Even for larger entities, ERP insurance doesn't provide a cure-all for employment-related risks. You must show your risk management skills in order to qualify for the insurance, and once you get it you have to keep those skills sharp in order to make sure you don't have to use the insurance.

Most of all, you must maintain the paper trail: job descriptions that state the essential requirements of the job, and explicit procedures that cover hiring, firing, promotion, performance review and discipline.

The Nature of the Business

As you review your insurance, remember that carriers act differently when they sell insurance than they do at settlement time. *All* carriers resist paying claims if they think they can make a case for it, as the following case study shows; it's the nature of the business. You should factor this reticence into your analysis of termination risks (or any other risks, for that matter).

In the 1991 California Court of Appeal decision *United Pacific Insurance v. McGuire Company*, the general liability insurer sought a court declaration exonerating it from the duty to defend the employer against a wrongful termination charge.

In April 1978, the McGuire Company — a family-owned furniture maker located in San Francisco — hired Dale Burgess as a senior executive under an agreement giving him certain stock ownership rights. After Burgess had worked for the company seven years, the principal stockholders, John and Elinor McGuire, decided to discharge him.

At a meeting in June 1986, the McGuires informed Burgess of their decision. They subsequently sold their company to another company in the furniture business.

Burgess sued for wrongful termination the next month, alleging that the McGuires had wanted to

get rid of him and his stock deal so as to make the company more attractive in sale.

At the time of Burgess's termination, United Pacific Insurance had issued the McGuires a comprehensive general liability insurance policy. The policy included a "Special Form Comprehensive General Liability Endorsement" which extended coverage.

This complicated things.

The endorsement covered "all sums which the insured shall become legally obligated to pay as damages because of bodily injury or property damage to which this insurance applies, caused by an occurrence. . . ."

It defined an occurrence as "an accident, an event or a continuous or repeated exposure to damage . . . neither expected nor intended by the insured."

'Intentional' Conduct

In earlier cases, California courts had interpreted these policy terms to exclude coverage for "intentional" conduct. Since an employer necessarily acts intentionally when firing an employee, therefore, a general liability policy wouldn't cover a wrongful termination claim.

Ruling for the insurer, the trial court determined that this policy language precluded coverage for the McGuires.

They appealed.

United Pacific Insurance argued that the phrase "neither expected nor intended by the insured" qualified the term "event." Under this interpretation, coverage extended only to events that were neither expected nor intended.

The McGuires maintained that the phrase modified the word "damage," excluding from coverage those elements of damage that are expected or intended by the insured. Under this interpretation, the policy covered intentional actions that resulted in unexpected injury.

The appeals court ruled that the McGuires' interpretation made more sense and gave "substance to

Key defenses

the extended coverage in the special endorsement." Otherwise, the court said, the endorsement wouldn't have changed anything in the standard policy.

Thus the special form that the McGuire's purchased turned out to work like an ERP policy — to the consternation of the insurer.

The ruling does not mean, however, that you will find added protection in similar endorsements to your own general liability policy. The McGuires had to press their case all the way to an appeal—a costly effort — and another judge might have ruled otherwise.

Warnings and Notices

A well-documented, progressive discipline system, fairly applied to all employees, goes a long way toward preventing most workers from filing post-termination lawsuits. If one does sue, the system becomes your best defense because it establishes 1) that you have rules and 2) that you live by them.

In short, a termination should never come as a surprise to the fired employee. Using your discipline system, you should long since have made the employee aware that his or her performance doesn't meet your standards.

Many companies enforce rules calling for automatic dismissal for serious rule violations — for example, drinking, using drugs or fighting on the job — but a termination usually results from a series of smaller problems such as absenteeism or poor performance.

One way or the other, you should establish an easy-to-understand system that provides for warnings and actions leading up to the termination. Make the system public and distribute an outline to all employees.

For example, many companies give a verbal warning the first time an employee misses work without valid cause, a written warning the second time and sometimes the third, a short suspension without pay the next, and finally, a pink slip.

Each warning, verbal or written, must state clearly the circumstances causing it and outline what happens next in the discipline process. Thus you tell the employee that you issue the warning because of the absence, and let him or her know what to expect if things don't get better.

As we've pointed out many times, you must keep thorough records of all warnings and suspensions. Even when issuing verbal warnings, your supervisors should complete dated memos describing the circumstances. This is the most important part of the paper trail.[2]

Accelerated Performance Reviews

Nobody enjoys giving warnings to their employees. All too often, they foster ill will and mistrust, for all intents and purposes making the problem worse.

It isn't any easier to subject the problem employee to an accelerated performance review, but it's a good idea. Doing so gives you time to make sure that the employee understands why you act. It allows you to make the urgency of the problem clear — and to give the employee the responsibility for choosing between improvement and termination. Thus you may not lift the cloud of ill will, but you can do something about the mistrust — because you make the employee understand just how far you intend to go to solve the problem.

You use your paper trail to good effect here. You show the employee your documentation of the problem — the contemporaneous notes made by you or the employee's supervisors as to each incident contributing to the problem. You also review those documents that establish the at-will status of the employee.

And you discuss each step in the paper trail in detail, with two ends in mind: to make sure that the employee understands and to see whether the paper trail contains any weaknesses or omissions. Generalizations don't count for much here. Be spe-

[2]See Chapter 7.

Make the urgency of the problem clear

Brief daily meetings

cific in describing the problem and in outlining what you expect the employee to do to solve it.

It's important to use the same format in the accelerated performance review as you use in your routine reviews. In fact, you protect yourself from charges of unfair or pretextual treatment by using the same format.

As for timing, don't kill yourself. Most employers work under deadlines every day, and they succumb to the temptation to give second priority to such things as sitting down with a problem employee to work things out. After all, it takes time to do this, and time is what employers don't have.

But it's a mistake not to make the time because if you don't, you turn a small problem into a big one demanding much more time — maybe including time in court.

One solution: brief daily meetings with the problem employee. Many employers try to have at least two reviews within two or three weeks of a termination. Others anticipate problems sooner and put a problem worker on monthly review as much as a year in advance. Some begin the process 60 days before they expect to terminate. (This practice reflects recent federal law requiring employers of more than 500 people — as well as those employing more than five percent of the local labor pool — to give 60 days' notice of plant closings.)

Whatever time frame you choose, it's best to be systematic so that you can chart problems and developments. Standardize as much as you can, because each additional step in the paper trail strengthens your position.

The Reaction

Most employees react strongly to a less-than-glowing review, so take it for granted that yours will, too. This probably contributes to the reluctance of many employers to bring things to a head; it's unpleasant, after all, and there's always the possibility that an angry employee will seek immediate revenge, perhaps by filing a workers' comp claim. Fearing this, some employers don't tell their prob-

lem workers that the accelerated review may end in termination.

Occasionally, you may use an accelerated performance review to reevaluate a problem worker. A rare employee, worth keeping, will require dire circumstances before reforming or improving.

"Usually what you get, though, is someone who swears he'll change. And does — for two weeks. Then its back to the same problems," says the personnel director for a light manufacturer based in Massachusetts. "That's why I like to use a six-week accelerated schedule. If a problem can't improve and maintain for that long, it's time to show him the door."

The Object

Most of the time the object of your accelerated review isn't to shock a problem employee into shape. It's to arrange your paperwork for a specific end — namely to fire the worker. So avoid any bluster or antagonism. The time for that has passed.

If, however, you remain uncertain whether you want to fire the worker, ask yourself the following questions:

- Has the employee been with you less than a year?

- Have you made or do you plan other terminations?

- Has the employee filed any workers' comp claims?

- Does the employee have a history of discipline problems or volatile behavior?

- Does the employee have a history of lawsuits or complaints against other employers?

- Do other employees or former employees from the same division have litigation or administrative actions pending against the entity?

- Has the employee reacted negatively to other reviews?

Don't harass the problem employee

- Does the employee have access to sensitive information?

- Does the employee pose a direct financial or security risk to you or the entity?

At the very least, the more often you answer yes to these questions, the less likely you should consider explaining too much.

Pitfalls to Avoid

Of course, using the accelerated review poses a few risks. In fact, you might think of the accelerated review as a series of pitfalls to avoid. Among them:

- Avoid using the accelerated review to harass the worker. Instead, analyze his or her shortcomings or problems in a frank and impartial manner. If the worker has problems with a specific manager, take that manager out of the process—but keep the process focused on specific problems.

- Avoid personal attacks or appeals. Personal tensions often come to a point during an accelerated review, so don't make or encourage comments of a personal nature. Focus on your standards and the requirements of the job, and go over previous reviews. Keep any questions about outside influences focused tightly on the job skills and description.

- Avoid engaging in debate. The employee under accelerated review may become confrontational, but it's a good idea to resist the urge to respond in like manner. Concentrate on performance. The employee meets your standards or doesn't. By this stage, only action counts—the employee's.

- Avoid using threats, and don't push the employee around.

- Avoid behavior that tips your hand. This includes scuttling the pet projects of someone about to be terminated, redirecting responsibilities before a termination, cutting the budgets of managers about to be fired, or speaking

to other subordinates about the termination. Instead, keep the communication open and directed between yourself and the employee under review.

"Basically, my advice to clients is, 'If you railroad an employee or act like a tough guy, that employee will sue,'" says a New York-based management consultant. "The best bet is to be passive and deductive, observant but reactive. Everything should be pro forma. You're inclined to terminate, but you could be convinced to hold off — if you see real improvement."

Expected Reaction

Often, an employee under accelerated review starts looking elsewhere for work. That's fine. You can also expect the employee to remove personal effects and professional tools (Rolodexes, calendars, computer files) from the work place, to hedge away from advocacy positions or aggressive schedules, and to spend time networking in professional or trade meetings.

The employee may seek to push you into admitting that the accelerated review presages termination. Don't deny this, but avoid the inflammatory. One Detroit attorney/consultant mentions a client whose employees broke expensive company machinery and damaged colleagues' cars because they felt themselves unfairly disciplined in an accelerated review.

Other points to remember:

- Don't overload yourself with paperwork. It doesn't take reams of paper to pave your paper trail. Record only the essential facts — usually centering on how the employee measures up to performance standards. The American Management Association recommends that employers limit their performance reviews to one page with standardized questions and observations.

- Avoid unnecessary formalities and red tape. Performance reviews — like any evaluative

Hold off only if things get better

Keep your reviews simple

process — can become ponderous and bureaucratic. The danger: Their usefulness may slip. Keep your meetings and analyses simple. Standardize the questions, but let your reviewers direct answers as they think best.

- Don't let the reviews occupy too much of your managers' time. For the manager with many subordinates, the accelerated review can become a sinkhole that sucks in time better spent otherwise. Instead, if you have personnel people, use them as much as possible, with a standardized format.

- Don't let short-run results interfere with long-run planning. Even using the ongoing reviews we've discussed, you still need to do at-least-annual reviews of all employees, not to mention many other annual chores: multi year operating plans, sales projections, etc.

- Don't make decisions simply by swapping memos. The great advantage of performance reviews — accelerated or ordinary — is the face-to-face contact. This way, the review acts as a form of management information system, only without computers.

An Ironclad Process

In 1992, the Alaska Supreme Court reviewed the case *Van Huff v. Sohio Alaska Petroleum*, which involved a somewhat sloppy termination but an ironclad accelerated review process.

Albert Van Huff sued Sohio, alleging that he had lost his job in 1987 as a result of the malice and ill will of his supervisors. He also claimed that Sohio fired him in a scheme to deny pension benefits.

Van Huff's termination generated much ill-will; both sides exchanged heated words. But when the time came to fight in court, Sohio stressed the facts.

It wanted to put its senior supervisors — not Van Huff's immediate bosses — on the stand to establish the objectivity of the review process. To do so, however, the company had to get around the hearsay rule; the senior supervisors would testify not to

their own responses to Van Huff but to the reactions of his immediate supervisors. Alaska allows a "state of mind exception" to rules prohibiting hearsay.

To bolster this contention, the company showed that its established policy was to review terminations against performance standards.

The trial court went along with Sohio. The company questioned senior supervisors about the opinions expressed by Van Huff's immediate supervisors. Sohio argued that the opinions showed that the supervisors acted reasonably and in good faith in rating Van Huff against the performance standards.

An Objection

After testimony ended, the court issued numerous instructions to the jury. Van Huff objected to one which provided:

> *An employer may terminate an employee if it has a fair or honest reason based upon a business purpose which the employer acts on in good faith.*

> *An employer's termination decisions are based upon a legitimate business purpose if you conclude that management acted upon information which reasonable minds might accept as adequate to support its conclusions. You are not permitted to substitute your judgment for that of Sohio Construction Company even if you would have acted differently had it been up to you.*

The jury returned a verdict for Sohio. Van Huff appealed, but the state supreme court affirmed the decision.

Sohio prevailed here by producing a good paper trail — once again a key. Setting up performance standards gets you a long way toward showing the courts that you treat people fairly. Focusing on those standards as you prepare to fire someone gets you even farther.

Many employers use accelerated reviews to assemble evidence against an employee suspected of wrongdoing.

'A fair or honest reason'

A high incidence of theft

They have reason to worry about wrongdoing in the work place. A 1991 study suggested that as many as one in every eight employees commits some kind of workplace theft. According to a 1989 study, you're likely to find one drug dealer in every 25 hourly employees and one drug user in every ten hourly employees.

A Heavy Hand

Many employers use surveillance to combat these problems. Some do it so awkwardly that they create even bigger problems for themselves, as Nissan discovered in a case having nothing to do with drugs, theft or, for that matter, any other crime.

In early 1991, two former employees of Nissan's American subsidiary sued the auto maker, accusing it of spying on their private electronic mail and then firing them when they complained.

Bonita Bourke and Rhonda Hallin alleged invasion of privacy and wrongful termination of employment. The women said Nissan managers showed them a "large stack" of their electronic mail messages, then issued written warnings citing each woman for making personal use of company software.

The women claimed that Nissan had presented the E-mail system as an alternative to regular mail, telephone and facsimile messages. But the company hadn't warned them that the system was off-limits to personal communications, they said.

Both women ceased working for Nissan within a few months of the written warnings.

"Whether they were fired or not, this seems like a pretty ham-fisted invasion of privacy," said an attorney familiar with the women's case. "The women weren't doing anything wild, just talking to each other a lot."

No one disputed Nissan's right to put its E-mail system off limits to personal communications. But the company didn't say so in advance — and then, according to the women in this suit, took revenge on them for breaking a policy about which they knew nothing.

Undercover investigators and hidden surveillance cameras probably catch more drug-using workers and petty thieves than random searches, but they can cause headaches, too.

The detective agency Pinkerton's says it solves "almost all" of the workplace theft cases it handles. About half of its investigations of drug abuse begin as investigations of theft. But employees resist surveillance, and labor unions generally oppose the technique outright.

"I can't think of a situation where we would condone that sort of investigation," said Sue Altman, assistant president of the Illinois AFL-CIO. "The key to any drug program should be rehabilitation, not retaliation." The union argues that workplace surveillance may break the Constitution's prohibition on illegal search and seizure.

"There is a trend among some attorneys that not following [this kind of] discipline may be a violation of due process," says Sacramento lawyer David Perrault. "It wouldn't surprise me down the line to see a court find that failure to follow your own system in violation of due process."

A Secret File

In 1993, insurance giant Cigna found itself contesting just such an argument in a lawsuit brought by a California physician.

Robert French sued Cigna, his former employer, for illegally and abusively firing him in 1991. He claimed that Cigna Healthplans of California, a Cigna subsidiary, secretly compiled a file of patient and employee complaints against him.

French charged that Cigna breached his contract and wrongfully terminated him without giving him an opportunity to contest his firing. "Cigna Healthplans thought they could handle [French's termination] with an iron hand," said one attorney involved in the case. "Actually, they were stupid about it. They sneaked around collecting testimony against him. They violated the spirit of the Fourth, Fifth and Fourteenth Amendments."

Due process on the job

A complex body of law

As the Founding Fathers wrote them, these amendments applied only to government, not to employers. But the civil courts don't hesitate to extend them to employers.

During a separate hearing to consider whether Cigna Healthplans afforded French due process when it fired him, the state judge handling the case called Cigna's actions "abominable."

French claimed that as a matter of corporate policy, the company targeted him and other tenured physicians who had favorable contracts. The campaign sought to renegotiate terms or to replace better-paid, older doctors with younger, lower-salaried hires, he said.

Poor Timing

Nor did Cigna try to soften the blow in terminating him, French said. He received his notice the morning he returned from his mother's funeral.

After a six-week trial, a jury awarded French $1.2 million for economic losses and $1.5 million for emotional distress and damage to his reputation, plus $5 million in punitive damages.

Bert Wagener, president of Cigna Healthplans, replied: "We care about every one of our employees. We are extremely disappointed by the verdict and we plan to appeal."

"They destroyed his career," replied French's attorney. "There's no doubt about it."

Before the trial, Cigna had offered to settle the suit for $80,000.

The law pertaining to legal surveillance is among the most complex in the American system. Few basic conclusions emerge from case studies, but private investigators and labor attorneys agree on some rough guidelines.

- It's easier to justify open surveillance equipment that has other legitimate uses — for example, workplace safety — than hidden equipment used specifically for surveillance.

- Surveillance efforts should focus on specific problems or crimes. Open-ended searches invite legal hassles.

- Other employees often prove the best sources of information. Private investigators suggest incentive-driven, employee-based systems for gathering information about wrongdoing — for example, telephone hotlines that protect the informant's identity. These programs involve employees directly in the safety and well-being of their workplace. They also systematize self-policing.

- As the *Van Huff* case shows, an established system of investigating and reporting employee performance and attendant problems lends credence to individual investigations.

- A well-developed case for terminating an employee shouldn't rely exclusively on surveillance results.

"You use an investigation to find problems affecting the company," says a Chicago-based investigation specialist who has worked for Pinkerton's and several smaller agencies. "You shouldn't have to count on an investigation to fire a bad employee.

"Ninety-nine percent of the time, an employee who's stealing from you or doing drugs will be a problem on the line. You have other reasons to fire; you just use the wrongdoing as the coup de grace."

Whistle Blowers

Sometimes the employees you want to get rid of stand in position to hurt you badly. They hold valuable information about contracts or accounts. They control key information or manage key steps in production. Worst of all, they can make allegations — true or not — of wrongdoing or malfeasance.

In recent years a number of defense contractors found themselves on the wrong end of litigation involving whistle-blowers — a sensitive subject that most companies prefer not to discuss.

In November 1992, the Justice Department joined a federal whistle-blower lawsuit against Teledyne

Threats tied to warnings

Corp. The feds alleged that Teledyne's controls division in Los Angeles falsified testing, bribed government officials and overcharged the Pentagon on numerous contracts.

A Teledyne quality assurance engineer filed the original suit in 1990, saying that her warnings to management about illegal practices led to threats against her job. She sued under the federal False Claims Act, which allows individuals to sue on behalf of the government and share in any damages.

Missing Panels

According to her suit — still pending as this book went to press — Teledyne shipped hundreds of cockpit warning panels for the Sikorsky Blackhawk helicopter without testing to ensure that light escaping from the panels would not temporarily blind aviators wearing night-vision goggles.

It also alleged that:

- The company failed to conduct adequate testing on cockpit instrument systems used in the Grumman F-14 jet fighter and the Blackhawk helicopter.

- Teledyne officials made "payments of kickbacks and other illegal gratuities" to government officials responsible for overseeing quality control.

- A Teledyne executive made cash "loans" to a Defense Department official. Both lost their jobs — quietly: the government didn't prosecute, and Teledyne made no public acknowledgement.

- The controls unit purchased millions of dollars worth of parts through an unapproved accounting "override system" that circumvented military cost- and quality-control standards — and the company's own procedures.

- The controls unit was plagued by schedule delays, sloppy production practices and poor training of workers. Most of the division technicians did not hold proper certification to perform work to government specifications.

Since the early 1980s, Teledyne has faced whistle-blower lawsuits seeking damages exceeding its net worth. The lawsuits portray Teledyne as a firm with weak central controls locked in a struggle to preserve a shrinking franchise.

"This is a good example of what kinds of company faces internal dissent and problems like whistle-blowing employees," says New York-based business security consultant Philip Garment. "You've got nervous management of a troubled company. They think the best way to handle problems — and problem people — is to fire first and settle later. It's a secrecy act. And it costs a lot in the long run."

The Lessons

The lessons here apply beyond the defense industry. Any time you find yourself facing angry employees, you have to resist the impulse to turn evasive and nasty.

Two approaches work best. First, the "hide in plain sight" approach entails going public with details of your operation — or at least of the events in dispute between you and the disgruntled worker — in such a way as to preempt the worker. Defense contractors resist this solution because of their belief that going public, even in a limited way, constitutes an even greater risk than fighting the former employees in court. Most employers see more to win than to lose in the tactic.

The second approach accepts the harm posed by the disgruntled employee as a cost of doing business. As a rule, employers who take this approach offer the disgruntled employee a generous severance package requiring that the employee agree to keep his or her mouth shut forever after.

Defense contractors don't use this approach because federal law prohibits it. But it can make sense to other employers, particularly those with trade secrets to protect.

In short, the more coolly you asses the information or assets you must protect, the better your position. Disgruntled employees and their lawyers have sensitive noses for fear. But most just want money,

Assess the assets you must protect

which buys a lot of vindication.

Unheeded Warnings

The 1990 Lockheed whistle-blower case stands as a strong example of what not to do when faced with disgruntled employees in position to hurt you. In this case, three former employees tried to warn management that the company's C-5B aircraft was defective and unsafe. Two internal auditors and a quality-assurance representative claimed that Lockheed Chairman Lawrence Kitchen wrongfully terminated them in 1985 after they warned him about the giant Air Force transport.

The Lockheed employees alleged that, as early as 1983, improper heat treating of the main frames of the C-5B at Lockheed's plant in Burbank, California, resulted in cracking, warping and other deformities. Clyde Jones and Terrence Schielke claimed that audit department executives told them not to undertake a formal investigation or write a report about their allegations. Still, they continued to sound warnings.

In 1985, the auditors and Thomas Benecke, a quality assurance expert, told Kitchen that they had hired an outside metallurgist at their own expense and had found defects in samples of the parts.

Kitchen testified that he fired Schielke and Benecke because they acted unprofessionally, failed to conduct a formal audit of their own allegations and took property off company premises when they went to the metallurgist.

Though the men brought their case on grounds of wrongful termination, the trial revolved around the question of the flawed parts, which received much attention in the press.

The fired employees alleged that ovens operated at too high a temperature and caused eutectic melting, in which certain metals inside the aluminum alloy melted.

When Kitchen heard this, he raged against the engineers and fired them in a vindictive manner, they

said. Worse, they accused Kitchen of actively engaging in a coverup of the product flaws.

In the end Lockheed had no chance of winning the case; the steady drumbeat of bad publicity attracted national attention, including much unwanted attention from Congress, and Lockheed lost badly. The court ordered the company to pay $45.3 million in damages to the whistle-blowers.

Lockheed settled out of court.

Kitchen came under fire for his handling of the case. His critics argued that he could have saved his company untold treasure, not to mention all the publicity, by heeding the warning of the whistle-blowing engineers. And if indeed he took part in a coverup, they said, he did worse than act foolishly.

The better idea, for the employer faced with a whistle-blower, is to investigate the charges and, if true, use them to reinvent things in the disputed department. Don't kill the bearer of bad news.

Despite the cautionary tale involving Lockheed, honest employers can fall prey to whistle-blowers who simply want revenge. Sometimes angry employees concoct tales of wrongdoing and coverups to hide their own failure, especially if they can point to the nefarious doings to accuse you of firing them on pretext.

In these cases, the accelerated review gives you evidence to prove otherwise, and the "plain sight" approach becomes even more attractive.

The Boy Scout Motto

You prepare yourself for the risks that follow your decision to fire an employee by anticipating what the employee might do and by ensuring that he or she meets with the same fair treatment accorded everyone in your employ. In this way you give the angry employee no leeway to accuse you of wrongdoing at any point in the process by which you terminated his or her employment.

The best tool remains the accelerated performance review. It allows you to strengthen any weak links in your paper trail. It enforces established standards.

The 'plain sight' approach

Weak
links

And it shortcircuits claims that you acted on pretext or in bad faith.

Throughout, if you act as though you do something wrong or have something to hide, you invite charges of mistreatment or wrongdoing.

Simply said, consistency and fairness pay big dividends. Set your rules up in advance, and then follow them. And be as straightforward and honest as you can without making promises or threats about what you'll do in the future.

CHAPTER 10: PREPARATIONS

No matter how carefully you lay the groundwork to fire someone, the fact remains that once you act, you expose yourself to litigation. Anyone who gets mad enough can sue, and it's always possible that your antagonist will find a judge or jury willing to go along with a campaign to punish you.

Those who sue their employers sing common refrains, mostly having to do with public policy or implied contracts. In order of frequency, more or less, the refrains boil down to claims of:

- Wrongful termination based on stated or implied conditions of employment;

- Discriminatory firing based on religion, race, physical handicap, national origin, age, gender, marital status, weight, or arrest record;

- Retaliatory discharge for exercising rights under federal or state law.

As a sort of bonus, many people tack on charges of slander, libel and defamation of character.

The Incentive to Sue

The American court system gives employees the financial incentive to sue. The system acts something like a lottery, with huge jackpots awaiting those who win. You don't want to fund somebody else's jackpot. And you avoid doing so by making sure that you don't have to go to court in the first place, because it often doesn't matter whether you prevail in the end. If you're like most employers, by the time you reach that end you will long since have spent a lot of money on legal costs.

The most common complaints

The Foley decision

Many of the preparations you take will themselves prevent a lawsuit. Nothing frightens the bottom-feeders of the legal establishment more than a well-prepared adversary.

The Challenge

The 1988 California Supreme Court case *Foley v. Interactive Data* stands as one of the most important wrongful termination cases ever litigated. In this case the court considered a range of issues relating to firing an employee and, for the most part, declared itself on the side of the employer.

Interactive Data, a subsidiary of Chase Manhattan Bank that marketed computerized "decision-support" services, hired Daniel Foley in June 1976 as an assistant product manager at a salary of $18,500.

Over six years, Foley received a steady series of salary increases, promotions, bonuses, awards and superior performance evaluations. In 1981 Interactive Data promoted him to branch manager of its Los Angeles office. His salary rose to $56,164. He received a $6,762 merit bonus just two days before his discharge in March 1983.

The event that led to Foley's discharge: a private conversation with his former supervisor, Richard Earnest. During the previous year, Interactive Data had promoted Earnest and hired Robert Kuhne to replace him as Foley's immediate supervisor.

Foley learned that the FBI had Kuhne under investigation for embezzlement from a former employer. Foley reported what he knew about Kuhne to Earnest, saying that he "worried about working" under Kuhne's supervision.

Earnest told Foley not to discuss rumors and to forget what he knew of Kuhne's past.

A few weeks later, Kuhne told Foley that Interactive Data wanted to transfer him to Massachusetts. Then Foley learned that he must agree to a "performance plan" that included an accelerated review process. Soon after, Kuhne met with Foley, purportedly to discuss the "performance plan" proposal.

Instead, Kuhne told Foley that he had the choice to resign or be fired immediately. Foley didn't resign, so Kuhne fired him.

Eight months later, Kuhne pleaded guilty in federal court to a felony count of embezzlement.

Foley sued, seeking compensatory and punitive damages for wrongful discharge. He made three claims:

- That Interactive Data had fired him in retaliation for informing Earnest about the investigation of Kuhne, in violation of public policy;

- That company executives had assured him orally of job security so long as his performance remained adequate, creating an implied contract; and

- That the company violated its own guidelines setting forth explicit grounds for discharge and a mandatory seven-step pre-termination procedure.

In pretrial motions, Interactive Data pressed for dismissal of all claims. The trial and appeals courts agreed, but Foley pressed on.

No Public Policy Claim

The California Supreme Court ruled that Foley could not claim that Interactive Data violated public policy in firing him after he informed Earnest of the investigation of Kuhne. In relaying the information to Earnest, Foley probably acted in the company's best interest, the court said, but he did not further the public interest — and Interactive Data did not violate public interest in firing him.

So Foley lost on that count. But the court did rule, on the other hand, that Foley could show bad faith in establishing that Interactive Data breached an implied contract governing his employment.

This, however, meant good and bad news for Foley — and for all others who pursue employers for bad faith dealings in respect of implied contracts. An implied employment contract is a contract, and as such it governs the damages the employee may col-

A big
win
for
employers

lect in the event that the employer breaches the contract. The good news for Foley, therefore, was that he could pursue Interactive Data for bad faith. The bad news was that the implied contract precluded him from seeking tort damages.

Legal experts consider *Foley* a major victory for employers. It reiterates the employer's right to fire an employee for any reason — even one that defies common sense. And it limits the grounds on which an employee who claims bad faith may pursue the employer for damages. *Foley* rules out punitive damages in cases involving implied contracts. This removes a big incentive for contingency fee lawyers.

But *Foley* isn't the last word on the matter. In an important dissent, one of the judges in the case wrote:

> *Although written in conservative tones of deference to legislative action, [the ruling] is in fact a radical attempt to rewrite California law in a manner which . . . will leave the wrongfully discharged worker without an adequate remedy.*

> *Under [this decision], employees will no longer have a tort cause of action for bad faith discharge, but, absent some violation of public policy, can sue only in contract . . . [But] traditional contract damages may provide inadequate compensation . . .*

> *[A] considerable number of commentators have suggested that the remedy for widely perceived inequities in the contract damages realm may lie in an expansion of the nature of damages that may properly be recovered within a breach of contract action.*

This dissent crystallizes the challenge that you face in any legal action—judges who actively want to expand the limits of contract law.

Wrongful Termination

An obscure legal concept even a decade ago, wrongful termination has grown rapidly. In 1992, an estimated 20,000 cases alleging wrongful termination clogged the courts, and the average damage award stood just under $500,000, up from $225,000 in

1986. Of the cases tried before juries, between 70 and 80 percent resulted in verdicts for the employee.

Most often, wrongful termination cases hinge on a combination of common law and statutes governing breach of contract, discrimination, intentional infliction of emotional distress, good faith and fair dealing, and personnel policy.

In the past, wrongful termination lawsuits usually involved only flagrant violations of an employee's rights — for example, firing someone because he or she had jury duty.

Exacting Revenge

Now attorneys don't hesitate to allege wrongful termination as a means of exacting revenge on employers. As one Michigan lawyer boasted in a 1993 interview:

> *Most employers, in order to keep workers happy, want to foster job security, good communications and a family atmosphere. On the other hand, they want the right to terminate at any time for any reason or no reason. But damages can be, and often are, much higher than lost back pay. Couple with that negative factors like legal fees, bad publicity and an opening toward similar suits by other employees . . . and the employers will settle.*

Contingency fee attorneys know the formulas insurance companies use to determine whether to settle claims—and they readily accept cases that fit the profiles. The ideal claim involves a worker more than 40 years old, employed for ten or more years with no history of disciplinary problems and little prospect of finding similar work because of age and field of expertise. The employer in the perfect case has an employment manual that spells out reasons for dismissal. Even better is the employer who has indulged in open-ended talk about long term employment with the employee.

You may remember this last issue from our discussion of the Michigan case *Toussaint v. Blue Cross.* That case established that, if an employer promises

The court can find causal link

—verbally or in writing, explicitly or implicitly—not to terminate except for just cause, it breaches a contract if it doesn't keep the promise.

Expanding the Concept

Three California Supreme Court cases echo *Toussaint's* findings and expand the concept of wrongful termination.

- In the 1980 case *Tameny vs. Atlantic Richfield* the court held that an employee can make a wrongful termination claim if he or she refuses to participate in unlawful conduct (in this case, an illegal price-fixing scheme) and then loses his or her job. The fired employee doesn't have to establish a strict causal link between the refusal and the firing. If he or she can prove the unlawful act, the court can determine cause.

 In *Tameny*, the court ruled that the employer's ability to fire at will "may be limited by statute . . . or by considerations of public policy . . . even in the absence of an explicit statutory provision."

- The same year, in *Cleary vs. American Airlines*, the court expanded the idea of wrongful termination, linking an employee's rights closely with the assumed covenant of good faith and fair dealing. In *Cleary*, the court found that the airline had violated its own established grievance procedures.

- In the 1981 case *Pugh vs. See's Candies*, the court allowed a wrongful termination action to stem from implied-in-fact promises. These promises can be based on personnel policies (as in *Cleary*) but also on the employee's tenure of employment, actions or communications by you that suggest continued employment, and even standard industry practices.

 The fired employee in *Pugh* had worked for See's Candies for more than 30 years, ascending the corporate ladder from dishwasher to vice president. When hired, he had been assured that "if you are loyal . . . and do a good job, your future is secure."

Throughout his long employment, the company maintained a practice of not terminating administrative personnel without cause, the court found. On this evidence, the court ruled that the jury could determine the existence of an implied promise that the employer would not arbitrarily terminate the plaintiff's employment — even if the promise didn't exist in writing, and even if no one ever specifically said it.

How Wrongful Termination Suits Work

Lawyers lump wrongful termination lawsuits into three categories:

1) Those involving employees fired before the end of the term of a written contract;

2) Those involving employees fired without contracts;

3) Those involving employees fired for refusing to break the law for an employer or for blowing the whistle on an employer who does something illegal.

Contractual employees enjoy the protections of the contract itself, so they must accuse you of violating the contract. As a rule, they can collect only those damages specified in the contract.

In contrast, at-will employees — in most cases — may claim only wrongful termination. That's why you see so many wrongful termination cases.

You have great discretion to terminate the employment of an at-will employee, but you can't do so if motivated by bad faith, malice or retaliation. Wrongful discharge constitutes an intentional tort; thus in most cases, intention becomes key. A court must infer intent on your part — a difficult feat. So most wrongful termination claims include charges of racial discrimination, unfair retaliation and violation of public policy, all easier to prove.

The fired employee has some obligations, too. Most important, the employee must "mitigate damages" by seeking new work. In *Boehm v. ABC*[1], ABC attempted to defend itself by contending that Boehm

[1]See Chapter 9

A gold mine for lawyers

couldn't recover damages because he refused to accept another job at ABC, thus failing to mitigate. The employee also has the burden of showing the employer's reasons for the termination to be pretextual.

Measuring the Damage

The 1975 Tennessee decision *Chapdelaine v. Torrence* set out the formula that most courts follow in assessing wrongful termination claims:

> *When an employee has been wrongfully terminated, the measure of damages is the amount the employee would have earned had the employer not dismissed him, less what would have been earned, or might have been earned, in some other employment, by the exercise of reasonable diligence.*

Employees can, of course, recover back wages and compensatory benefits for wrongful termination. They may win punitive damages when they show that a related cause of action stems from the termination — for example, defamation, damage to reputation, or emotional distress caused by the anxiety and frustration of the firing.

Not surprisingly, they make every effort to do so.

"The plaintiffs' bar sees wrongful termination as a gold mine; it's money in their pockets," says one California attorney who defends companies and managers. "I have cases now that are filed by someone who was employed for six months and was terminated for not doing a good job and then filed a lawsuit wanting $100,000. It's outrageous."

Running a close second to wrongful termination cases comes a group of charges involving implied, oral or de facto contracts. Most stem from employee manuals and written policies.

These charges reflect the 1972 Supreme Court decision *Perry v. Sindermann*, in which the employee claimed a right to continued employment in the absence of sufficient cause for discharge. In *Sinderman*, the court ruled:

> *The law of contracts in most, if not all, jurisdictions long has employed a process by which*

agreements, though not formalized in writing, may be implied. Explicit contractual provisions may be supplemented by other agreements implied from the promiser's words and conduct in the light of the surrounding circumstances.

You don't have to put things in writing in order to form a contract, in other words, and you can "supplement" an implied contract by what you do and say.

Clearly, *Sinderman* stresses the need for care in dealing with job applicants and employees, including those you fire.

Establishing a Claim

In order to establish a claim for breach of contract the employee must prove:

- That a contractual relationship existed between employer and employee;

- That the employer had knowledge of the contractual relationship;

- That the employer acted intentionally to breach the contractual relationship;

- That a breach occurred; and

- That the employee suffered demonstrable, resulting damage.

You can defuse most of this exposure by having all employees sign an agreement upon hiring acknowledging explicitly that they 1) work on an at-will basis, 2) recognize no contractual agreement, and 3) waive all rights to contractual claims.

You have a few other tools which work in your favor.

According to the 1990 California Court of Appeal decision *Shapoff v. Scull,* the "owner of an entity" has a limited privilege to terminate a contract if the owner's predominant purpose is to further the entity's interests. Likewise "a manager . . . enjoys a qualified privilege to induce the entity to breach a contract that he or she reasonably believes to be harmful to the entity's best interests."

Don't put faith in loopholes

Most states have loopholes like this in their labor codes.

But don't count too heavily on such loopholes when it comes to hiring and firing. First, you usually must prove that in breaching the contract you served a specific, quantifiable purpose. If you succeed, you make your action a justified termination — a good thing, but sometimes difficult to prove after the fact. Second, most courts interpret the "qualified privilege" to mean they can insert themselves into the matter. They might rule against you, even if you prove your legitimate interests.

A Textbook Case

In the 1992 Utah Supreme Court case *Sanderson v. First Security Leasing,* the employer faced a textbook implied contract charge. It handled the charges fairly well.

In October 1980, First Security hired Russell Sanderson to collect delinquent equipment leasing accounts. Sanderson received favorable performance evaluations and regular increases in salary and responsibility, becoming manager of First Security's equipment services division and account services department in 1984. He served as a vice president of the company and as one of five members of the senior management committee, positions he held until his termination.

In late 1988, Sanderson became ill. Although his ailment remained unclear, it involved chest pains and depression. Sanderson took more than five weeks of sick leave during his illness, entering hospital at least six times.

Sanderson kept in contact with Bud Cummings, First Security's CEO, who told him to "take all the time . . . [he] needed."

Four months after Sanderson became ill, First Security restructured its management and placed an intermediate supervisor between Sanderson and Cummings.

During his first month as Sanderson's supervisor, the new manager ordered an audit that revealed a

number of accountancy and fulfillment problems in Sanderson's department.

Cummings told Sanderson that he must choose between a demotion or termination. Sanderson chose termination.

In September 1989, Sanderson sued First Security for wrongful termination, breach of implied contract and breach of the covenant of good faith and fair dealing.

The trial court granted a summary judgment rejecting all of Sanderson's claims.

An Implied Contract

He appealed, claiming that First Security's employee handbooks created an implied contract and that Cummings's oral assurances about his job further limited the at-will presumption. The handbooks provided that employment with First Security remained at-will. The company distributed these to all employees and required them to sign an annual statement that they understood and would follow the policies outlined.

A separate handbook went only to managers. This handbook set forth detailed guidelines for firing employees, requiring a series of informal and formal evaluations and warnings. But it also contained a disclaimer: "In situations where employee behavior warrants immediate termination the stages of this process do not need to be followed."

The Utah Supreme Court rejected Sanderson's good will and handbook claims but ruled that factual questions did exist as to whether First Security fired Sanderson for his illness-related absence, which would have violated Cummings's oral promises.

The court sent the case back to lower court to determine the single question of whether Cummings' promises limited the company's ability to fire Sanderson at will.

First Security tried to characterize Sanderson's departure as a voluntary resignation. In an embarrassing turn, its own termination form identified the action as an "involuntary termination."

More than one option

But you don't protect yourself from legal claims by giving an employee a choice between resignation and termination. Only voluntary resignation does that.

Still, most employers would be content to do as well as First Security, which persuaded the court to reject two of Sanderson's three charges before the case went to trial.

You can reasonably expect even more.

'An Express Limitation'

In the 1992 decision *Preston v. Champion Home Builders*, the New York Court of Appeals held that an employer's manual didn't limit an employee's at-will employment or create any implied contract.

"For an employment manual or other written policy to meet requirements for rebutting employment at will, it must contain an express limitation on the employer's right" to do so, the court ruled.

A "progressive discipline" system outlined in Champion Homes' employment manual didn't imply any such limitations, the court said. The manual stated that the company would "generally" apply certain disciplinary rules.

Thus Champion escaped because it didn't tie itself down to following the disciplinary rules in every case — an important point for all employers to remember. You must set up and follow procedures for hiring and firing but not make them so rigid that you give yourself only one course to follow no matter what the circumstances.

You must reserve the right to dispense with procedure at your discretion.

Scratch a retaliatory discharge claim and you're likely to find a weak case — and strong passions. Sometimes retaliatory discharge claims come from employees who have signed waivers against suing the employer.

The best defense against a retaliatory discharge claim is to have a substantiated for-cause explanation for the termination. The employee has a lot to prove to make a retaliatory discharge claim hold up,

and you complicate the employee's task if you can justify your action.

Retaliatory discharge suits often claim that the employer 1) broke the law and then fired an employee who threatened to blow the whistle or 2) fired an employee who refused to break the law on instruction of the employer.

The Burden of Proof

Note where the burden of proof lies in each case. In the first the employee must show that the employer broke the law — a relatively easy charge to defeat. In the second, however, the employer must show that he or she did not induce the employee to break the law. This pits the word of the employer against that of the employee, and requires the employer to prove a negative — a difficult task.

The solution is simple: Don't let the question come up. Don't even think about ordering your employees to break the law.[2]

As noted before, most retaliatory discharge litigation comes from at-will employees, and the employee undertakes a substantial burden of proof in such cases. But it's easy to tack on other charges to a retaliatory discharge claim — for example, retribution for the filing of workers' comp claims, criminal behavior, violation of civil rights and (very common, but not commonly successful) the intentional infliction of emotional distress.

Consider one example of each of these claims.

In a California lawsuit, filed in early 1993, an attorney alleged that the law firm Rubenstein & Perry padded its bills in the Executive Life Insurance Co. insolvency case. Rubenstein & Perry collected more than $11 million in legal fees after the state insurance department seized Executive Life in 1991.

Adriana Moore alleged that the firm fired her because she refused to go along with excessive billing. In deposition, she cited conversations with col-

Don't order employees to break the law

[2]The action in question must break the law explicitly; actions which are merely ill advised or morally questionable don't count.

Employer's intent is key

leagues at Rubenstein & Perry that persuaded her of rampant bill-padding at the firm. Seeing the hours billed by some lawyers, she asked a co-worker how such high totals were possible.

"She laughed and said, 'Well, you'll be surprised, but they just bill, bill, bill on Mission [another insolvent insurer] and ELIC [Executive Life], and it's really easy,'" Moore testified.

She supplied records indicating that several Rubenstein & Perry lawyers billed more than 300 hours a month and that one billed 3,326 hours in 1991 — or more than nine hours for each day in the year, including Sundays and holidays — at $200 an hour.

Karl L. Rubenstein, who founded Rubenstein & Perry, denied that Moore's termination had anything to do with the firm's billing practices. He denounced Moore's accusations as "total hearsay" and said there was no doubt that the lawyer who billed 3,326 hours in 1991 had worked that much and more.

Moore's lawsuit remained unsettled as this book went to press.

The Employer's Intent

In the second case — *Marin v. American Meat Packing*, handed down in Illinois in 1990 — the court had to decide the employer's intent in firing a worker who had filed a workers' comp claim.

American Meat Packing prevailed here because the worker could not show that the employer acted solely in retaliation for the claim.

"We need to . . . caution," the court said in this case, "that the causality element requires more than a discharge in connection with filing a workers' compensation claim. In other words, an employer cannot be held liable for a retaliatory discharge solely because the employer fired an employee who at one time or another filed a workers' compensation claim. It must be affirmatively shown that the discharge was *primarily to retaliate against the employee for exercising the protected right and not for a lawful business reason.*"[3]

[3]Emphasis added.

As a rule, however, the employee doesn't have to establish malice in a retaliatory discharge claim involving workers' comp. The employee need show only a direct causal link between the comp claim and the termination.

In practical terms, this makes it important to check the workers' comp history of anyone you plan to terminate. If the employee has made a claim recently, make sure you can show a legitimate for-cause explanation for the firing — even if you don't have to, legally.

Also, make no direct references to the employee's comp history in the paper trail.

Drug Use

Pennsylvania gives employers unusual leeway in firing at-will employees, as the 1993 Pennsylvania case *Brown v. St. Luke's Hospital* shows. The case involved a woman who alleged employment discrimination and retaliatory discharge.

Denise Brown had worked at St. Luke's Hospital as a store room clerk. She claimed that other employees harassed her, using racial epithets.

In May 1989, the hospital suspended Brown without pay when she reported to her supervisor that police had charged her with possession of drug paraphernalia. A few days later, the hospital fired Brown. Shortly before the arrest, she had requested admission into St. Luke's Drug Rehabilitation Program, but the hospital had refused.

In her lawsuit, Brown claimed that St. Luke's terminated her because of her race and that its given reason — that she had distributed controlled substances at work — constituted a pretext. Furthermore, she claimed that the hospital retaliated against her by firing her after her arrest. She sought compensatory and punitive damages.

The hospital argued that Brown's only remedy lay in the Pennsylvania Human Relations Act (PHRA), which set out administrative procedures for handling claims of discriminatory discharge.

The Pennsylvania court agreed, thus allowing the

'Extreme and outrageous conduct'

hospital to escape compensatory and punitive claims, which PHRA didn't allow.

More importantly, the court agreed with St. Luke's that the state's at-will presumption allowed the hospital to fire Brown for drug use — and that she couldn't seek damages even if she could show that the hospital sought to inflict emotional distress.

Emotional Distress Claims

The Second Restatement of Torts — a reference work used in most states to guide civil damage litigation — defines intentional infliction of emotional distress as follows:

> One who by extreme and outrageous conduct intentionally or recklessly causes severe emotional distress to another is subject to liability for such emotional distress, and if bodily harm to the other results from it, for such bodily harm.

Once again, intent is key in these cases — a difficult thing for even the most ambitious lawyer to prove.

A 1992 Louisiana appeals court decision illustrates exactly how difficult the process can be. In *Massey v. G.B. Cooley Hospital for Retarded Citizens*, a man sued his former employer and its CEO for damages including intentional infliction of emotional distress.

Larry Massey worked as a mid-level administrator at Cooley Hospital for more than five years. In September 1989, the administrator of the hospital informed him "suddenly and unexpectedly" that he had the option either to resign or to be fired.

Senior administrators had accused him in front of other employees of misappropriating various items of property owned by the hospital. Massey denied the charges.

He refused to resign and immediately received notice of termination for "neglect of management responsibilities [and] conduct and behavior unbecoming of a department head."

Massey sought reinstatement in accordance with Cooley's employee manual. Cooley refused, without

explanation, so Massey sued. He charged Cooley and its chief administrator with defamation and intentional infliction of emotional distress.

In pretrial maneuvering, the trial court found that Massey's lawsuit failed to articulate a cause of action for intentional infliction of emotional distress. It ordered Massey to amend his lawsuit or focus on the defamation claim.

Instead, Massey appealed.

The appeals court went against him. It set three standards for emotional distress claims, requiring that the plaintiff show "extreme and outrageous" conduct on the part of the defendant, severe emotional distress, and intention on the part of the defendant "to inflict severe emotional distress or [knowledge] that severe emotional distress would . . . result from his conduct."[4]

The Louisiana court ruled that Massey "failed to allege . . . any facts which stated either that the [employer] actively desired to bring about mental anguish or . . . realized to a substantial certainty that it would occur."

Thus the trial court had properly dismissed the charge.

Most courts consider emotional distress a personal injury not subject to recovery under workers' comp.

Indeed, according to a leading legal commentator, professor and author Arthur Larson, "when the intentional injury is committed by a co-employee the better rule is that an action in damages will not lie against the employer. . . ."

Slander, Libel and Defamation

In recent years some lawyers have begun adding charges of slander, libel and defamation of charac-

<div style="text-align: right;">

Three standards for distress claims

</div>

[4]Other states follow similar standards in emotional distress cases. Louisiana defines outrageous conduct as behavior "so extreme in degree, as to go beyond all possible bounds of decency, and to be regarded as atrocious and utterly intolerable in a civilized community."
As vague as that may sound, it's not the definition of outrageous conduct that makes emotional distress claims tough. It's proving intention.

Injury to the employee's good name

ter to their retaliatory discharge claims.

Generally, defamation includes any statement deemed capable of damaging a person's reputation. You may engage in defamation by:

- Criticizing an employee's job performance, specifically by implying incompetence or inability to perform;

- Accusing an employee of a crime;

- Implying insubordination or disruption of workplace harmony;

- Implying a lack of integrity in the performance of employment duties (e.g., alcoholism, lack of ethics, dishonesty or untrustworthiness).

A defamation suit involves more than just making a statement, though. The worker must prove that you "published" the defamatory statement — made it known to a third party, directly or indirectly.

Once the fired employee proves publication, he or she must show that the allegedly defamatory statement was false, and that publication of the statement caused injury to his or her reputation.

You can probably guess that defamation suits frequently stem from comments made by an ex-employer to a prospective employer who calls seeking references.

Even so, like emotional distress, these claims can be hard to make.

The 1989 Michigan Court of Appeals case *Smith v. Fergan* involved a woman allegedly discharged for shortages in her accounts.

The trial court found that no defamation existed because the employer, Robin Fergan, had made no accusation of theft and no publication. The appeals court ruled that, even if defamation existed, Fergan enjoyed a "qualified privilege" involving people who had a direct interest in the shortages. The court quoted an earlier decision, *Tumbarella v. Kroger,* which found that "an employer has the qualified privilege to defame an employee by publishing statements to other employees whose duties inter-

est them in the same subject matter."

But the privilege exists only if the employer:

1) Acts in good faith;

2) Pursues a legitimate business interest;

3) Limits the statement to this purpose;

4) Chooses a proper occasion; and

5) "Publishes" in a proper manner and to proper parties only.

The Key Issue

In the 1989 New Mexico Supreme Court case *Newberry v. Allied Stores*, a man sued his former employer for breach of implied contract of employment, defamation of character and intentional infliction of emotional distress. The defamation claim became the key issue on the case—and it illustrates the legal exposure well.

Allied Stores, Inc., owned the T-Bird Home Centers retail chain. John Newberry managed a T-Bird store in Artesia, New Mexico, from 1977 until December 1984, when the chain's general manager, Derrell Ballard, fired him.

Newberry claimed to have purchased some disputed merchandise on credit, as allowed by Allied policy. Ballard claimed that Newberry hadn't followed the policy correctly and had in fact abused a courtesy extended to store managers.

The firing took place in the store's back offices. Ballard emerged from these offices, Newberry following him onto the store floor. An argument ensued during which Ballard said in a loud voice, "I don't trust you."

About six months later, at a private dinner party, the spouse of a T-Bird store manager asked Ballard what had happened to Newberry. Ballard said, "He was fired for stealing."

Ballard said this even though he had fired Newberry for failing to fill out charge forms in a timely and accurate manner, not for theft.

Newberry's defamation claim rested on the two

Fact or opinion

statements made by Ballard. Allied defended itself by arguing that Ballard had expressed a personal opinion, but the trial court found that Allied Stores and Ballard had defamed Newberry. It entered verdicts in favor of Newberry of nearly $120,000.

Allied and Ballard appealed.

The New Mexico Supreme Court quoted the Louisiana case *Mashburn v. Collin* that whether a statement constitutes opinion or fact "depends upon whether ordinary persons hearing . . . the matter complained of would be likely to understand it as an expression of the speaker's . . . opinion, or as a statement of existing fact."

The court agreed with Allied Stores and Ballard that the statement, "I don't trust you," uttered during an argument, amounted to an expression of opinion and not a statement of fact.

But it found "substantial evidence" to support the lower court's verdict that the statement, "He was fired for stealing," amounted to defamation.

Even so, it ruled that circumstances mitigated the damages.

For "Newberry to be compensated for actual injury, he must prove that . . . the communication proximately caused actual injury to [his] reputation," the court ruled. "The statement in question was not made until May 1985, at which time Newberry was gainfully employed."

So it rejected actual damages.

On His Own Time

The court also found no evidence that Ballard had made the statement during the scope of his employment. Allied couldn't be held liable for something Ballard said on his own time. Nor, the court said, did Ballard make the statement with actual malice — i.e., with knowledge of its falsity or with a reckless disregard for whether it was false.

It reversed the award of damages against T-Bird. It ordered a new trial limited to the issue of damages against Ballard.

In *Newberry* the New Mexico Supreme Court admitted that the line has blurred between slander, an *oral* communication, and libel, a *written* communication. Each is a kind of defamation, the court said, but in the confusion "we agree there are good reasons for abolishing the distinction."

Courts cannot presume defamation, but they can find a statement defamatory per se, if "viewed in its plain and obvious meaning" it makes one or several specific charges:

- The commission of some criminal offense involving moral turpitude;

- Affliction with some loathsome disease which would tend to exclude the person from society;

- The unchastity of a woman;[5]

- Some falsity which prejudices a person in his or her profession or trade; or

- Unfitness to perform duties of office or employment for profit, or the want of integrity in discharge of the duties of such office or employment.

Scripted Outlines

The last two charges matter to employers. It's easy to make such statements in the course of a termination if you don't take care. For this reason, some employers actually follow scripted guidelines for what to say during a termination.

Your conduct is important, in other words, although the courts don't hold you to impossible standards. As the New Mexico Supreme Court noted in *Newberry*:

> *Ballard terminated Newberry in the back offices of the store for violating company policy. Even though Ballard's method of termination, namely, shouting at Newberry, is not above reproach, it does not evince bad faith. Further, a defamation claim requires proof of actual malice for an award of punitive damages.*

[5]Feminists, hold your fire; the law in many states still says this.

Shield the employee from rumor

Most states allow the truth as an affirmative defense to charges of defamation. If what you say about an employee is demonstrably true, you should stay safe from charges.

In the 1991 federal case *Chube v. Exxon*, the employee charged that Exxon defamed him through the use of a positive drug test as the basis of the termination.

The court found Chube's argument without merit. If Exxon's collective bargaining agreement allowed drug testing — which it did — then it would also allow the use of test results as grounds for termination, the court said.[6]

To make sure, hold all conversations with the employee — fired or about to be fired — away from other employees. And speak no ill of the fired employee to others.

A New Theory

In recent years the courts in California, Texas, Minnesota, and New York have begun accepting a new defamation theory called "compelled self-publication." The fad may catch on.

In an ordinary defamation suit, someone — namely, you — must publish a defamatory statement. In self-publication cases, employees claim that they have no choice but to tell prospective employers why you fired them. Thus, they say, you compel them to publish defamatory statements against themselves.

One of the earliest self-publication cases involved claims processors for Equitable Life Assurance who had lost their jobs for "gross insubordination." The company questioned their expense accounts after a business trip; the processors refused to change them, and the company fired them.

[6]An interesting side note: Chube tried to extend the defamation claim to include a violation of the Fair Credit Reporting Act. His theory was that the positive test was false and would become a permanent part of his employment record. The court rejected this claim as unfounded.

When they sought new jobs, they had to repeat the company's allegation to would-be employers. In 1986, the Minnesota Supreme Court upheld a $450,000 trial court award in the processors' favor.

In the topsy-turvy world of self-publication, if a court believes you made a mistake about a worker's performance, it may force you to pay damages even if you haven't said anything to anyone. This makes almost any for-cause termination a potential defamation case.

The best way to avoid trouble here is to agree in advance with the worker, in writing, on a nondefamatory response to all inquiries from prospective employers.

Choosing Your Issues

You face dozens of basic legal exposures when terminating an employee. Smart lawyers multiply these exposures by combining charges and varying the themes.

In this chapter, we've taken a quick survey of the most common exposures and come up with basic rules for minimizing your risk:

- Set policy for handling terminations and stick to it, but don't hamstring yourself;

- Emphasize your employees' at-will status at every opportunity;

- Substantiate "good cause" grounds for every termination, even when you don't have to;

- Review an employee's work history before termination, to make sure that no causal links exist in which the courts could find retaliatory discharge;

- Say as little as possible about the termination, before and after the fact, to anyone not having a direct interest.

The objective is to minimize risk — and to remember the hard truth that the worker can use against you almost anything you say to soften the blow.

Agree what to say to others

CHAPTER 11:
COMPLICATIONS

You still have work to do even if you prepare your way to firing someone and then carry it out with minimum fuss and muss. The courts remain open to an angry worker who believes you have acted unfairly, and you can't predict what the worker will do, much less the courts.

Judges dismiss more post-termination lawsuits than ever reach trial, but you can't count on their dismissing any case against you. For one thing, it takes time and money even to persuade a judge to dismiss. For another, any given judge is as likely to come down against you as the most unsympathetic jury, depending on the nature of the complaint against you.

It becomes all the more important that you lay the groundwork carefully when preparing to fire a worker holding equity rights in your enterprise — for example, an employee vested in your pension or employee stock option plan. You must take extraordinary care in terminating a member of your family or employees with access to trade secrets and valuable company information. Whistle blowers present special problems, as do layoffs.

The Challenge

In business as in Shakespeare, character is everything. Put people under pressure and they give you a good showing of character, good or bad. Put them under the sorts of pressures encountered by a start-up business and you learn many things, as the following case study shows.

The 1992 dispute involved an Illinois man who accused his partners of firing him because he refused to make good on $800,000 owed to his firm by clients.

Equity rights muddy the waters

Dispute over stock rights

As executive vice president of Technology Solutions Co., Woodrow Chamberlain handled relations with key customers, earning $200,000 in base salary. When he lost his job in August 1992, some $8 million in TSC stock and options due him went into legal limbo.

Chamberlain and a group of partners formed TSC in May 1988 to provide management consulting services emphasizing computer use and advanced technology.

In an $18 million wrongful termination lawsuit, Chamberlain accused TSC chairman and co-CEO Albert Beedie of "a pattern of extortion and coercion" and a "pattern of racketeering activity."

Chamberlain claimed that Beedie expected TSC employees to cover unpaid accounts owed to TSC "or face termination and the loss of millions of dollars worth of TSC stock" in an employee stock program.

According to Chamberlain, Beedie wanted to make senior officers responsible for unpaid accounts. If they refused, the company could fire them and strip them of TSC stock.

That's precisely what happened to him, Chamberlain said.

The lawsuit said Beedie asked Chamberlain to sign an agreement making Chamberlain personally responsible for $1.3 million owed to TSC by one key customer, troubled Northwest Airlines.

The Response

Beedie had words of his own for Chamberlain. "[Chamberlain] was fired for substantial nonperformance," Beedie said. "[He] produced negative profits for TSC and had no backlog at the end of the year. This was a continuation of falling far short of expectations, which he exhibited in the four years he was with TSC."

Beedie also charged that Chamberlain violated his employment contract, which required that he take any dispute to non-binding arbitration before filing suit.

"The fact he didn't [go to arbitration] means he thinks he can't win, so he is using pressure," Beedie said. "We are going to sue Woody for failing to live up to his contractual obligations. This is the way Woody acts."

Disputes involving employee stock — or any arrangement that complicates the ownership structure — often end up in court, leaving judges to decide how to divide things up. Disputes involving employee benefits also make messes of hiring and firing cases, as do those involving proprietary information and trade secrets. And every courthouse in the country contains the detritus of that mainstay of American capitalism, the family-owned business.

In this chapter we consider all of these complications in turn.

The Unpredictable Courts

It is the business of the courts to settle disputes and mete out justice. But in the hurly-burly of everyday life, the primary effort on around the former, not the latter. The courts would like to do justice to the people who come before them, and in some very broad sense they probably do. But on any given day they concentrate just on settling disputes.

So in going to court to defend a termination as just, the employer engages in an act of irony, for he or she may come away, not with justice, but merely with a court order imposing a settlement. The courts put a halt to things; like referees in a boxing match who, at the bell, confine the spitting fighters to opposite corners of the ring, the courts worry less about declaring winners and losers than about keeping conflicts within acceptable bounds.

But this is not to criticize the courts as ineffective. They deal in practicalities, after all. They may or may not see justice in what employers do, depending on a variety of factors — the makeup of the jury, the perspective of the judge, the vagaries of state law, the effectiveness of your lawyer and that of your antagonist, even the backlog of cases — but they must act, and as rapidly as they can.

The family business

A system under pressure

You can't control these things, however much they impinge on your own search for justice. You can control only those things around which this book centers: the procedures by which you seek to ensure that those who work for you win fair treatment from the day they show up to apply for a job to the day they leave, willingly or otherwise.

If you keep these procedures in order and follow them, you do as much as you can. The rest is up to people over whom you exercise no control whatsoever.

As a measure of what you go up against, consider what one California court had to say in a case which disputed the right of the employer to judge the employee's work as good or bad:

> *The jury as trier of facts decides whether the employee was, in fact, discharged for unsatisfactory work. A promise to terminate employment for cause only would be illusory if the employer were permitted to be the sole judge and final arbiter of the propriety of the discharge.*

And:

> *There must be some review of the employer's decision. . . . Where the employer claims that the employee was discharged for specific misconduct—intoxication, dishonesty, or insubordination — and the employee claims that he did not commit the misconduct alleged, the question is one of fact for the jury: Did the employee do what the employer said he did?*

A Fair Assessment

To be sure, judges insist that judges and juries seek merely to make a fair assessment of disputed facts. And in fact federal and most state law explicitly forbids juries from substituting their judgment for the employer's.

But this puts the system under pressure. On the one hand juries must root out the employer's true reasons for firing someone, but on the other hand, they can't second-guess the employer's business judgment.

Given the conflict inherent in these two factors, there's no way for them *not* to become inconsistent. In determining the facts, juries oversee the employer's right to give meaning to such words as "dishonesty" and "insubordination" and "satisfactory" in accordance with the needs of the enterprise.

Thus they pass judgment on the *consequences* of your judgment and so, for all intents and purposes, on your judgment itself, no matter what the law says. They listen to plaintiff's lawyers argue that employers use their prerogative to define *dishonesty* and *insubordination* and *satisfactory* so as to fashion pretexts to fire people they don't like — that employers customize their standards to suit their likes and dislikes.

These are tempting arguments among Americans, who root for the underdog and protect the downtrodden. Besides, some employers do, in fact, commit the lurid sins painted by the plaintiff's bar; hence the need for the courts to look over their shoulders. But not all do. And yet all have juries looking over their shoulders.

The bottom line here is that the courts don't trust you as employer to act justly, either. So you must never slacken your efforts to do so anyway.

Pension and Profit-Sharing Plans

Employers increase efficiency and profits by seeking workers loyal to the firm and committed to its success. To this end, employers use profit sharing plans, employee stock ownership plans and other programs that give workers a stake in the company's future.

But such programs sometimes conflict with the at-will presumption. It's not so easy to fire someone who owns a piece of the enterprise, especially someone nearing retirement with a vested interest in your stock or pension plan. Judges and juries tend to shower big damage awards on such people, even when no legal reason exists to support their bias. So it becomes crucial to make sure that they find no discrimination in what you do.

A stake in the enterprise

233

Class action suit over ESOP

During the summer of 1993, a convoluted case involving an ESOP and a wrongful termination claim wound its way through U.S. District Court in Los Angeles. Almost 900 employees of Pacific Architects & Engineers Inc. sued the company and CEO Edward Shay alleging, among other things, that Shay cheated them out of some $25 million when he bought out their ESOP.

In the mid-1970s, Shay sold 40 percent of his company to his employees through an ESOP for $4 million. The employees had the option at retirement of holding their stock or cashing it in.

In 1988, the company fired Joan Howard. She sued for wrongful termination, eventually triggering a class action suit that threatened to bog down Pacific Architects & Engineers for years.

Later in 1988, while Howard's case awaited action, Shay bought out the ESOP's 400,000 shares for about $5 million. The buyout had the approval of the ESOP management committee, which consisted of Shay and two top executives.

The Real Value

In probing the sale, Howard's attorney Ray Kolts came to the conclusion that the deal smelled. Shay bought out the ESOP for $14.40 per share, but Kolts argued that the real value ranged between $78 and $83 per share. Instead of $5 million, Shay should have paid the ESOP something closer to $30 million, Kolts said.

Among the assets of the company was a square block of real estate west of downtown Los Angeles that included an office building, a parking lot and undeveloped land, valued at about $20 million, Kolts said. Other assets included a 50-percent interest in a Japanese real estate company called K.K. Halifax, plus property on the island of Guam. Kolts valued all of the company's assets at $80 million.

Howard negotiated an out-of-court settlement on the wrongful termination charge, but by the end of 1990, Shay faced a class action suit joined by most of Pacific Architects' current and former employees.

Testimony showed that Shay's purchase price of $14.40 per share reflected a valuation of the company done by the accounting firm Arthur Young & Co. The firm pegged the company's assets at $83 million but then applied several discounts to the value to arrive at the price Shay paid in the buyout.

Arthur Young discounted the value of the company's interest in the Japanese real estate firm by 60 percent because Pacific Architects didn't have complete control of the assets. Arthur Young reduced the value of the company's stock another 50 percent because it lacked "marketability" — then cut what was left in half again because the ESOP held a minority position.

An ESOP evaluator hired by the plaintiffs called the marketability discount inappropriate, since the stockholders were under no compulsion to sell their stock. In any case, the evaluator said, Shay should put a greater value on the ESOP's 40 percent share, not a lesser, because gaining it would give him control of 100 percent.

The class action suit remained unsettled as this book went to press.

Keeping Information Secret

"ESOP law is complicated and involves a lot of valuation and disclosure that owners don't often like to get involved in," said one CPA brought in to consult on the class-action lawsuit. "Often, the majority owner can keep information and valuation under wraps. But all it takes is one weird catalyst — in the Pacific Architects case, the wrongful termination lawsuit — to release information that can send the whole process into turmoil."

His advice to employers who have an ESOP and face a wrongful termination lawsuit: Settle before you must turn over documents for discovery.

You don't have to be involved in something as complex as an ESOP to face compensation problems. Sometimes you just need someone who retires and then wants to change his mind, as the city of Los Angeles discovered in 1991.

ESOPs require disclosure

Property right in a pension plan

The case involved a police lieutenant, dismissed for misconduct, who elected to take his pension. Then he sued to overturn his dismissal and won. Then he sued to rescind his retirement application.

This time he lost.

The lawsuit over Lt. Ronald Williams' dismissal lasted almost two years. When he filed it, Williams also applied for and won pension benefits. He received a monthly check throughout the litigation.

The law governing his pension stated plainly that police pensioners ranked higher than sergeant could not return to active duty.

Moreover, testimony showed that in casual conversation with Williams, Deputy City Attorney Eudon Ferrell, who represented the pension department, attempted to warn Williams that he could not go back to work once he had retired.

Williams tried anyway, once he succeeded in overturning his dismissal.

And the trial court found that Williams had erred by presuming that, if he prevailed in the lawsuit over his dismissal, he could return to work. It ordered that the city reinstate Williams.

A Unilateral Mistake

The California Court of Appeal reversed the decision. It called Williams's error a unilateral mistake, made while he had legal counsel and not induced by the city.

"Williams elected to take his retirement pension, effectively converting his property right of continued employment into a property right to a pension," the court ruled. "[He] should have known this would preclude his return to active duty."

It was too late for Williams to claim that taking a monthly pension pending the outcome of his lawsuit wasn't the same thing as retiring. Correspondence from the Department of Pensions to Williams referred to Williams' "pension," the court noted; it didn't matter that the correspondence did not also use the term "retirement."

Williams v. City of Los Angeles raises several important points. One is that you can defend yourself if you can show error on the part of the employee. Another is that as an employer, you have no obligation to inform an employee that he or she has made a mistake in handling pension matters.

"[The city] told [Williams] nothing to indicate that . . . he was laboring under a mistake [even though it] knew . . . that such was the case," the court said. "The city as involuntary defendant and adverse party to Williams had the right to defend the dismissal and owed no duty toward Williams to advise him of the consequences of the litigation."

ERISA as a Defense

Employers sometimes feel driven to distraction by the cloud of federal and state legislation covering employee benefits. But this cloud has a silver lining when it comes to firing certain employees.

The Employee Retirement Income Security Act of 1974 states plainly that when you offer your employees non-cash benefits like health insurance, you must protect the interests of all employees — even against those of a single one.

Thus employers use ERISA as a defense for firing specific employees who pose a risk to the benefits of the group as a whole. To date, most such disputes center on health insurance, but they can include any benefit offered to all employees, including pensions and ESOPs.

In the 1991 federal appeals case *Felton v. Unisource*, the employer used ERISA as a defense for its termination of an employee and almost carried the day.

Don Felton, a systems and procedure manager, had been with Unisource since 1978. In March 1986 he took a leave to fight lung cancer. Unisource, which self-insured its employee health benefits, paid some $39,000 for surgery and treatment.

Felton returned to work in May. In October the company fired him.

Felton filed claims with the Arizona attorney general's office alleging age and handicap discrimination

'Strong federal policy'

under the Arizona Civil Rights Act. Later, in November 1987, Felton and his wife sued Unisource in state court alleging breach of employment contract and wrongful termination. They contended that Unisource had fired Felton in order to avoid paying any more medical benefits.

In early 1988, the attorney general's office concluded that Unisource had discriminated against Felton because of a disability. It rejected Unisource's business reason for the termination — that the layoff was part of a workforce reduction — as a pretext.

It saw "reasonable cause" to believe that Felton had lost his job because Unisource wanted to avoid the costs of treating his cancer.

Unisource managed to transfer Felton's suit to federal court on the grounds that ERISA governed the dispute. Once in federal court, Unisource argued that ERISA's one-year statute of limitations barred Felton lawsuit.

The court agreed, dismissing Felton's claim.

Liberal State Statute

Felton appealed on a technicality. He argued that the law permitted him to cite ERISA in a civil claim in state court without subjecting him to ERISA's statute of limitations. Instead, he said, he was subject to the more liberal statute of limitations under the Arizona Civil Rights Act.

The U.S. Court of Appeals agreed. It ruled that the "adoption of a two-year limitation period is in accord with [the] holding that 'imposing too short a statute would interfere with the strong federal policy that underlies ERISA.'"

It reversed the district court's judgment in favor of Unisource and sent the case back for a new trial.

So Unisource lost the effort to dodge Felton's claim on the statute-of-limitations claim, but it did show that ERISA governed his claim. As the Arizona trial court noted in sending the dispute on to U.S. District Court, "It is well settled in this circuit that a wrongful termination claim based on the theory

that the employer intended to avoid pension or insurance payments is preempted by ERISA."

Since then, the U.S. Supreme Court has removed any remaining doubts regarding ERISA's preemption of wrongful termination claims. In *Ingersoll-Rand v. McClendon,* an employee alleged wrongful termination based on the employer's desire to avoid making contributions to the employee's pension fund.

The case began in Texas state court with Ingersoll-Rand asserting that it had fired McClendon as part of a workforce reduction. The Texas Supreme Court, hearing an appeal, held that McClendon demonstrated that the motivation for the termination was Ingersoll-Rand's attempt to avoid pension plan contributions. This, the Texas Supreme Court said, made it a common law claim to which ERISA did not apply.

The U.S. Supreme Court reversed, concluding ERISA preempted McClendon's common law action both explicitly and implicitly.

It noted that, under ERISA's broad language, "a state law may relate to a benefit plan, and thereby be preempted, even if the law is not specifically designed to affect such plans, or the effect is only indirect."

Trade Secrets and Proprietary Information

It's a good idea to review the trade secrets and proprietary information in the possession of an employee you want to fire. Trade secrets are a double-edged sword. They are the lifeblood of many businesses, and they pose a threat if the employee takes the information to a competitor.

The courts back the employer up here almost without exception, as the 1992 case *Vacco Industries v. Van Den Berg,* shows.

Tony Van Den Berg went to work for Vacco Industries in November 1961 and stayed until February 1984. By the early 1980's he had worked his way up to operations manager, and he was an officer of the corporation. He bought Vacco stock, accumulating a three percent interest.

Secrecy contracts hold up

Vacco made complex products for the military and the aerospace, petrochemical and nuclear power industries. Several of its products emerged as important to the litigation:

- A so-called "quiet manifold" used by the U.S. Navy on its nuclear submarines;

- A three-way bypass valve used on Navy submarines and surface craft; and

- A series of special filters used to remove contaminants from nautical engines and motors.

In August 1983, Emerson Electric agreed to buy out Vacco at $27.81 per share—about $23 million in all. In anticipation of the sale, Vacco signed employment contracts with key employees and non-competition agreements with 12 major shareholders, including Van Den Berg. The agreements would take effect only if the sale to Emerson went through.

A Three-Year Contract

Van Den Berg's agreement held him to employment at Vacco for three years at $80,000 per year. It allowed the company to fire him only for specified causes. In return, Van Den Berg agreed not to compete with Vacco for the lesser of five years or "so long as Vacco conducts the business within the territory."

On signing the agreement, Van Den Berg sold all of his shares to Emerson for about $500,000.

The company fired Van Den Berg in February 1984, despite his employment contract.

Just before, Van Den Berg had bought all of the stock of Kamer Solenoid, Inc., a Vacco subcontractor. According to Vacco, he had also:

- Received two boxes containing a complete set of Vacco's proprietary plans and drawings, including those for the quiet manifold, from his brother Jacob Van Den Berg (then employed by Vacco but later an employee of Kamer); and

- Instructed Vacco employees to break the welds on numerous "quiet elements" — a critical part of the quiet manifold — and put each sub-part of each element on a labelled index card with a pertinent description so that a complete configuration of each different quiet element would be set forth on the card.

Almost immediately following his termination, Van Den Berg began to solicit Vacco customers to sell them products through Kamer Solenoid.

One such customer wanted a control device of extremely detailed specifications. Kamer Solenoid's bid file contained a Vacco drawing with engineer's notes. The drawing showed a proprietary Vacco legend.

In March 1985, Vacco sued Van Den Berg and Kamer Solenoid. Among Vacco's allegations: breach of Van Den Berg's non-competition agreement, misappropriation of trade secrets, breach of fiduciary duty, and interference with business relations.

Van Den Berg filed a cross-complaint, alleging breach of good faith and fair dealing in Vacco's termination of his employment.

A Standoff

The case went to trial in May 1989. The verdict produced a standoff between the parties.

The jury found for Van Den Berg on the charge of breach of good faith and fair dealing. It awarded him $24,500.

Even so, the jury said, none of this invalidated Van Den Berg's noncompetition agreement. The jury awarded Vacco compensatory damages of $15,000 and punitive damages of $17,500 for Van Den Berg's misappropriation of trade secrets. It also gave Vacco attorney's fees of $526,360.

Van Den Berg appealed, arguing that Vacco had no protectable trade secrets that he could have possibly stolen, but the appeals court rejected his argument.

The smoking gun

Model secrecy policies

Van Den Berg, it ruled, obtained the product designs improperly. "The termination of Van Den Berg implicated only his contract for a term of employment and had nothing to do with his obligation . . . to refrain from a tortious invasion of the proprietary rights of Vacco," the court wrote.

Otherwise, the court said, every employee could justify theft from a former employer by establishing breach of contract or wrongful termination.

The appeals court found Vacco's policies for protecting its trade secrets legally compelling, so they stand as models for other companies seeking to protect their own proprietary information. Vacco's policies provided for:

- Using extensive internal security controls — for example, visitor logs, sign-out sheets for proprietary documents and a document destruction policy;

- Making lockable storage cabinets mandatory throughout the company, including the engineering department;

- Employing strict security control measures for documents made available to vendors or subcontractors;

- Prohibiting the use of detailed engineering notes, plans or drawings in manufacturing by outside parties.

Clear Warning

All documents shown to outside parties bore the following legend:

THIS DRAWING, PRINT OR DOCUMENT AND SUBJECT MATTER DISCUSSED HEREIN ARE PROPRIETARY ITEMS TO WHICH VACCO INDUSTRIES RETAINS THE EXCLUSIVE RIGHT OF DISSEMINATION, REPRODUCTION, MANUFACTURE, USE AND SALE. THIS DRAWING, PRINT OR DOCUMENT IS SUBMITTED IN CONFIDENCE FOR CONSIDERATION BY THE RECIPIENT ALONE UNLESS PERMISSION FOR FURTHER DISCLOSURE IS EXPRESSLY GRANTED IN WRITING BY VACCO INDUSTRIES.

Vacco fought Van Den Berg over trade secrets as defined in the Uniform Trade Secrets Act, which embraces the common law in defining trade secrets broadly to include:

> *Information, including a formula, pattern, compilation, program, device, method, technique or process, that:*
>
> *1) Derives independent economic value, actual or potential, from not being generally known to the public or to other persons who can obtain economic value from its disclosure or use; and*
>
> *2) Is the subject of efforts that are reasonable under the circumstances to maintain its secrecy.*

This definition compels the owner of a trade secret to work to keep it secret. You lose the protection of the act if you get sloppy. In contrast, the *Second Restatement of Torts* contains no such injunction. It says that a trade secret "may consist of any formula, pattern, device or compilation of information which is used in one's business, and which gives him an opportunity to obtain an advantage over competitors who do not know or use it."

Disclosure by Other Means

Most employers lose their trade secrets by theft, which is a crime. Some suffer embarrassment by other means — for example, in the courts in the course of post-termination lawsuits.

In 1993, Levente Csaplar, an insurance adjuster, took State Farm Fire & Casualty to court for wrongful termination. He challenged the big insurer's procedures for damage appraisal and questioned the competence of its adjusters. In the process he subjected the company to a nightmare of publicity.

Csaplar said State Farm fired him in 1991 for refusing to comply with unfair claims handling procedures after the Loma Prieta earthquake in Northern California in 1989. State Farm, in return, accused Csaplar of "gross misconduct and violation of claims handling" procedures.

Csaplar won the name-calling contest. He produced witnesses who accused State Farm adjusters

Missing evidence

of intentionally and severely underestimating damage claims following the earthquake.

Glenn Strong, a contractor, testified that company adjusters made "wild-ass guesses," often inspecting damaged homes without looking at foundations, in attics or on roofs. He said the insurer consistently underpaid claims.

A former office manager said her superiors at State Farm ordered her to resist paying claims "unless it would kill us in court."

Csaplar produced a confidential company document suggesting that losses had been severely underestimated in as many as 60 cases. In the memo, company officials expressed concern that contractors "could parade these people through the court showing the company lowballed these claims."

The memo went on: "The jury would then have to make a decision as to [contractor] overpricing versus our low estimating and it was felt we would not win on this issue."

Inexperienced Adjusters

Kevin Stockton, regional claims manager, acknowledged that the company hired inexperienced adjusters whose only training came in workshops run by the company.

The company's internal affairs investigator admitted that he had destroyed the notes that served as the basis for the allegations against Csaplar.

At one point, the trial judge threatened to throw State Farm attorney Jane Lennon out of the courtroom for unethical conduct. He saw her flashing signals to a State Farm employee on the witness stand.

In the face of all this, State Farm didn't have a chance. The jury ruled for Csaplar but awarded him only $21,634 in damages for lost wages. Lennon described the verdict as a victory. "I think that the jurors' verdict confirms that State Farm did a good job in resolving earthquake claims," she said.

The jury thought otherwise.

Jurors reported that they had engaged in much

fighting as they deliberated through a heat wave in a room with no air conditioning. They came within one vote of finding that State Farm had violated public policy, which would have allowed Csaplar to recover punitive damages.

"We were one vote away from screwing State Farm for three days," the jury foreman said. "I'm disgusted with the verdict. I think State Farm should get what they almost had coming. [It] did lowball everybody. Csaplar was right."

As a whole, insurers suffered a black eye following the Loma Prieta earthquake, as they routinely do in the wake of catastrophes. State Farm may not have revealed any trade secrets in fighting Csaplar, but it endured a spate of highly inflammatory publicity.

Most employers, faced with the prospect of such damage, would choose to settle a wrongful termination case like Csaplar's.

The Family Business

Few things complicate the picture more than the family-owned business, as the 1991 South Dakota Supreme Court case *Larson v. Kreiser's*, shows. The case addressed two issues: whether a family-run business owes special treatment to employees who are family members, and whether you make an oral contract by promising your son that someday he can run your company.

Kreiser's, a family-owned business based in Sioux Falls, SD, sold medical supplies. David Larson, the son of Harold Larson, the president and CEO of Kreiser's, wanted a part-time job while a high school student in the late 1960s. His father offered him work in the family business.

According to David, the father told the son that it was important to him that the business stay in the family.

In 1967, David began working in the warehouse, eventually becoming responsible for the warehouse crew. Then he learned the purchasing side of the business.

After high school, David went to college for one year

The tricky blood tie

in Sioux Falls while he worked part-time at Kreiser's.

In 1976, David transferred to Sioux City, IA to fill a sales position in a newly opened Kreiser's store. Two years later, Kreiser's general manager retired and David took the new position of operations manager. He became vice-president in 1981.

His father repeatedly promised him that one day he would be president of Kreiser's, David testified. But he produced no written contract and offered no evidence that he held employment for a specified term.

In 1986, David took three checks payable to Kreiser's and deposited them into his personal bank account. David admitted this and confessed judgment in the amount of $6,805.11 plus interest.

In January 1987, his father fired him.

Conflicting Claims

Later that year, David sued Kreiser's alleging breach of implied and express contract, wrongful termination, breach of fiduciary duty, and intentional infliction of emotional distress. Kreiser's countered that David owed it money — namely the money from the three checks — on account.

During the trial, Kreiser's lawyers tried to introduce evidence respecting the three checks, but the trial court wouldn't allow this.

At trial, the court gave the following instructions to the jury:

> An employer who promises as part of the employment agreement to employ a person in a specified position, such as 'president', is bound by law to discharge that person only for 'good cause.'

> These promises do not have to be made to the employee at the time of hiring, or be in writing, but can be verbal and can be made during the period of his employment.

> If you find that defendant promised the plaintiff that he would become president and if you find a reasonable expectation of getting that position,

and if you find plaintiff continued to work in reliance upon such promise, then you are instructed that there was an employment contract which could only be terminated for good cause.

In determining whether David Larson's employment contract with Kreiser's Inc. contained an implied promise that the employer would not act arbitrarily with respect to his employment, that is, would not terminate him without good cause, you may consider the totality of the parties' relationship.

The Family Relationship

By "the totality of the parties' relationship" the court referred to the fact that Harold and David Larson were father and son.

The trial jury awarded David $1.2 million and Kreiser's $7,888 on its counterclaim.

Kreiser's appealed, arguing among other things that an oral employment contract must offer a specific position at the inception of employment.

The South Dakota Supreme Court upheld most of the lower court's instructions, but ruled that the trial court should have allowed Kreiser to bring up the subject of the pilfered checks. It also questioned the jury instruction referring to the "totality of the parties' relationship."

It sent the case back for trial.

As shaky as the lower court's interpretations of family business ties may have been, the South Dakota Supreme Court did support the trial court's take on the strength of the father's promise of the company presidency. Wrote one of the justices: "The trial court correctly instructed the jury that a worker who is verbally promised future promotion to a specific position in exchange for his labor is not an at-will employee and may be discharged only for cause. This is good law."

Avoiding the sting

It doesn't stretch the point too far to exercise caution in what you say to your employees—even if they are your kids.

The Layoff

The axiom "hire individuals, fire groups" holds many attractions, not the least of which is the fact that the employee involved in a layoff doesn't feel singled out.

But some employers show such an aversion to firing people that they try to fool even themselves by confusing the termination with the layoff. The employer feels less sting, just as the employee does.

But layoffs and terminations aren't the same.

The greatest advantage of layoffs: You can claim business reasons for the termination — namely, that the layoff is part of a workforce reduction. Your biggest risk: Your employees may prove your explanation pretextual.

Technically, layoffs don't differ from any other for-cause termination. They certainly don't give you carte blanche to act any way you wish. Instead, you must follow your own procedures here as in any other termination.

Union contracts set terms for layoffs and stand as a good standard against which to measure any employer's procedures for layoffs. Among the most common union terms:

- Layoffs hit less-experienced workers first and proceed according to seniority;

- They must be occasioned by specific decreases in workload;

- They must be limited to specific, relevant job classifications;

- You must warn workers in advance;

- Severance packages must meet predetermined minimums; and

- Disputes must go to arbitration.

A number of cases show the care an employer must take in laying off employees.

In the 1992 U.S. Court of Appeals case *Zanders V. O'Gara Hess & Eisenhardt*, the company terminated Nathan Zanders in a layoff. But it gave no notice as required by policy, and the court found for Zanders.

In the 1990 New Mexico Supreme Court decision *McGinnis v. Honeywell, Inc.*, the company failed to allow an employee to "bump" another with less seniority, as allowed by policy. Shirley McGinnis had the option to take the employee's job, but Honeywell didn't make the offer.

McGinnis claimed that Honeywell sought to terminate her in retaliation for her efforts to explore certain alleged financial discrepancies that Honeywell, she said, wanted to hide.

The court ruled that a jury might reasonably find that "since the parties had signed an employment agreement containing a promise by Honeywell to lay off McGinnis only in accordance with certain procedures. . . . Honeywell's failure to afford McGinnis the benefit of those procedures was a breach of its express written contract."

Even so, the court noted that Honeywell's policy also allowed it to consider job performance in identifying employees suitable for "realignment."

In planning a layoff, make sure you:

- Document the economic reasons for the move;
- Hold exit interviews;
- Check that the layoff doesn't fall disproportionately on any protected group such as women or minority employees;
- Avoid the term "layoff" if you don't intend to bring the employees back;
- Keep in mind what human resources types call "DITO-DITA" — Do It to One, Do It to All.

Other Considerations

If you can, bring in your personnel people in a layoff to help your employees move on.

The long reach of the law

And whether it applies it not, pay attention to the federal Worker Adjustment and Retraining Notification Act (known by its acronym, WARN). The act requires employers of more than 500 people — as well as those employing more than five percent of the local labor pool — to give 60 days' notice of plant closings.

The courts can define the WARN Act in ways you might not anticipate. In March 1994, for example, a federal judge in Rhode Island ruled against Brown & Sharpe Manufacturing Co. in connection with a layoff in North Kingston. The company had given some employees only one day's notice before laying them off.

In the late 1980s, Brown & Sharpe created a new Consolidated Parts Department with the goal of reducing overhead. But by 1991 it became clear that overhead costs had not fallen enough. Brown & Sharpe struck a deal with another company to outsource the manufacture of certain products. It kept the deal secret from the affected workers — and promptly let them go.

Brown & Sharpe maintained that it had ordered neither a "mass layoff" nor a "plant closing" as defined by the WARN act and thus had no responsibility to provide notice to its workers. It noted that other departments in North Kingston continued to employ some workers from the closed operation who did the same work on the same equipment.

But the judge didn't buy that argument. "The evidence is clear that Brown & Sharpe considered the [Consolidated Parts Department] to be a separate organizational unit, and that it planned and executed a shutdown of that organizational unit," he ruled.

"The defendant's argument that no shutdown occurred because some of the work of the CPD was picked up by other operating units is without merit."

That made the company liable for damages, so it settled quickly — and quietly.

Special Situations

This chapter has studied the handful of special circumstances that complicate terminations more than others.

Not all apply to all employers. None may apply to you. But no assumption is safe when it comes to firing people, whether the individual is a cop reaching pension age, an employee-owner, an equity partner or a blood relative. When you fire someone, you send that individual's life topsy-turvy, and it doesn't matter whether things work out for the best in the long run or not.

What matters is the here and now — the passion, the bruised ego, the shattered confidence of the person who has just lost a livelihood. People in such frames of mind listen more to their guts than to their heads, and if you inflame them enough to send them to a lawyer, you make trouble for everybody.

Tread carefully — at all times.

The here and now

CHAPTER 12: THE ACT ITSELF

So you have made your preparations, reviewed your files, paved your paper trail. What do you do now?

You go face to face, look the individual in the eye, and say: "You're fired."

It's the most difficult part of the whole process, of course — the messiest, the most traumatic, the most painful. And it's easier said than done. You become the bearer of bad news, maybe the worst news your outgoing worker has ever heard. But you can't avoid it; the time comes to act.

Some employers plunge ahead with something less than total concentration at this point, allowing their frustration and anger to take control at the last minute and, as often as not, doing damage not only to the outgoing employee but to themselves as well. Others have trouble accepting the finality of things, and so thrash about for some way to put a nice gloss on what they do.

Set Speeches

But if there aren't any nice glosses, there are some set speeches to which you can resort if you can't think what to say. Human resource types suggest that you say:

"I hope this doesn't come as a surprise, but your services are no longer required by the company."

Or:

"Please sit down; I have some bad news for you. We have reached the point we discussed two weeks ago. I have decided that termination is in our best interest."

Or some variation on these themes.

The messiest step in the process

Paying for clumsy action

The first of these is the less direct; it works by implication. The second is the more forthright. Either gets the job done well enough.

The Challenge

The important thing at this point in the game—as at all others — is to follow some sort of procedure. In the 1993 federal appeals court decision *Censullo v. Brenka Video*, the judges ruled on a widely publicized case in which the employer seemed to have no procedure at all, not to mention a heart. The employer may have had the law on its side, but it acted so clumsily as to give itself a bad name—and a hard time in court.

In November 1989, James Censullo's wife gave birth to a gravely ill child. Doctors transferred the child from a local hospital near Manchester, New Hampshire to Boston Children's Hospital for surgery.

Censullo and his wife went with their baby.

Censullo worked as a sales manager for Brenka Video, a distributor of home videos, in the New England region. He had an employment contract through 1989.

Censullo's supervisor, David Bowders, contacted him in Boston about a week later and asked when Censullo would return to work. Censullo said that his son's condition had improved but remained tenuous.

Shockingly, Bowders told Censullo that he needed to "straighten out his priorities" and consider "whether it would be better to suffer one loss or two."

Censullo called Bowders' supervisor David Perrier, an officer of Brenka Video, who agreed that Censullo should separate his personal problems from his business responsibilities. A telegram arrived later that day informing Censullo that he'd been terminated for poor performance.

In November 30, an article appeared in the Boston Globe entitled "A Heart of Stone," detailing Censullo's termination.

254

The president of Brenka Video sent Censullo a telegram the same day, saying he'd reversed the termination. Censullo could continue to cash his paychecks and go on "administrative leave" until his son's condition improved. The president assured Censullo, "I will personally get back to you."

The next day, Brenka Video's controller sent Censullo a telegram, asking him to check in "regularly."

Censullo cashed two paychecks and kept two others. He never contacted Brenka Video again. On December 14, he received another communication terminating him again, this time for failure to comply with the terms of the administrative leave.

Censullo sued for wrongful termination and intentional infliction of emotional distress.

Brenka Video argued that only at-will employees can make claims for wrongful termination and that Censullo's employment contract disqualified him.

New Status

But the trial court ruled that Censullo's status had changed after November 24 to an at-will employee. The two telegrams relieved Censullo of the job he had contracted to do, and placed him in a "nebulous administrative leave status," the court said.

Thus the company could not fire Censullo under the terms of a contract that no longer existed.

The jury decided that the telegram from the president more accurately stated the requirements of the change in status. Censullo accepted the change in status by doing nothing and cashing his paychecks, as the first telegram asked him to do.

The court awarded Censullo $73,000 in damages from Brenka on the wrongful termination claim plus another $250,000 from Bowders on the emotional distress claim.

Brenka Video erred in trying to bully Censullo back to work and in allowing Bowders and Perrier to fire Censullo without any review. It made things worse by hiring Censullo back and then firing him again. This clouded the company's management and ter-

When contracts cease to exist

Outside the limits of convention

mination processes and gave the company a big dose of bad publicity.

No employer should have to carry a nonproductive worker, but Brenka Video stepped outside the limits of conventionally acceptable behavior by responding harshly and then indecisively to Censullo.

You can't spend your days trying to anticipate what a jury might decide in any possible lawsuit your employees might file. On the other hand, you should realize that the courts tend to make certain assumptions about the employer/employee relationship.

"It's a lot of common sense," says one of the attorneys who worked on the Censullo case. "Before you act, stop a second and step back. How would an average working stiff look at this? [Brenka Video] fired a decent worker who was staying with his wife and dying baby son. They had a manager who acted like an ass. . . . There's no court in the country that's going to let that slide."

The intensely personal nature of a termination assures that vicarious liability will always be an exposure. You run the risk — as Brenka Video did — of facing liability for your weakest manager's mistakes. That's why larger companies usually set strict policies for who can fire employees and how they can do it. Small companies benefit from following this lead.

Voluntary Resignation

It's best to be truthful and discharge an employee who deserves it. Sometimes, though, you might consider allowing the employee to choose between quitting and being fired.

The employee who chooses to resign saves you from a variety of exposures, including wrongful termination claims in all their various forms.

Why should an employee agree to resign? Because you make this option attractive. You can offer assistance in finding another job, for example, ranging from the use of office facilities to positive recommendations to new employers. You can also offer an employee some form of compensation — generous

severance pay or vacation allowances, perhaps a limited employment contract.

In exchange — and as a condition of the severance benefits — you get the employee's signature on a legal release of all claims against you.

Don't overestimate how attractive voluntary resignation will be to an employee. Most employees know that workplace laws make them ineligible for such things as unemployment benefits if they resign voluntarily. And five minutes with a lawyer is enough to inform them that they damage their chances of prevailing in court if they leave the job voluntarily.

But for the employer, it's worth a try anyway. In most cases, these tactics work better with white collar management or professional employees than with hourly workers. White collar people have a sense of career investment and so an incentive to avoid a termination.

But even though you get a voluntary resignation, if the employee can show later on that you initiated the action, the courts will probably consider it a discharge.

In addition, if you press an employee too strongly to resign, you may face so-called "constructive discharge" claims — an increasingly popular claim among labor lawyers. In this version of wrongful termination, an employer intentionally creates intolerable work conditions in order to force a resignation.

Making Bad Things Worse

You can't count on a voluntary resignation to protect you from all exposure, however. Sometimes the suggestion only worsens a troubled situation.

In the 1991 Tennessee case *Frye v. Memphis State University*, MSU[1] gave professor Ronald Frye the chance to resign in the wake of an administrative hearing into allegations that he had made improper use of MSU computer resources for personal gain.

[1]See Chapter 13

A good strategy for any employer

He didn't accept and, following extensive hearings, a faculty committee unanimously recommended Frye's termination.

The Tennessee courts eventually agreed with Frye's claims that he'd been wrongfully terminated. MSU's efforts to force a voluntary resignation — while never a central issue — only strengthened the court's decision.

Sometimes you must work hard to convince a problem employee to move on. In 1992, for example, city officials in Los Angeles sought to fire Police Chief Daryl Gates in the wake of the Rodney King police brutality trials. But Gates was a civil servant protected by complex civil service laws.

So — behind the scenes — bureaucrats in city hall began a methodical review of Gates and the laws that protected him. They engineered things so as to make Gates feel so isolated from the politicians and his own police officers that he would resign.

They undermined his access to the city council and mayor. They made talk of his plummeting effectiveness a self-fulfilling prophesy.

Soon the stubborn Gates realized that he couldn't operate effectively. He agreed to negotiate a diplomatic withdrawal.

Throughout, the city had to take care not to violate any of the laws protecting Gates — a good strategy for any employer seeking to root out a problem worker.

The Key

As we argue throughout this book, the key to protecting yourself from litigation lies in the discipline and consistency you show in applying your policies respecting termination. You must establish and follow procedure so as to ensure that you treat everybody fairly and, if necessary, defend your actions in court.

The body of law dealing with hiring and firing gives employees a lot of reasons to sue. Whether a specific employee actually does sue often depends how that worker feels upon termination. Your job, as the employer who has decided to fire an employee, is to

make things go as smoothly as possible.

Your managers should know what to do at every step: regular review, accelerated review, the warning, and finally the termination. They must know and stick to the penalties leading up to termination. But they can't follow guidelines too closely. Chevron Corp. warns managers in its guidelines to "follow your script, but avoid reading it."

Time of the week and location are important. Friday firings are considered taboo. Early in the week during the lunch hour is good — but never over lunch itself. This gives the employee the rest of the day to make arrangements to clean out his or her office later in the week. The best location for the firing is neutral territory — for example, an empty boardroom. If that's not possible, seek territory where the employee feels comfortable — perhaps the employee's own office.

Different Workers

The combinations of time and place vary from division to division within your organization, and according to the type of employee you're terminating. You handle a marketing vice president differently than an entry-level production worker. But make sure that you can defend your procedures in court, no matter how different: Be fair and as consistent as you can.

To this end, most employers keep the job of firing people in few hands. If you delegate to line managers, make them file reports that explicitly review how well they follow standard procedures in firing every worker. Some employers allow line managers to discharge employees only with approval from the personnel department or upper management. This aims—and usually succeeds—at avoiding angry or emotional extremes which lead to litigation. It also relieves the manager doing the firing of some stress.

A good point to remember: Hire individuals, fire groups.

You decrease your exposure to wrongful termination claims if you let people go in small groups. In the eyes of employment law, there is no huge difference

The layoff as strategy

between an at-will termination and a layoff. In the eyes of workers, though, there are big differences. If you let several employees go at once, the blows seem softer. The workers share the experience — often a help to everyone in the group. If you fire one individual, on the other hand, you isolate him or her.[2]

Red Flags

You may want to set up red flags at certain points in the procedures you establish to warn line managers that they must refer the termination decision to you. In any case, make sure that the terminated employee gets a written statement of the reasons for the action. In addition:

- There's no legal bar to giving employees a list of reasons for which they may be discharged. Indeed, such a list can reduce employee fears about arbitrary actions by the company. Your employee handbook should also state, however, that the list functions as a guide only and that you reserve the right to discharge an employee for other reasons.

- Double check the at-will status of every employee you fire, but be especially sure with employees of long standing. Those who have worked at the company a long time may make the case that they had a reasonable expectation of continued employment. More than any other group in the last ten years, workers over 50 have littered the legal landscape with age discrimination claims.

 With such people, make sure that you establish cause for firing, and don't advertise for a replacement at a lower salary immediately after termination.

- Employees hired under any program designed to comply with federal anti-discrimination law may try to show discrimination in your termination procedures. In these cases, your best defense is a well-documented cause for firing.

- Employees who file workers' comp claims may make charges of retaliatory discharge if you fire them soon after the claim. Document the

[2]See Chapter 11

causes for your termination scrupulously or hold off on the termination until the employee completes rehabilitation.

If you have to fire someone in a red flag category, have the employee sign a release absolving you of liability for wrongful termination. These releases can be defeated in court, but they add a barrier that attorneys prefer to avoid.

Put Yourself in the Employee's Shoes

You avoid making impassioned decisions if you keep an objective perspective during the termination, and you foster objectivity if you follow procedure. Putting yourself in the position of the employee can help establish what your procedures should call for.

For example, most employees know when they aren't meeting goals and expectations. If you assume that they don't know this, or treat them as if they don't even when they do, you breed antagonism.

You rarely take the individual by surprise when you fire someone. Instead, you usually find the individual worrying most about money and benefits. The employee wants to know how to keep health care benefits[3] while looking for another job, and how to pay the mortgage.

So have an outline of your severance package ready for the termination interview. If you can, adjust the package to meet the specific needs of the individual; this makes things easier for everyone involved.

Give the employee a moment to defend his or her performance and accomplishments even if you have already made up your mind. Be businesslike, but don't be callous. Be willing to listen to some degree.

Some employees react by negotiating; they ask for more severance, extended benefits, outplacement help. Don't be annoyed by this — use it. Letting the

Workers usually know what's coming

[2]An important note: In some states, you have to offer a terminated employee some or all of the benefits he or she received as an employee — at his or her expense. In others, you have to make this available to ex-employees only if they ask.

261

Stay calm against emotion

worker feel that he or she squeezed extra benefits out of you sometimes helps the individual to move on quickly, without calling an attorney.

And remember that even if you rarely take the employee by surprise, the termination interview always generates strong emotion. Don't fool yourself into expecting the employee to take termination with a smile. Instead, expect anger and let it vent in the quickest possible manner. Keep calm; if you prepare well, you control the interview. You don't have to prove you're the boss. Nothing proves that more than the facts at hand. Don't fear letting the employee sound off. One or two angry words now may mean one less lawsuit later.

Mistakes to Avoid

It all sounds simple—be honest, be professional, be considerate, be brief — but it requires more than platitudes to carry things off when you fire someone. Indeed, the subtleties defy easy explanation, but they become clear when you contemplate the examples of others who don't carry things off well.

Through the spring of 1993, the California utility Pacific Gas and Electric Co. went through some brutal down-sizing. The business cycle and deregulation forced it to fire more than 11 percent of its work force.

PG&E had never undertaken such staff cutting before. In fact, it prided itself on the job security and generous benefits it offered employees.

But the company had little time to cut kindly.

Some nervous managers ran into trouble when they followed company guidelines too literally and ended up reading a script. The company abetted these problems by printing the guidelines in a script format.

Laid-off workers angrily complained that managers treated them badly. One employee learned that he'd been fired through a posting on a department bulletin board. Said another: "My boss read from a script and told me not to return to my office. It was incredible."

Also incredible was a guidebook which advised managers to expect "the fight-or-flight response typical of animals under siege." The analogy insulted workers, and it wasn't even valid.

The handbook also advised: "Before terminating someone, determine whether that person could easily overpower you or has a belligerent nature. In that event, ensure that you have a witness." This assumed the worst of the employees. It also assumed that managers would fire employees without a witness present — a huge mistake in any case.

The company countered some of its errors by hiring a well-known outplacement firm to help people find new jobs. It also tried to encourage voluntary retirements by offering lump-sum and benefits bonuses of up to 30 percent to long-term employees.

In the end, the layoffs left PG&E with a major public relations problem and a slow trail of wrongful termination suits.

Common Mistakes

A brief list of common mistakes you should avoid:

- Firing in December. As cliched as this may sound, courts generally look unfavorably on firings carried out just before the holiday.

- Writing a positive letter of reference for an employee whom you fire for cause. Don't offer any such letter, or decline if the employee asks, when you fire for cause.

- Trying to document a just cause case that doesn't exist. The courts usually see through such shams; it's better simply to give notice and offer a fair settlement.

- Firing a worker to whom you have just given a merit raise or a favorable performance review.

- Disassociating yourself from the firing decision during the termination interview. You invite a lawsuit if you tell the employee you're sorry or that you think your line manager — or whoever made the decision — erred.

The 'flight or fight response'

Stick to the facts

The termination notice — the written back-up for the termination meeting — is the single most important link in the paper trail. Keep it as simple as possible, and stick to a predetermined form.

Copies of the termination notice should go to the employee's immediate supervisor, to your payroll and employee benefits administrators, and where appropriate to compliance officers or labor organizations. The employee gets a copy, too, of course.

The letter should state:

- The name, social security number and any other identification relevant to the employee;

- The date of termination;

- The contractual obligations, if any, owed the employee; and

- The name of the supervisor who approved the termination.

The Option

Anything more than this — for example, the reasons for the termination, severance terms or exit interview questions — remains optional. Sometimes it makes sense to go into great detail, as the city of San Diego found in terminating a longtime police officer.

Richard Draper had a long record of problems with the San Diego police department. Over a 10-year career, his name appeared in some 25 citizen complaints alleging excessive force or violent confrontation.

The police department fired Draper in May 1988 after he failed to heed repeated warnings to end his "continuing pattern of misconduct."

The catalyst for the action: an incident in which Draper allegedly pistol-whipped and threatened to shoot a college student during an off-duty altercation.

The formal notice of termination noted that the department had warned Draper about his conduct and had even suspended him for "overly aggressive behavior."

"The latest incident is another in a continuing pattern of misconduct by you," Police Chief William Kolender wrote in the notice. "In each incident, you have displayed serious problems with your judgment and with your interactions with the public. Despite counseling by supervisors and a warning that additional misconduct would result in more severe discipline, you have continued to lose your temper and use excessive or unnecessary force to gain compliance with your demands."

The Details

The notice detailed the incident that led to Draper's firing:

"While off-duty, you pursued Scott McMillan at speeds reaching 100 miles an hour for cutting you off while you were driving your private vehicle. . . . You did this in moderate to heavy freeway traffic, interfered with the operation of other vehicles, and endangered the safety of other motorists."

Draper overtook McMillan, forced him to a stop, identified himself as a police officer, "pointed a loaded revolver at him, yelled profanities and, although he [McMillan] was passive, forcibly removed him from his vehicle," the chief wrote.

The notice charged Draper with violating five SDPD policies:

- Unsafely handling his revolver, causing him to strike McMillan on the head;

- Using unnecessary force by bending McMillan over the hood of the vehicle and tearing his shirt;

- Engaging in a "groundless high-speed pursuit" on the highway;

- Acting rudely and discourteously; and

- Displaying conduct unbecoming of an officer "by being overly aggressive, obviously angry and, according to witnesses, irrational and out of control."

The notice cited three other occasions for which Draper had been reprimanded for im-

proper behavior. "On each of these occasions," it read, "you were counseled that further instances of misconduct would result in more severe disciplinary action."

Taking Pains

The San Diego Police Department took pains with Draper's termination because it was a public entity embroiled in a very public scandal. Most employers don't need to go into such detail, but if you anticipate complications, you might want to add to your termination notice these elements of the SDPD's formula:

- Identify the employee in question, the date and the fact that the letter is a termination notice;

- Describe the background circumstances (including infractions and responses) that preceded your action, including events leading directly to the termination; and

- Explain how the circumstances show that the employee violated established policies and procedures.

This kind of detail assumes that you will have to show cause for the termination and defend your action. This defensive position may frustrate you, since it gives away your at-will prerogative. But it leaves the terminated employee no legal choice but to prove that the reasons you give are pretextual.

As we've seen before, that's tough to do.

Here are 16 steps to take when firing a problem worker:

1) Whenever possible, fire the worker in private, not on the shop floor.

2) The more rushed or impassioned you are, the more likely you are to make a mistake. Firing people on the spot can be an expensive indulgence.

3) Give a written termination notice to the employee after you've spoken with him or her. The notice should review disciplinary history,

events leading up to the termination, and the cause — if you choose. It should list procedures that the employee should follow after the meeting.

4) From the termination list, make your own checklist of things to do after the meeting.

5) Apply your rules, policies and penalties consistently and accurately. When you fire for cause, make sure you have all the relevant facts. Review them carefully and prepare to explain how they violate or fail to satisfy company policy. Review the employee's history. Review your own practices to make sure that this termination matches past practice for similar misconduct.

6) Avoid scheduling the meeting at the end of the work day, the end of the work week, just before a holiday, or just after the employee returns from a business trip.

7) Find a neutral location. Using a supervisor's office attaches a stigma to the location for employees who remain.

8) Have at least two people in the room in addition to the employee — the immediate supervisor and someone with whom the employee does not have a day-to-day relationship. The neutral person should act as a witness, present to listen and only to speak in an emergency.

9) Deliver the news and answer questions without engaging in an argument. Say what you need to say and nothing more. Work from prepared notes, if necessary. Don't ramble; it's too easy to use words or make promises that you'll regret later.

10) No matter what the employee's response, remain calm and stay in control of the conversation. Listen to what the employee has to say, but never get angry or loud just because the employee does. Treat fired employees with fairness and tact.

11) Be prepared to discuss severance terms but, if possible, reserve the matter for another meeting.

Make your move in private

267

Don't send mixed messages

12) Avoid the "brass-knuckles-with-velvet-glove" approach — offering emotional support in the midst of the termination interview. Don't send mixed messages. Don't give career advice to someone you've just fired.

13) Avoid euphemisms like the term "layoff" because they lead to misunderstanding. A "laid off" employee may expect to come back. A fired employee doesn't.

14) If at all possible, offer the employee some type of assistance in finding a new job. This helps the employee at relatively little cost to the company, and it also reduces the chance that the employee will sue by mitigating claims of bad faith.

15) Write up an accurate record of the termination interview. Pass a copy on to the terminated employee.

16) Notify all managers and employees affected by the discharge that you have fired the employee.

Severance Packages

Severance payments, although expensive, may be your single best means for avoiding litigation. Needless to say, it takes negotiating to settle on any severance payment and to tie it to an enforceable release of all claims by the executive.

Severance pay isn't usually an issue for contract employees since the terms of separation usually appear in their contracts. For other employees, the least you can offer is accumulated vacation and benefits. Most employers offer two weeks of pay per year of employment. Many offer more money or non-cash benefits like insurance coverage, outplacement counselling or the use of facilities for a job search.

The premiums paid for the extended insurance are insignificant compared with the potential expense of a lawsuit. The same goes for severance pay, especially for longer-term employees, even if discharged for cause.

As for offering increased severance benefits as an

incentive for the fired employee to sign a liability release, proceed carefully here. You want to avoid appearing to coerce the release or to promise more than you deliver.

An Arrogant Termination

In the 1991 Connecticut case *Sperry v. Post Publishing,* a federal court penalized an employer for a particularly arrogant termination involving a liability release.

Post Publishing owned three newspapers in the Bridgeport, Connecticut area. The company showed excessive operating costs — primarily because of a longstanding, unofficial policy that it would never fire workers. In 1988, the company began exploring early-retirement packages with older workers.

Post Publishing fired Frank Sperry in January 1989, as part of its downsizing efforts.

Sperry accepted the terms of a separation agreement and signed a general release. In return, he received severance pay totaling $28,840 and a six-month continuation of his group medical and life insurance coverage.

Sperry sued after he applied for unemployment benefits with the Connecticut Employment Compensation Commission. The state said that Post Publishing had classified his termination as a business-related layoff — therefore, not grounds for collecting unemployment.

Sperry based his charges on three premises:

- That Post Publishing Company had unlawfully fired him pursuant to the Age Discrimination in Employment Act;

- That he suffered damages and emotional distress due to false statements Post Publishing made to the CECC; and,

- That Post Publishing breached his employment contract.

Post Publishing sought to dismiss the claims. It argued that the lump-sum severance payment given

The 'bait and switch' scheme

to Sperry and the release he signed constituted a "voluntary separation" that precluded any wrongful termination claim.

A federal court rejected that argument. Sperry's lawsuit explicitly contested the "voluntariness" of the release he'd signed.

Next, Post Publishing argued that Sperry couldn't sue because his acceptance of the severance payment constituted de facto acceptance of terms.

The court also rejected that argument, ruling, "Such a draconian policy would encourage an employer planning a wrongful termination to offer some form of token compensation, and thus defeat [any legal] action."

It agreed to hear the ADEA case — which Post Publishing promptly settled — but ruled that a state court would have hear the other charges.

Heavy-Handed Treatment

Post Publishing used its severance packages as a kind of "bait-and-switch" scheme to convince employees to resign. It said it was firing them, then tried to have them resign. Worse still, it acted in a heavy-handed manner toward a longtime employee, tinkering with the truth enough to leave him feeling abused.

If you use severance packages to convince employees to leave, do so honestly. You don't break any laws by acting arrogantly — but your lawyer's bills tend to rise when you do.

An earlier Connecticut case, referred to in *Sperry*, went more favorably for the employer. In *Grillet v. Sears*, an employee received a substantial severance pay package in exchange for a release. A year later the employee brought suit, claiming that Sears had misrepresented the release and that she had signed it under duress.

In the meantime, of course, she had received the severance pay.

The court went against her, ruling that her acceptance of the severance pay effectively ratified the

terms of the release she had signed. In order to press her suit, the court said, she would have to return the compensation to her employer first.

The lesson here is that you can accomplish the same ends that Post Publishing sought. You can use severance payments to encourage resignations from employees in exchange for agreements not to sue.

Just do it in a straightforward way.

Some employers give a fired employee the chance to take the severance package to a lawyer. This establishes goodwill and tells the employee that you believe in your offer.

Exit Interviews

A 1991 study of 672 members of the Society for Human Resource Professionals, a trade organization based in Virginia, found that 96 percent of their companies used exit interviews.

Workers in smaller companies had high participation rates in exit interviews. Of companies with fewer than 500 employees, 74 percent reported they nearly always used exit interviews. This compared to 62 percent of those with 500 to 999 employees and 56 percent of those with more than 1,000 employees.

Some employers admitted that they ensured attendance by stipulating that employees pick up final paychecks at their exit interviews.

The exit interview allows you to outline the employee's pay, severance, or pension and benefit options. It can defuse a potentially explosive situation by letting anger and frustration vent. And it can highlight policies or practices on your end that suggest bias or unfairness.

Some guidelines for bringing off an exit interview well:

- Make the terms of the interview fairly standard. You may choose to use different interviewers in different circumstances. Make sure they ask relevant questions.

Severance package in exchange for a release

- In the case of a termination, have someone other than the firing manager conduct the exit interview. If a line manager does the firing, you may want a more senior person (or yourself) to handle the exit interview. If you handle the firing yourself, have an underling talk to the employee.

- Invite departing workers (fired or not) to talk candidly about your company. Keep the discussion voluntary, but confidential. Assure the employee that what he or she says won't cause you to withhold a good reference or other benefits you've already agreed upon.

- If possible, keep the exit interview separate from the meeting in which you actually fire the employee. Give the employee time to read his or her termination notice, consider the reasons for termination, and, in some cases, calm down.

- If necessary, conduct an exit interview over the telephone or in the form of a letter.

- Ask the employee to voice any concerns or complaints. This allows the employee the opportunity of complaining without filing a legal complaint or lawsuit.

Neutral Parties

Consultants recommend using a neutral third party to conduct exit interviews. And they present themselves as candidates, of course. But if you can afford the cost, an outsider can become useful in exit interviews. Strong emotions become less likely to disrupt the process; employees speak honestly if they don't have to face the boss.

Another important point: The exit interview should inform the employee about what type of personal reference he or she can expect. Lawsuits claiming libel, slander, invasion of privacy, and intentional infliction of emotional distress often occur when fired employees are surprised by what former employers say in references.

Ultimately, the exit interview has a twofold purpose. You want the fired employee to vent frustrations and air grievances. You also want to document the state of mind and physical well-being of the former employee as he or she leaves your company.

A Clear Understanding

In cases of skill or disciplinary problems, exit interviews can ensure that everyone walks away clear about why you fired the employee.

Questions often asked in exit interviews:

- Did you have a clear awareness of the firm's policies and procedures?

- Did the firm apply its policies consistently?

- Did you understand your job responsibilities?

- Did supervisors treat you fairly?

- Did you feel you used your skills to your highest potential here?

- Did equipment and facilities match your needs?

- Did your job match your expectations?

- Were compensation and benefits levels fair?

- What did you like least about working here?

- What could the company do to make it easier for other employees?

- Would you recommend this as a good place to work?

- What would you change?

- What was it like to work for the organization?

You should state plainly to exiting employees during the interview that you want honest feedback.

If you don't interview your exiting employees regularly, you miss out on useful information. With exit interviews, you get a clearer picture of how your company comes across to its employees and how it might work better. You may never hear more candid, insightful criticism.

An intensely personal process

In the end, firing an employee is an intensely personal process. No single method stands out as the best way to do it. No magic phrase makes it easy.

But you must act. Remember that your object in firing an employee isn't retribution or revenge or letting the employee know what you really think. The object is to get rid of a problem.

From this perspective you can see that you hold most of the cards in the game. So keep your head, and don't run afoul of the common sense guidelines that emerge from case law and the conventions of ordinary decency. Don't spread the word about a firing before it takes place. Don't fire an employee on the spot or in anger. Don't fire the employee in public or in humiliating circumstances.

In all but the most risky situations, don't take actions involving the employee (changing locks, canceling perks) until he or she's been told.

The Basics

Be honest and straightforward about telling the employee your decision. Stay calm.

Some explanation of how you've reached your decision may be in order — but decide beforehand what you will say and stick to that. Give the fired employee time to respond and recover. Don't let a few harsh words upset you.

No matter how small your operation, set up the exit interview with another (preferably uninvolved) manager or a third party. This is the main vent for the employee's anger or frustration and the main tool for ending the paper trail.

If you plan carefully, set policy wisely, hire scrupulously and manage well, the firing process becomes much easier. Sometimes it comes as an anticlimax.

But don't count on it.

CHAPTER 13:
AFTERMATH

Many employers find firing an employee so difficult that, once they've done it, they heave a sigh of relief and consider the problem solved.

But your task isn't quite over yet.

You must still figure out what to say to those employees who want to know what happened to their departed colleague, and to other employers to whom your former worker goes looking for a job.

And don't underestimate the problems your former employee can cause even if he or she doesn't sue you. People tend to stay in the industries and geographical regions they know. Your problem worker may land a job with a competitor or a customer. If the individual feels badly treated, he or she could cause you some trouble.

Two Risks

In general you face two risks from the departed employee — those linked to the way you fired the employee and those created by the fact that employee has moved on.

As a rule, the former show up in the form of lawsuits, the latter in more subtle ways. Either way, you can minimize both risks by making the right preparations.

First, you need to communicate what has happened to the rest of the company and to outsiders. This may entail doing damage control.

Second, you need to decide what to say if other employers come calling for reference checks.

In all of this you should think critically about how you fired the employee. Did you leave any loose

How to spread the news

The glare of publicity

ends? Did you create legal exposures? This process will help you know whether to fight or settle any lawsuits that might crop up.

The Challenge

In 1991 and 1992, the city of Cleveland and Cuyahoga County, Ohio discovered the perils that arise when publicity highlights your personnel policies — or as is this case, the absence thereof. The case involved the city and county in a running battle with the executive director of the Cuyahoga Metropolitan Housing Authority, who had done some messy — and secret — housecleaning at the CMHA.

In September 1991, the CMHA discovered that Claire Freeman, its executive director, had spent more than $500,000 of county money on severance payments for a host of people who left the housing authority over one year — all without informing the housing authority's board of directors. Federal officials investigated, and the housing authority found itself facing litigation.

A few examples of Freeman's excess:

- She spent more than $200,000 to settle charges made by Cynthia Ward, a $47,250-a-year bureaucrat who sued CMHA after contending that Freeman failed to follow CMHA termination guidelines.

- She spent more than $40,000 on a severance package for John Hornsby, a $55,000-a-year procurement chief whom Freeman had hired only a year earlier.

- Eric Brewer, a public relations director, received a $38,000 settlement, an amount equal to his salary. Brewer, like Ward, said he was encouraged to resign because Freeman doubted his loyalty.

- Bernard Buckner, deputy director for housing, received a $25,000 settlement. He was earning $55,000 a year when Freeman told him to resign or be fired.

- Gail Livingston, a former interim CMHA director, received a $25,000 settlement. Livingston made $50,000 a year when she left.

- Jeanine Herblot, a $43,000-a-year aide to Buckner, received $12,000 after CMHA laid her off. CMHA spent another $3,081 on legal fees associated with an arbitration concerning Herblot's layoff.

Ward's firing stood out as the most costly step of Freeman's aggressive housecleaning.

An independent arbitrator ruled in favor of Ward, noting that "[Freeman] could not recall telling [Ward] anything specific that was wrong with [Ward's] work."

After the decision, CMHA and Ward agreed to a $125,000 lump-sum settlement.

Legal Fees

In addition, CMHA paid the law firm of Weston Hurd Fallon Paisely & Howley $55,948 to represent it in the Ward case. CMHA paid another $4,600 to the law firm of Jones Day Reavis & Pogue for representation on the same case, plus arbitrator's fees of $12,154 and court reporters' costs of $3,831.

And it lost the case.

"This was a brutal, foolish and wasteful termination of a valuable employee," Steven Sindell, Ward's lawyer, said. "Freeman chose to squander huge sums of money trying to justify her wrongful termination of Cindy Ward rather than utilizing this competent and committed person for the benefit of CMHA."

The severance payments strained the relations between Freeman and several members of the CMHA board. Chairwoman Louise Harris said she didn't learn about the Ward settlement until long after the fact.

Freeman argued weakly that CMHA had no policy on severance payments and no policy requiring

Lawyers tailor their cases

board approval of such expenditures. She said she had seen no impropriety in making the settlements without board approval.

Through all this, Freeman managed to keep her job as the CMHA board backed away from a possible confrontation.

Fight or Flight

Most employers follow the same course — and face the same dilemma in handling trouble that crops up after they fire people: When do you settle a case? When do you fight it in court?

Insurance companies offer some insight into the difficulty of dealing with post-termination lawsuits. As a rule, they settle at around three times the former employee's salary. They go as high as five times salary in cases alleging discrimination against protected minorities or in states such as Texas and California, known for big awards. [1]

Plaintiff's attorneys know the settlement formulas used by various insurers better than some insurance people themselves, and they tailor their charges to elicit quick settlements. This means avoiding clients who make less than $30,000 a year. It also means cultivating clients who can allege discrimination and fraud.

For this very reason, some employers choose to go without liability insurance. "Why make it easy for those jerks?" says a risk manager for an Illinois-based industrial manufacturer that goes without. "If they want to sue, I want them to know we're going to fight."

Other employers worry about the odds against them; a Rand Corp. study showed that 80 percent of all wrongful termination claims end up in a judgment or a settlement favoring the plaintiff. To such

[1] A caveat: Most employment liability insurance policies exclude coverage for activities involving criminal wrongdoing. Most attorneys know this and avoid charges that allege wrongdoing. But even if criminal allegations are only one charge of many, you may have trouble convincing your insurance company to settle.

employers, the high odds make buying insurance a good idea as a means of financing the risk.

When you consider settling a complaint, keep the three-times-compensation rule in mind. Every complaint comes with its own nuances, but if you don't want to pay that much, get ready for a fight. Get ready to spend some money, too; it costs $80,000, on the average, to fight a given case.

Heavy-Handed Tactics

In April 1993, a Texas psychiatrist accepted a $250,000 wrongful termination settlement from the Austin-Travis County Mental Health and Mental Retardation Center.

Dr. Robert Taylor was fired from his $105,000 staff position in September 1991 by his chief executive, John Brubaker. When Taylor refused to leave the premises immediately, Brubaker summoned police to escort Taylor to his car.

"That decision alone cost [MHMRC] a hundred thousand dollars — or more," says one Dallas area psychiatrist.

Brubaker's treatment of Taylor caused serious problems. Taylor sued MHMRC for wrongful termination and intentional infliction of emotional distress. Staff physicians held several press conferences in which they criticized MHMRC management. Several quit in protest.

Brubaker defended his firing of Taylor on the grounds of "management differences."

That didn't stop the revolt.

MHMRC hired an outside auditing company to conduct a management study. In June 1992, the auditor concluded that the MHMRC engaged in possibly illegal employment practices and had an unprofessional management system.

In July, Brubaker resigned.

The new management never seriously considered going to court with Taylor. Still, it waited several months before settling, to let the problems drop out of the public eye.

Taylor, now working at another hospital, called the $250,000 fair "given the circumstances." He said that being led away by police implied he had "probably done some criminal activity or represented some serious threat to people."

Mary Alice Cruz, legal director at MHMRC, called the settlement "a good, constructive conclusion to a very trying time in the center's experience." But she added: "Our position was defensible."

She was probably right. Taylor held at-will status in a state that defends the presumption. But MHMRC still erred in calling the police to remove him from the premises.

The Flip Side

In another case showing the flip side of the issue, the California-based Jet Propulsion Laboratory won a significant post-termination legal battle at about the same time of the skirmish between MHMRC and Robert Taylor.

Greg Richard, a black engineer, spent two years trying to prove that JPL discriminated against him and violated affirmative action laws when it laid him off in 1990.

JPL argued that budget constraints forced the layoff. It kept scrupulous records from the day it hired Richard to the day it released him.

Richard sued JPL for $200 million, charging discrimination and breach of contract. JPL prevailed by fighting back aggressively and denying any improper behavior.

Richard lost his last bid to air his complaint in April 1993 when a federal judge dismissed his breach of contract claim. The court had dismissed four counts of racial discrimination earlier the same year.

"There's no middle ground when you're facing racism charges," says one attorney involved in the JPL case. "You have to fight all-out or settle quickly. Any hesitation might be perceived as an admission."

JPL refused to disclose how much it spent fighting Richard. But $100,000 — probably a high estimate — looks good compared to the $250,000 spent on discrimination claims on the average. Costs may rise to seven figures if the plaintiff wins punitive damages.

Where the Money Goes

The awards in post-termination complaints go to front pay, back pay, and punitive damages, plus legal fees. The courts define front pay as "the amount of salary agreed upon for the period of service, subject to the duty of mitigation."[2] Most state and federal courts recognize that front pay can extend into retirement.

The period of service remains a separate — and hotly contested — issue.

It's easier to calculate back pay. It includes salary and benefits that would have accrued to the employee between the time of the disputed termination and any court decision or settlement.

As for punitive damages, they remain every employer's nightmare. The courts use punitive damages to make examples of employers who act illegally or unethically in dismissing employees.

In the process they sometimes make law that doesn't exist anywhere else. Critics deplore the wonderland this creates, and they write long books describing it. Meanwhile jury awards climb. One 1992 study noted that the average wrongful termination jury award surpassed $1.3 million — up 300 percent over five years. And punitive damages may mutiply actual or compensatory damages many times.

[2]The federal appeals court case *Boehm v. ABC* illustrates some ground rules concerning front pay. In *Boehm,* a federal judge had given the fired employee six years of front pay benefits. On appeal, ABC argued that six years was too much. The appeals court disagreed: "Although the six year period of front pay is longer than customary in federal discrimination actions, it is not so unsound as to warrant reversal. Evidence in the record would support a finding that Boehm would no longer be able to obtain a position equivalent to his former job. The calculation is . . . based upon Boehm's losses up to the trial coupled with the expected income for the next six years if Boehm had not been wrongfully discharged by ABC." See Chapter 9.

A way to save time, money

In an effort to avoid claims like Tashjian's, a growing number of employers require workers to arbitrate any dispute, especially those involving employee discrimination, wrongful termination or sexual harassment. Many employers set up arbitration programs modelled after those run by stockbrokers, construction contractors and health maintenance organizations.

Employers like arbitration because it can prevent "runaway jury awards where emotions are involved," says Arthur Rosenfeld, vice president California-based Kaiser Permanente. This point has particular meaning in post-termination cases.

In arbitration, a third party conducts an informal hearing and renders a decision that is usually binding. (In mediation, by way of contrast, the parties work together toward a solution with the help of a neutral intermediary.)

Some employers — for example, stock exchanges and brokerages — require workers to sign agreements saying that they will submit any grievances to arbitration. Defense contractors Lockheed Corp. and Northrop Corp. have similar policies.

Saving Time

Proponents hail the arbitration process as a way to cut months or even years from the dispute-resolution process and save businesses millions of dollars in legal costs. And there is no disputing the popularity of the process. Case filings at the American Arbitration Association, the nation's largest nonprofit arbitration group, have nearly doubled since 1982 to 14,669 nationwide.

Judicial Arbitration and Mediation Services, the largest for-profit arbitration firm, has seen revenues rise more than 800 percent since 1988 — to between $25 million and $30 million a year. JAMS helped settle a big gasoline price-fixing case, and as this book want to press sought to settle lawsuits stemming from breast implants and from the Interstate 880 collapse in the 1989 Loma Prieta earthquake in Northern California.

"Litigation is very expensive," says Charles Cooper, San Francisco-based vice president of the American Arbitration Association. "It's very cumbersome, and it doesn't respect a businessperson's time. Arbitration takes less time. It's more efficient, less disruptive to business and much less expensive."

The Council for Public Resources, a New York-based nonprofit group that promotes alternatives to litigation, studied 142 companies that avoided court by using arbitration. The companies saved more than $100 million in legal costs from disputes concluding in 1990, the study showed, mostly by avoiding the costly procedure known as discovery, by which attorneys gather information for trial.

Under a model statute written by the National Conference of Commissioners on Uniform State Laws, a worker who felt wrongly fired could challenge the boss before a panel of impartial arbitrators. If they agreed, the worker could win reinstatement with back pay. The worker could also sue, but arbitration is faster and cheaper than litigation, in which legal bills alone can run as high as $250,000. In contrast, arbitration costs as little as $2,500.

More Predictable

Arbitrators tend to look to average settlements as a guide for establishing damages, so their conclusions are more predictable than courts — but no less expensive.

Employers sometimes complain that arbitrators compromise in cases that deserve a decisive response on one side or the other. The practice should come as no surprise, though; arbitrators are supposed to do exactly that. If you strongly believe in your case and commit to defending your position, arbitration won't offer you much.

Also, if you make arbitration a condition of employment, an employee can make the case that you coerced agreement. This allows the employee's lawyer to argue that you forced the employee to give up the right to a trial by jury, as guaranteed by the Seventh Amendment to the Constitution. Lawyers also

Keep an eye on morale

claim that mandatory arbitration violates employee rights under the Civil Rights Acts of 1964 and 1991.

The manner in which you announce a termination to your employees can have a significant effect on morale and productivity.

Done well, your announcement makes a firing understandable and helps your employees get on with the work at hand. It's important to assure your workers that their jobs and lives will survive this event. And if you don't make them feel completely at ease, you can remove the departure as a source of distraction.

Some suggestions for accomplishing these goals:

- Be truthful. False optimism erodes your credibility, as do evasion and outright deceit. Employees know that firing is a part of business; what they expect is fair treatment.

- Be careful. Truthfulness doesn't mean foolishness, so don't spill all the details, some of which should remain confidential. Don't fear telling your employees that you can't talk about some specifics. Remember that you demonstrate good faith and professionalism if you restrict the number of people informed of the particulars behind an employee's termination — important defenses in court.

- Be absolutely certain that you can substantiate any factual circumstances discussed. And make sure personnel files contain only what you can substantiate.

- Don't dwell on the fired employee's problems. A good rule of thumb: Don't say anything you can't defend in court. You may have to.

- Don't make an example of the departed employee. You may wish to discourage behavior similar to that of the departed employee by allowing information concerning the termination to filter into the workplace. But if the fired employee can prove you the source of the information, he or she may have grounds for a defamation suit.

- Have a plan ready. You don't have to go into intricate detail, but you should prepare to talk about how your company will handle the fired employee's responsibilities. Distribute memos advising all affected departments of the departure. Prepare receptionists and secretaries to answer telephone calls explaining the departure.

There is a gray area between saying enough to reassure your remaining workers and saying too much.

You may choose to say less rather than risk saying too much. But you should say something so as to be open and honest. An acknowledgement of the termination also reins in the back-channel gossip and speculation that inevitably follow a firing.

Put yourself in the position of the employee. In recent years people have become more sophisticated and understanding about those who move from one job to another. They accept the practice as never before. Corporate loyalty isn't what it was. Employees aren't loyal to the corporation, and the corporation isn't loyal to its employees, either.

Be careful not to air any grievances against the departed employee, especially when you can't substantiate them.

In late 1993, a Dallas man won a $15.5 million judgment against Procter & Gamble for publicizing, as the reason for his termination, an allegation that he had been tried and convicted of theft.

The man claimed that no proof existed to substantiate the allegation. He held the company responsible for destroying his reputation and causing him to be turned down for 100 jobs.

Dealing with Outsiders

When a large, publicly-traded company fires a CEO, teams of public relations experts draft the announcement, spinning their explanations to mean the needs and concerns of stockholders, Wall Street, the press, regulators, and countless other constituencies.

What to say to outsiders

In most cases, the only outside constituents that you have to worry about are the suppliers and customers who did business with the departed employee. But it pays to take a lesson from the public relations types:

- List all suppliers and customers with whom the dismissed employee had contact.

- Prioritize the list, contacting those with whom you have current work. Provide information as soon as possible to avoid rumors or misinformation (which, never forget, may come from the departing employee personally).

- Tell the truth. Don't describe a termination as a resignation — or vice-versa. Admit what you can't discuss.

- Do not disparage the dismissed employee. If possible, come to an agreement with the departing employee on how to explain the termination and how much detail to discuss. Have the employee sign off on an agreed explanation.

- Be sympathetic to the supplier or customer but do not make or agree with any negative comments.

Damages for Publicity

In the 1991 Tennessee Supreme Court case *Frye v. Memphis State University,* a tenured professor sought damages for publicity generated by the university. This case stands as a study in how not to discuss a termination.

MSU fired Roland Frye, professor of psychology, in 1979 in a dispute over the use of computer facilities. Frye ran an outside consulting practice for which, the university alleged, he used its computers.

The university reported the termination to the ethics committee of the American Psychological Association. It notified the public by issuing a press release that stated: "In connection with work being performed by Frye-Joure and Associates, [Frye] made improper and fraudulent use of the university computer, including requiring or allowing certain graduate students of the psychology department

then employed by Frye-Joure to perform improper computer runs . . ."

The dispute received considerable media coverage in Memphis.

One thing the publicity didn't do, however, was to justify the termination itself. Tennessee law gives special, heavily protected status to tenured professors, whose professional standing relies on public trust.

The law provides that "[t]he burden of proof that adequate cause for termination exists shall be . . . satisfied only by clear and convincing evidence in the record considered as a whole."

Adequate cause might include incompetence or dishonesty in teaching or research, failure to perform the duties of a faculty member, conviction of a felony or crime involving moral turpitude, or capricious disregard of professional conduct.

In 1988, a state court found no adequate cause for Frye's discharge. It ordered him reinstated and referred the question of damages to an arbitrator. The arbitrator awarded Frye damages of $429,258.

The university objected, arguing that Frye's failure to seek employment during seven years following his termination constituted a lack of diligence in mitigating the damages.

The court agreed, modifying the award to $39,515.

'A Futile Act'

Frye appealed to the Tennessee Supreme Court. He justified his failure to seek work by arguing that his reputation had suffered such damage "that applying with other colleges or universities would amount to a futile act."

This, the university argued, didn't negate Fry's duty to try.

The Tennessee Supreme Court ruled that:

- The MSU press release essentially accused Frye of theft and fraud;

Too much and too loudly

- The media coverage and the report to the APA ethics committee made it difficult — if not impossible — for him to locate a comparable job;

- The circumstances of Frye's firing became the subject of disparaging and negative comment among academics and in the business community that would rely upon his expertise.

The court reinstated the arbitrator's original $400,000 award.

Clearly, Memphis State erred in publicizing its firing of Frye too much and too loudly, causing publicity that undermined its defense. People familiar with the case hinted that Frye's enemies within the school, jealous of his financial success, had set out to get revenge. True or not, MSU ended up liable for damages caused by the spiteful publicity.

The Lesson

And it learned a painful lesson: You should fire someone to get rid of a problem, not to exact revenge, prove a point or indulge a whimsy.

And don't mention any wrongdoing even if you're prepared to press criminal charges against the employee. The accused may win exoneration, and your announcements will make attractive grounds for a lawsuit.

As the Frye case suggests, the employee has a duty to mitigate losses by seeking other employment. You have the burden of proving that the employee failed to mitigate — but this is usually worth doing.

Most courts limit the amount of time a claimant can blame you for his or her unemployment — one year, as a rule. If you've been in court for more than a year and the employee hasn't found another job, you can probably make the failure-to-mitigate defense.

But as the Frye court noted, "An employee [suing for wrongful termination] is not required to go to heroic lengths in attempting to mitigate his damages, but only to take reasonable steps to do so."

And the courts don't require the employee to take a job that amounts to a demotion.

The matter of giving and getting references cuts like a double-edged sword. Tough new laws require employers to inquire into an applicant's background or risk liability. The courts, meanwhile, penalize the employer who gives bad references.

In the first ten months of 1993, U.S. courts decided some 60 defamation cases and had almost as many pending. They demonstrated a willingness to award large damages in these cases — anywhere from $20,000 to more than $15 million.

This forces former employers into giving no comment or, at least, declining to offer any information other than dates of employment and positions held. Even salary information is difficult to obtain without a written authorization from the applicant.

But you can tame these troubles.

A Generous Offer

In 1992, a federal court in New York rejected a wrongful termination claim by an employee fired for doing what an internal document called "woefully deficient" work. The decision merits study because the employer, New Jersey-based catalog retailer J. Crew Group Inc., gave the former employee a generous offer.

It volunteered to minimize his embarrassment by telling outsiders that he lost his job because of "a change in corporate direction." He turned down the offer and sued, alleging — among other things — that J. Crew had defamed him and forced him to defame himself by admitting he'd been fired.

The court ruled that the employee "cannot have been compelled [to defame himself] when, without being dishonest, he could have simply repeated the reason proposed by his former employer."

Indeed, it was an offer he shouldn't have refused. Even the court saw that J. Crew wanted to help him out.

These days strategies like J. Crew's, even if misleading, become commonplace. An employer expecting problems from a fired employee has great incentive to make such an offer. They trade candor in ex-

Employers keep their lips sealed

Get a release from the employee

change for insulation from slander and defamation charges.

As an employer looking for references, you should expect some evasion from those you contact. In a 1993 survey of corporate executives conducted by the San Francisco employment consultant Robert Half International, 68 percent complained that it had become more difficult to check a job applicant's references over the previous three years.

Fearing a suit if something goes wrong, potential employers know they must ask about an applicant's work history. Fearing a suit if they answer, former employers know they should keep mum.

Juries, meanwhile, look on employers with skeptical eyes. But you may go too far if you refuse to give references altogether. Defamation lawsuits can be costly — but they're not really all that common. And they're not all that easy to make.

Besides, it's in your interest to see that a fired employee finds new work as quickly as possible. This makes the employee less likely to sue. It also mitigates any damages.

A Few Basics

You can control the legal exposure caused by giving references if you follow a few basics:

- Don't give oral references. Ask the inquiring employer to send you a written request. This causes some delay, but juries often interpret oral comments in unexpected ways.

- Give a reference only when the former employee knows the type of reference you're giving and — if possible — has signed a release to this effect. Some employers toe this line sharply. If they don't have a signed release, they ask the inquiring company to send the former employee back to sign one. This, in itself, can act as a negative recommendation.

- Where you offer a severance package, agree with the employee precisely how to handle reference checks — who will take the call, what exactly this individual will say.

- Authorize only one or two persons to give references and coach these people. Keeping close rein here controls a number of risks including bad information and lingering ill-will toward the former employee.

- Don't lie. If you fired the employee for cause, a positive reference could become evidence against you. (J. Crew flirted with trouble on this count. Another court might have found pretext in the difference between the internal document citing "woeful deficiency" and the company's offer to cite a change in corporate direction.)

- Limit yourself to factual information — not opinion. Astoundingly, many managers give their personal opinions about former employees. Some inquiring employers seek out the loose-lipped manager as a means of confirming their own suspicions.

- Set policy for what information you give out and stick to it, even if it includes only name, dates of employment, and final title, and even if a former employee specifically requests that you release performance related information. Consistency is a strong defense when the courts look for bad intentions.

- Have the employee sign a consent form authorizing you to give references. Specify what the reference is to cover in the agreement.

The J. Crew approach remains tempting, though.

One Step Too Far

In the 1991 Texas case *Miles v. J.C. Penney*, a federal court considered a case involving a questionable recommendation about a former employee.

Valerie Jo Miles resigned from a management training program with J.C. Penney in 1988 after the company told her she wouldn't make it very far because of a weak performance record. Soon after, she filed an EEOC complaint alleging that she had received less support than other trainees in her program because she was black.

The telltale job record

Before the EEOC resolved her complaint, Miles applied for a job with the Department of Justice, and the FBI conducted a routine background investigation.

Miles authorized the FBI to contact former employers. Miles's former supervisors at J.C. Penney said they wouldn't recommend Miles for a position of trust and confidence. Miles's low skills, they added, led to her termination.

The Department of Justice chose not to hire Miles. A personnel officer noted on Miles' file that she'd been rejected "based on employment records."

Miles tried to expand her EEOC claim to include the derogatory comments made to the FBI agents — in retaliation, she said, for her filing a complaint with the EEOC.

A Texas federal court rejected Miles's initial complaint but accepted the addition. It ruled that she had engaged in protected activity in filing her EEOC complaint, and adverse consequences ensued. The court found a casual connection.

It noted that the J.C. Penney managers had reported that they would not recommend Miles for a position of trust "based on the unfounded claims made in her EEOC complaint" and that the Department of Justice didn't offer Miles a job "based on employment records."

That may sound tenuous, but the court awarded Miles $15,000 in compensatory damages, costs, and attorneys fees anyway. It awarded no punitive damages.

"While the record is not clear that the Department of Justice would have offered Miles a position, J.C. Penney's characterization of Miles was retaliatory in nature," it wrote.

The Better Idea

The J.C. Penney managers could have avoided the claim by telling the FBI agents that they couldn't comment about Miles because of a pending EEOC action.

But that doesn't mean they should have refused to comment on Miles at all. They were fine as long as they concentrated on the circumstances that led to her resignation in the first place.

The blacklists of the 1950s Hollywood "red scare" prohibited certain people from working in movies and television. These lists echoed unofficial practices used by employers and trade guilds for hundreds of years, and they spawned a whole special niche of hiring and firing law.

In these litigious days, blacklisting results in big punitive damage awards. But the plaintiff in a blacklisting case carries a tough burden. The lawsuits turn on fuzzy issues like malice and harmful intent. They grow out of bitter disputes between employers and employees, who must show that the employer made derogatory comments and sought to create a negative impression of the departed employee among potential employers.

Thus the former employee must prove intent — possible but very difficult.

Charges of blacklisting usually come combined with other post-termination claims. The best way to defend yourself against them is to show that nothing you did adversely affected the employee's search for work. If you can't show this, you may win by proving the charges without merit.

Union Blacklisting

One common blacklisting charge involves labor unions and collective bargaining agreements.

In February 1993, the Virginia Supreme Court reinstated a lawsuit filed by a former Eastern Airlines pilot who contended that he was unable to find work because a pilots' union blacklisted him.

Aron Krantz participated in a strike against Eastern in 1989 but later withdrew from the strike, placed his name on the Eastern recall list and applied for a job with United Airlines.

Krantz got a preliminary interview with United, but another pilot, Richard Nottke, sent a computer

message from New York to the bulletin board of the Air Line Pilots Association in Virginia.

Nottke urged other pilots to pass the word that Krantz was a "scab." United received more than 300 adverse comments about Krantz. It didn't hire him. Krantz turned out to be one of more than 2,200 pilots who received similar treatment.

Krantz filed suit in Virginia court, alleging that the union and Nottke had interfered with a prospective employment contract.[3]

The union contended that the federal government had such a strong interest in labor relations that state courts could not get involved in the dispute, but the Virginia court rejected this notion. It ruled against Nottke and the ALPA.

Civil Rights Law

Many blacklisting complaints involve civil rights law. The 1990 New Jersey case *Smith v. Continental Insurance* illustrates how volatile these cases can become.

Gigi Smith, a black woman, joined a unit of Continental as a clerk typist in March 1976 and subsequently advanced to claims processor, claims investigator and, finally, liability adjuster. Continental fired her in August 1982 for poor performance and unprofessional behavior. This followed a meeting to discuss her performance during which she began to "curse, rant and scream," creating such a disturbance that other employees vacated the area.

Continental received two inquiries related to Smith. The first was a telephone call from a woman claiming to represent a department store chain. Smith's former supervisor directed the caller to his human resources department. The caller never contacted the human resources department.

[3]A high-tech note: Although Nottke's actions occurred in New York, his alleged interference with Krantz's effort to get a job with United could not have occurred without the use of the computer in Virginia, which gave the court jurisdiction.

The other inquiry came in the form of a written request for employment information from the U.S. Postal Service. Continental confirmed Smith's dates of employment and job title but declined to offer any salary figures "per policy." This followed longstanding Continental practice.

Smith sued, citing the telephone conversation as evidence that Continental had blacklisted her.

The court ruled for Continental. It found "utterly no evidence — or even inference — that defendants defamed her rendering her unable to find employment . . ."

Continental simply provided the Postal Service with Smith's last title and dates of employment, as required by company policy, the court noted. "The revelation of such innocuous facts pursuant to a uniform policy could not have created any negative impression," the court ruled. "[Smith] admits to being unaware of any negative verbal or written job references to prospective employers yet rationalizes that her lengthy search for employment could only have been a consequence of blacklisting by defendants."

She lost.

Dramatic Stories

Plaintiff's lawyers like to talk about blacklisting because — like defamation claims — they make dramatic stories. They try to sell juries on blacklisting charges by dredging up images of McCarthyism. The law keeps things less melodramatic.

Employers who engage in blacklisting have criminal liabilities to worry about in addition to civil damages. This gives them plenty of incentive to settle — or to fight.

In the 1991 decision *Anderson v. United Telephone of Kansas*, the U.S. Court of Appeals considered a blacklisting charge common among cases involving small companies.

UTC fired Denver Anderson in November 1985. In December 1985, he interviewed with United Telephone of Missouri, a UTC affiliate. United Missouri

The exposures continue

didn't offer him a job. Neither did Installation Technicians, Inc., which did telephone installing for United Kansas.

Anderson brought suit against UTC in federal district court, alleging blacklisting and several federal labor law violations for which, Anderson admitted, the company had never been prosecuted.

UTC asked for a directed verdict dismissing all claims. Instead, the court submitted the case to the jury, which found in favor of UTC on all claims except that of blacklisting. On that charge, it returned a verdict for Anderson and awarded damages.

UTC appealed. It argued that because no criminal blacklisting charge existed, the court couldn't award civil damages under Kansas law. Anderson responded that Kansas law didn't require a criminal conviction as a prerequisite to civil liability.

The appeals court sided with UTC. Kansas law did require a criminal conviction for blacklisting before civil damages, the court said. It reversed.

The Lingering Risk

The financial exposures created by hiring and firing don't end with the exit interview. Keep complete records on any terminated employee for at least one year after the separation. Some consultants recommend three years. State law may require you to keep some records longer.

Whatever the specifics in your own state, the weight of case law compels you to keep quiet about your experiences with former employees. In many ways, this serves your interest. Once you've fired a problem worker, risk management becomes a deductive process. As long as you remain careful about what you say or write, the risks remain fairly static.

By any standard, this controllable risk poses less of a threat than the uncertainty generated by a problem worker who clocks in every morning.

CODA:
A MADNESS OF SORTS

A fever of litigiousness has come to dominate the employment law landscape.

Traditional rights that defined the workplace no longer apply.

Legislators avoid dealing with hiring and firing rules because they mix personal life with professional life in a way that assures no politically safe conclusions. Their hesitance fuels the fever.

Judges add to the problem by handing down inconsistent rulings on questions of hiring and firing. Some use workplace cases to advance their own pet social theories.

Some employers contribute by capitulating altogether. They choose not to fire problem workers and avoid layoffs until these manageable troubles grow into crises.

Other employers, lacking the safeguards and policies which take the hazard out of hiring and firing, contribute by treating their employees according to the needs, if not the whims, of the moment. This leads to inconsistency — a spur for the employee who wants revenge.

A Critical Mass

With virtually no one making a stand against it, the fever — a madness of sorts — has come to infect a critical mass of corporate America's assets. It weakens those assets to the point that they become easy spoils for angry employees and their lawyers, who hunger for the big settlement.

As an employer, you must respond. You must fight this fever until it breaks, and you can't expect others to fight it for you.

The employee who wants revenge

Use all your tools

Your weapons are good will, common sense, discipline, a clear idea of what you wish to accomplish, and a commitment to follow the rules of engagement: Be fair, be honest, assert yourself, stay calm.

And write everything down.

The battle begins the moment you look to hire new people. It continues through the selection process. It intensifies immediately after hiring and threatens to explode after termination.

Things to Remember

As you fight the righteous fight, remember these principles:

1) Keep things simple. Structure your policies and procedures to fit the needs of your enterprise; ignore what doesn't. Don't try to out-lawyer the lawyers.

2) Be fair and consistent. Consistency is your best defense in the legal battlefield. It disarms those who would accuse you of bad faith, retaliatory discharge, and discrimination — three of your adversaries' biggest weapons. Not coincidentally, it reassures your employees by making the workplace predictable.

3) Maintain the paper trail. No other practice serves you so well. Document all your decisions and actions respecting hiring and firing. Document mistakes, conflicts and complaints. Document specific employees and their performance.

4) Know your adversary. The litigious fever strikes hard when it hits. It can blindside you with allegations ranging from sexual harassment to conspiracy to defraud, all under the general rubric of wrongful termination. It can entangle you and your enterprise in the courts for years at a time, threatening ruin.

5) Prepare early, and stay prepared. Establish policy before crisis comes, and keep it simple; you don't want to give ammunition to the other side. Maintain your at-will presumption, even as you prepare not to use it.

The litigation fever thrives on fear and ignorance. Its lawyers — an aggressive lot, all working on contingency — hope that you'll be sloppy and scared. They want you to pay them to go away. You send them away empty handed if you remain ready and willing to fight.

If you do these things, you help to ensure that the litigious fever that saps American commerce comes to an end. If all employers follow suit, the fever will die out altogether.

Then real reform begins.

Reform begins

FORMS, LETTERS AND CHECKLISTS

The following 22 appendices give you primary source material, forms and checklists for hiring and firing employees. All the forms support various strategies discussed in the course of this book.

A caveat: Workplace laws and standards vary from state to state. While these materials will help you analyze exposures and manage risks, they're not a substitute for specific legal or financial advice. If you think a particular situation will be troublesome, talk to a lawyer.

With that understood, you should find these forms helpful in keeping on top of your employment situation. Feel free to use them verbatim or modify them as you see fit.

JOB SKILLS PROFILE

Date: _____

Position: _____

Score the importance of each characteristic on a scale of 1-to-10 (ten being most important). Then give a brief description of the ideal skills set that applies to each.

Education
Score: 10 9 8 7 6 5 4 3 2 1
Description: _____

Vocational or trade training
Score: 10 9 8 7 6 5 4 3 2 1
Description: _____

Type and scope of employment background
Score: 10 9 8 7 6 5 4 3 2 1
Description: _____

Minimum level of work experience
Score: 10 9 8 7 6 5 4 3 2 1
Description: _____

Stability in employment
Score: 10 9 8 7 6 5 4 3 2 1
Description: _____

Initiative
Score: 10 9 8 7 6 5 4 3 2 1
Description: _____

Knowledge of industry-specific techniques
Score: 10 9 8 7 6 5 4 3 2 1
Description: _____

Command of the language
Score: 10 9 8 7 6 5 4 3 2 1
Description: _____

Previous compensation
Score: 10 9 8 7 6 5 4 3 2 1
Description: _____

Organizational skills
Score: 10 9 8 7 6 5 4 3 2 1
Description: _____

Adaptability to new circumstances
Score: 10 9 8 7 6 5 4 3 2 1
Description: _____

Enthusiasm for work
Score: 10 9 8 7 6 5 4 3 2 1
Description: _____

Physical appearance and demeanor (only if relevant as a bona fide occupational qualification)
Score: 10 9 8 7 6 5 4 3 2 1
Description: _____

SAMPLE EMPLOYMENT APPLICATION FORM

Employment Application

It is the policy of this company to comply with all federal, state and local equal employment opportunity laws and guidelines.

Please complete all items.

Date: _____

Position desired: _____

Date available: _____

Days/hours preferred: _____

Salary desired: _____

Referred by: _____

☐ advertisement
☐ friend
☐ relative
☐ walk-in
☐ employment agency
☐ other

Personal Information

Name: _____
 (last) (first) (MI)

Social Security number: _____

Address _____

City, State, ZIP _____

Home telephone: (_____) _____

Business telephone: (_____) _____

Are you over the age of 18? _____

If no, please state your date of birth: _____

Are you eligible for employment in the United States? ☐ Yes ☐ No

Has any restriction been placed on your eligibility for employment in the United States?

 ☐ Yes ☐ No

If yes, please explain. _____

NOTE: If hired, you will be required to provide proof of employment eligibility.

Have you been employed by this company before? ☐ Yes ☐ No

If yes, please give previous dates of hire and departure. _____

Do you have any personal friends or relatives employed at this company?

☐ Yes ☐ No

If yes, please list them and their relationship to you and their positions. _____

Are you capable of performing — with reasonable accommodation — the essential functions of the position which you seek? ☐ Yes ☐ No

If no, please explain. _____

Have you even been convicted of a felony? ☐ Yes ☐ No

If yes, please explain date and nature of conviction. _____

NOTE: Disclosure of a criminal record will not necessarily disqualify you from employment. The nature and date of the conviction and the position desired will be taken into consideration.

Military Service Information

Have you ever served in the United States armed forces? _____

If yes, please give the dates of service. _____

If yes, please list skills, abilities and other relevant training you received. _____

Educational Information

	name and address of school attended	date of graduation	type of degree, diploma or training received	major fields of study
High school	_____	_____	_____	_____
College/ undergraduate university	_____	_____	_____	_____
Graduate school	_____	_____	_____	_____
Technical school	_____	_____	_____	_____
Other	_____	_____	_____	_____

List honors, awards, or scholarships received: _____

List relevant activities, memberships or positions held: _____

Employment Record

Please list all employment, starting with most recent position and working back. Please attach a separate sheet if necessary.

Company: _____

Address: _____

Phone: (_____) _____

Position, with brief outline of duties: _____

Supervisor's name and title: _____

Dates of employment: from _____ to _____

Reason for leaving: _____

References

Please list — with address and phone number — three people familiar with your education, training, or professional experience. Please do not include family members or relatives.

1) _____
2) _____
3) _____

Notice of physical testing

This company is commited to maintaining a drug-free workplace. All candidates for employment are required to complete a physical examination and/or test for drug and alcohol use. These tests will be administered by a physician or clinic of the company's choice.

I agree to undergo pre-employment drug and/or alcohol testing. I understand that results of any such test will be disclosed only to the human resources department of this company and relevant management employees. I understand that if I refuse to undergo testing, fail to provide physical specimens when requested, provide false or tampered specimens or otherwise fail to complete the testing process, I will not be hired.

Applicant Acknowledgement

I grant permission for this company to conduct an investigation and solicit information related to my educational, employment, military service and criminal histories. I release this company and any of its employees or representatives from any liabilities arising from such investigations.

I grant permission for this company to conduct an investigation and solicit information related to my personal credit and financial histories as well as my professional character and reputation. I release this company and any of its employees or representatives from any liabilities arising from such investigations.

I understand that this employment application and any other company documents do not constitute or in any way imply a contract of employment. I understand that no employee or representative of the company has authority to make or imply any contract of employment with me. I understand that any individual hired by this company may voluntarily leave or be terminated at any time, with or without cause being given.

If terminated, I authorize this company to deduct — to the extent permitted by law — any monies which I might legitimately owe the company from any monies the company might owe me.

All statements made and information given by me on this application are true and correct to the best of my knowledge. I understand that any false, inaccurate, omitted or misleading statements or information can be grounds for rejection of my application or termination of my employment.

I have read, understand and by my signature consent to these statements.

Signed _____ Date _____

APPENDIX THREE

GUIDELINES AND TALK POINTS FOR JOB APPLICANT INTERVIEW

Ask questions that allow the applicant to elaborate on his or her background, skills and working style. The questions should concentrate on issues relevant to the job at hand. Ask candidates how they react to typical situations and how they would react to hypothetical ones.

Example: Give an example of a time when you encountered someone with whom it was difficult to work.

what did you do about it?

what happened?

Don't crowd the conversation. Try to have the applicant do most of the talking. Look for initiative, self-confidence, thoughtful decision making, and constructive problem-solving.

Ascertain the basic skills the applicants used in previous jobs. Have them describe their normal work load in previous positions. Sometimes, a person will take key skills for granted or neglect to mention them.

Sometimes, in recounting a former job, an applicant will give you a better image of his or her work habits than he or she intends.

Focus on goal-orientation. As for specific answers and examples of assignments a candidate has accomplished.

Ask applicants to assess their performance at previous jobs. Look for consistency in tone and work history. Lots of job-hopping paired with nothing but glowing memories might suggest a problem worker.

Look for stability, both in work history and career goals.

When possible, interview candidates more than once. Have different people handle each interview.

Twelve types of questions you should never ask:

- ☐ Where have you lived?
- ☐ Are you married? Are you divorced?
- ☐ Are you pregnant or do you plan to get pregnant?
- ☐ How would your spouse feel about your working?
- ☐ How many children do you have?
- ☐ Have you ever had any illnesses? Do you get sick a lot?
- ☐ Have you ever filed a workers' compensation claim?
- ☐ What is your race or ancestry?
- ☐ What is your religion? Are you religious?
- ☐ How old are you? When did you graduate? How old were you when you had that job?
- ☐ Do you have any physical or psychological handicaps?
- ☐ Have you ever been arrested?

Never promise permanent employment or guarantee job security.

APPENDIX FOUR

SAMPLE APPLICANT INTERVIEW REPORT FORM

To be filled out by interviewer.

Applicant: _____

Interviewer: _____

Date: _____

Examples of tasks the applicant performed that used important skills and abilities.

What did he or she do? _____

How? _____

Why? _____

What were the results? _____

How did these skills and abilities suit the previous employer's needs? _____

Examples of important decisions the applicant has made on the job.

In each case, describe the situation, the process and the end result. _____

Examples of how, in previous jobs, the applicant solved a specific problem.

How did the applicant adapt to changes during a previous job? _____

Applicant's description of his or her work habits. _____

Description of himself or herself as worker. _____

Description of timeliness or tardiness. _____

Examples of how this has worked for or against the applicant in previous positions.

Examples of how the applicant took direction from former supervisors.

How does the applicant prefer to work: independently or on a team? _____

Examples of how the applicant has worked each way.

How would the applicant's past experience contribute to the company? _____

In what aspect of work does the applicant take the most pride? _____

How important is it for the applicant to feel that he or she:

receives specific instruction? _____

has clearly-defined responsibilities? _____

has constantly changing work? _____

deals with people on a close basis? _____

is working in a creative environment? _____

can speak his or her mind freely? _____

solves problems? _____

has secure job and income? _____

Overall impression of the applicant on the following standards:

	excellent	good	average	fair	poor	unacceptable
Qualification	☐	☐	☐	☐	☐	☐
Organization	☐	☐	☐	☐	☐	☐
Experience	☐	☐	☐	☐	☐	☐
Education/training	☐	☐	☐	☐	☐	☐
Cooperation	☐	☐	☐	☐	☐	☐
Flexibility	☐	☐	☐	☐	☐	☐
Problem-solving skills	☐	☐	☐	☐	☐	☐
Communication	☐	☐	☐	☐	☐	☐
Discipline	☐	☐	☐	☐	☐	☐
Enthusiasm	☐	☐	☐	☐	☐	☐
Match for corporate culture	☐	☐	☐	☐	☐	☐

APPENDIX FIVE

GUIDELINES AND TALK POINTS FOR MAKING REFERENCE CHECKS

Tell candidates ahead of time that you intend to check their references.

When calling references, provide:
- [] your name and company name
- [] an explanation of the position being offered and your industry
- [] how you plan to use the interview
- [] an assurance of confidentiality

Establish:
- [] dates of employment
- [] job descriptions
- [] voluntary or involuntary departure

Describe information offered on application or resume. Check for veracity.

Ask open-ended but relevant questions.

For example:

What were this applicant's strengths as an accounting department employee?

How did this applicant perform as a marketing research assistant?

What is most memorable about this applicant as a line manager?

If possible, talk to your counterpart at the previous employer. For example, if you're a controller, try to talk to the previous employer's controller. Better yet, if you have a friend or acquaintance at the company, talk to him or her.

Generally, employers will give positive references for past employees whom they viewed favorably, but will only confirm specific information for those whom they viewed unfavorably. Be alert when the past employer says, "Sorry, standard company policy is, we can only give names, date of employment, and last title."

Remember that past employers are fallible, too. None are entirely objective, and some color their appraisals of employees with their own prejudices.

APPENDIX SIX

REFERENCE CHECK REPORT FORM

Date: _____

Applicant: _____

What was the applicant's former title? _____

Job description? _____

What were the dates of the applicant's employment? _____

Did the applicant leave voluntarily or involuntarily? _____

Details? _____

How does the former employer rate the employee against other similar employees?
- ☐ Exceptional
- ☐ Top third
- ☐ Middle third
- ☐ Bottom third
- ☐ Horrible

Reasons for this ranking: _____

Applicant's strengths and weaknesses in former position? _____

Did he or she get to work on time? ☐ Yes ☐ No

Did he or she meet all duties? ☐ Yes ☐ No

How did the applicant handle on-the-job pressure? _____

Would the former employer rehire him or her? ☐ Yes ☐ No

If no, please explain _____

Was he or she honest? ☐ Yes ☐ No

If no, please explain _____

SAMPLE REJECTION LETTERS

Source: Jorgensen & Associates, Inc., La Crescenta, CA

_____, 19___

Name _____

Address _____

City, state, ZIP _____

Dear:

Thank you for applying for the _____ position. We appreciate the time you took to submit your resume.

Although we were impressed by your qualifications, we have selected another candidate whose qualifications more closely meet our needs for this position.

Once again, thank you, and good luck in your career endeavors.

Sincerely,

_____, 19____

Name_____

Address _____

City, state, ZIP_____

Dear:

Thank you for your interest in employment opportunities with _____.

After carefully evaluating the qualifications of those individuals interested in employ-ment with the firm, we have determined that our needs can best be met with another applicant. Naturally our decision was quite difficult based on the enthusiasm, profes-sionalism and past experience of the individuals who submitted resumes and those interviewed by phone.

We apologize for having taken this long to respond to you, but the selection process was very important and took some time to complete.

While we are unable to offer you a position at this time, we wish you success in your job search.

Sincerely,

APPENDIX EIGHT

GUIDELINES FOR EMPLOYEE HANDBOOKS AND MANUALS

Employee manuals can cover a range of subject matter, depending on the state and industry in which you're doing business. Check with your local trade association or state labor department for the specifics you need to include.

Here are some generally applicable guidelines to follow.

The manual should:

- [] outline company policies on tardiness, absence, vacation time and sick pay
- [] outline available benefits — workers' comp and any others — and emphasize the employee's self-interest in controlling related costs
- [] outline usual disciplinary procedures — while preserving your right to step outside them if you wish or circumstances merit
- [] make no promises to dismiss only for "just cause"
- [] reflect all relevant collective-bargaining arrangements
- [] outline available complaint or appeal mechanisms
- [] avoid such subjective terms as "fair," "timely," "reasonable" and "equitable," which stimulate litigation
- [] state, clearly, that it is not a contract and that you reserve the right to modify or amend any personnel policy at any time, with or without notice
- [] state that only specifically designated company officials can enter into oral or written contracts with employees
- [] state that, if there is any inconsistency between a statement in the handbook and actual practice, the handbook governs
- [] not imply that the employee can expect promotions regularly or as a matter of course

If your handbook specifies a probationary period for new employees, it should also state that such employees can be fired before probation ends and that successfully completing probation does not guarantee continued employment.

The handbook should change as policies change; when you alter policy regarding conduct (to comply with laws barring sexual harassment, for example), change your manual accordingly.

EQUAL EMPLOYMENT OPPORTUNITY AND
SEXUAL HARASSMENT POLICIES

Company name _____

Address _____

Date_____

It is the policy of this company to provide equal employment opportunity for all people. All qualified applicants for employment will be recruited, reviewed, hired and assigned on the basis of merit and the best economic interests of this company.

This company does not consider race, color, gender, disability, sexual orientation, creed or ethnic origin in its employment and staffing decisions. It demands that all qualified applicants and employees are treated fairly and equally, without discrimination, in matters of compensation, training, advancement and discipline.

This company will not tolerate unlawful discriminatory behavior in any employee or representative. Such behavior is grounds for disciplinary action.

It is policy of this company to maintain a work environment free from sexual harassment or misconduct.

While recognizing appropriate rights to privacy and free expression, this company will not tolerate unlawful sexual harassment or misconduct in any employee or representative. Included in this company's definition of sexual harassment are:
- requesting or demanding sexual relations as a condition of employment;
- unwarranted or uninvited touching, fondling, or physical contact;
- intentional, specific and disparaging sexual remarks;
- specific remarks or actions related to a person's gender, sexuality or sexual orientation that create a hostile work environment.

Such behavior is grounds for disciplinary action.

Any employee subjected to sexual harassment or discrimination is expected to contact his or her supervisor in a timely manner. If that employee feels uncomfortable discussing the misconduct with his or her supervisor, he or she may speak with any other management-level employee. Any manager informed of sexual misconduct is expected to take immediate corrective action.

Because it takes issues of employment discrimination and sexual harassment seriously, this company will not tolerate dishonest, manipulative or untrue accusations of such behavior.

By signing this document, you—as an employee—attest that you have reviewed and understand these policies.

Signed _____ Date _____

EMPLOYEE PERFORMANCE REVIEW

Employee name: _____

Employee ID number: _____

Date: _____

Position: _____

Reviewer name and position: _____

To the reviewer: Each evaluation and each rating category must be accompanied by written explanations. Space is provided in this form, but feel free to use more space, if needed.

Ratings

Excellent (5): Performance always exceeds expectation and requirements of position, exceeded by few — if any — peers

Good (4): Performance exceeds requirements of position most of the time, consistently and noticeably above average

Average (3): Consistently meets all requirements of position

Fair (2): Performance requires improvement

Poor (1): Performance does not meet requirements of position; immediate improvement on part of employee necessary

Unacceptable (0): Abject failure to meet requirements of position; immediate action from supervisors necessary

Knowledge of position

Employee knows the job to be performed and the most efficient ways to do it. Employee has needed skills and abilities; pays attention to keeping these skills and abilities up-to-date. Employee knows relevant company policies and procedures.

- ☐ Excellent
- ☐ Good
- ☐ Average
- ☐ Fair
- ☐ Poor
- ☐ Unacceptable

Comments: _____

Quality of work

Employee does job efficiently and well, on time and without disruption to other employees. Employee works without unwarranted supervision or mistakes.

- ☐ Excellent
- ☐ Good
- ☐ Average
- ☐ Fair
- ☐ Poor
- ☐ Unacceptable

Comments: _____

Reliability

Attendance is good. Employee can be trusted to meet all demands of position, will work as needed to complete assignments and jobs.

- ☐ Excellent
- ☐ Good
- ☐ Average
- ☐ Fair
- ☐ Poor
- ☐ Unacceptable

Comments: _____

Responsibility

Employee is self-starter and self-manager, helps others when necessary, takes pride in work and shows desire to improve self and skills.

- ☐ Excellent
- ☐ Good
- ☐ Average
- ☐ Fair
- ☐ Poor
- ☐ Unacceptable

Comments: _____

Cooperation

Employee works well with peers and supervisors, shows maturity and stability.

- ☐ Excellent
- ☐ Good
- ☐ Average
- ☐ Fair
- ☐ Poor
- ☐ Unacceptable

Comments: _____

Judgment

Employee exercises sound judgment and discretion in focusing on job goals, establishing priorities and reacting to the unexpected.

- ☐ Excellent
- ☐ Good
- ☐ Average
- ☐ Fair
- ☐ Poor
- ☐ Unacceptable

Comments: _____

Communication:

Employee can express basic necessary information related to job in clear, efficient manner.

☐ Excellent

☐ Good

☐ Average

☐ Fair

☐ Poor

☐ Unacceptable

Overall rating among peers

☐ Top fifth

☐ Second fifth

☐ Middle fifth

☐ Fourth fifth

☐ Bottom fifth

Employee's strongest assets: _____

Employee's primary weaknesses: _____

Reviewer's signature: _____

Date: _____

Employee acknowledgement

A copy of this report has been discussed with me. I understand its contents and conclusions.

Employee's signature: _____

Date: _____

Employee's comments, if any: _____

APPENDIX ELEVEN

GUIDELINES AND TALK POINTS FOR VERBAL WARNING

For consistency in your company's personnel policies and paper trail, it's best not make detailed written records of verbal warnings. They are, after all, meant to be verbal. Still, you should follow the general standards you use for written warnings.

These will probably include:

- ☐ a simple explanation of the problem that has occurred
- ☐ an explanation of how the problem impacts the company's productivity
- ☐ an explanation of how the problem deviates from or hinders the employee's job description
- ☐ expected improvements and time-frames for these improvements

Some basic information should be written and kept in the employee's file. This includes:

Employee: _____

Supervisor: _____

Date of verbal warning: _____

Reason for verbal warning: _____

APPENDIX TWELVE

WRITTEN WARNING NOTICE

Date: _____

Company name: _____

Department or division: _____

Employee: _____

Date hired: _____

Supervisor: _____

The following problem occurred (include date): _____

A verbal warning was issued on this matter (date): _____

This problem affects company performance in the following way: ___

This problem interferes with or hinders your job description in the following way: _____

The standard goal for improvement is: _____

The time frame for improvement is: _____

Further substandard performance or disregard for company rules and procedures may result in additional discipline — including termination.

Supervisor signature: _____

Date: _____

I have been informed of and have reviewed this written warning. I understand its contents and potential responses to continued problems.

Employee signature: _____

Date: _____

Employee comments, if any: _____

APPENDIX THIRTEEN

RESPONSE TO ALLEGATIONS OF DISCRIMINATORY BEHAVIOR

As soon as an employee raises a discrimination concern or complaint, ask him or her to complete a written questionnaire, which you should keep on file. If the employee will not complete the form, his or her manager should.

Company name _____

Division: _____

Date: _____

Complainant: _____

Form filled out by: _____

What — exactly — happened? _____

Was this a subtle act, or a blatant one? Explain. _____

Was this an isolated incident, or part of a pattern? _____

When — exactly — did the alleged incident occur? _____

How many people were involved? List names. _____

How many witnesses saw or heard the incident? _____

Do the people who did this act as though they have protection?_____

Does the alleged victim know the company's policies on discriminatory behavior? _____

What does the alleged victim expect the company to do about the complaint? _____

APPENDIX FOURTEEN

FIFTEEN STEPS TO A MORE EFFECTIVE FIRING

1) Whenever possible, conduct the termination in a private meeting.

2) The more rushed or impassioned you are, the more likely you are to make a mistake. Firing people on the spot can be an expensive indulgence.

3) Have a written termination notice to give the employee after you've spoken with him or her. The notice should review disciplinary history, events leading up to the termination and cause—if you choose. It should also list all the procedures and details that the employee should follow after the meeting.

4) Identify the employee about to be fired. Make a checklist of topics to cover and reactions to expect. The following list may be helpful:

 ☐ Has the employee been with the company less than a year?

 ☐ Have you made or do you plan other terminations?

 ☐ Has the employee made any workers' comp claims?

 ☐ Does the employee have a history of discipline problems or volatile behavior?

 ☐ Is the employee an attorney or does the employee work in the legal field? Has he or she ever worked in the legal field?

 ☐ Does the employee have a history of lawsuits or administrative actions against other employers?

 ☐ Do other employees or former employees from the same division have litigation or administrative actions pending against the company?

 ☐ Has the employee reacted negatively to other reviews?

 ☐ Does the employee handle sensitive or vital material?

 ☐ Does the employee pose a direct financial or security risk to you or the company?

5) Make sure that you've applied rules, policies and penalties consistently and accurately. If you are firing for cause, make sure you have all the relevant facts. Review them carefully and prepare to explain how they violate or fail to satisfy company policy. Review the employee's history. Review your own practices to make sure this termination matches past practice for similar misconduct.

6) Avoid scheduling the meeting at the end of the work day, the end of the work week, or just before a holiday. Try to avoid giving the notice just after the employee has returned from a business trip.

7) Find a neutral location. Using a supervisor's office attaches a negative stigma that sticks with employees who remain.

8) Have at least two people in the room in addition to the employee—the immediate supervisor and someone with whom the employee does not have a day-to-day relationship. The neutral person should act as a witness, present to listen and only to speak in an emergency.

9) Deliver the news and answer questions without engaging in an argument. Say what you need to say and nothing more. Prepare notes, if necessary. Nervous, unnecessary rambling can lead to words or promises that you'll regret later.

10) No matter what the employee's response, remain calm and stay in control of the conversation. Listen to what the employee has to say, but never get angry or loud just because the employee does. Treat fired employees with fairness and tact.

11) Be prepared to discuss severance terms but, if possible, reserve that for another meeting.

12) Avoid the "brass-knuckles-with-velvet-glove" approach—offering emotional support in the midst of the termination interview. Don't sent mixed messages. Don't give career advice to someone you've just fired.

13) Avoid euphemisms like the term "layoff" because they are vague. ("Layoff" could be taken to imply that the employee might be brought back. Better to use the word "termination.")

14) If at all possible, offer the employee some type of assistance in finding a new job. It not only helps the employee at relatively little cost to the company, but also reduces the chance that the employee will sue (if nothing else, it mitigates claims of bad faith).

15) Write up an accurate record of the termination interview. Pass this letter on to the terminated employee.

APPENDIX FIFTEEN

TERMINATION LETTER — LAYOFF

Company name _____

Date: _____

Dear _____,

I know that you are unhappy and disappointed about losing your job. Those of us who are continuing at this company are sorry to see you go. You have been a dedicated and loyal employee for the past ____ years, and what has happened has nothing to do with your job performance. As I have explained to you, the company is changing its operations. The job you were doing won't be necessary and will cease to exist.

Through the severance pay the company has offered you, I hope this hard time will be made less difficult. I hope you will be able to recover quickly and find another good job. As I've mentioned, I will be glad to write you good letters of recommendation or talk to prospective employers about your qualifications.

To help you make this transition, the company will pay for you to attend a program where you will have the opportunity to brush up on your job-hunting skills and learn better ways of looking for employment. The firm we've hired to run this program is experienced in teaching people how to prepare job applications and have successful interviews.

I hope this program will be helpful, and I sincerely hope you will attend.

Lastly, I want to thank you again for the contributions you have made to this company and for the good work you have done throughout your time of employment here. I hope that new doors will open for you and that the future will be good for you as you go forward.

Sincerely,

APPENDIX SIXTEEN

TERMINATION LETTER — FIRING

Company name _____

Date: _____

Dear _____,

This letter serves as official notice that your employment with this company has been terminated.

The decision hasn't been made casually. We have taken a serious look at your work history and the company's best financial interests in coming to the conclusion that this is the appropriate action to take at this time.

We want you to be aware of your rights, now that your employment with this company has ended. We have attached to this letter our severance policy, outlining what you can expect. We've also enclosed specific forms for you to read and sign related to severance pay, workers' compensation and COBRA (optional continuation of your health insurance coverage). You can sign these forms and leave them with us now — or you can take them home and return them in the enclosed business-reply envelope.

We are sorry that this decision has become necessary. We hope you will have greater success as you move forward.

Supervisor's signature: _____

Date: _____

APPENDIX SEVENTEEN

TERMINATION REPORT FORM — FIRING

Company name _____

Department or division: _____

Date: _____

Terminated employee: _____

Terminating supervisor: _____

Witnesses: _____

Were the following materials included in the employee's file?

- ☐ application
- ☐ job description
- ☐ verbal warning memo
- ☐ written warning records

List the reasons given to the employee for the termination:

Did the employee expect the termination? ☐ Yes ☐ No

 If no, explain why not _____

Characterize the employee's reaction:

- ☐ hysterical
- ☐ angry
- ☐ sad
- ☐ calm
- ☐ lethargic

Comments: _____

Did the employee mention anything that could create a lingering exposure for the company?

- ☐ sexual harassment
- ☐ discrimination
- ☐ new workers' comp claims
- ☐ other _____

Did the employee threaten any peer or supervisor? ☐ Yes ☐ No

 If yes, explain _____

Did he or she act in any way which might suggest prolonged instability or tendency toward violence? ☐ Yes ☐ No

 If yes, describe _____

What, if any, questions did the employee raise about the termination? _____

How were these questions answered? _____

Was the employee satisfied?　　☐ Yes　　☐ No

　If no, explain _____

Did the employee ask to review written warnings or any other element of his or her file?

Was this request granted?　　☐ Yes　　☐ No

What severance was offered? _____

Did the employee accept the severance, agree to consider it, or reject it? _____

If the employee will consider the severance, how long was he or she given? _____

If rejected, what reason did the employee give? _____

What company property did the employee agree to return?
- ☐ keys
- ☐ tools
- ☐ company credit cards
- ☐ company car
- ☐ portable or home-use computer or communications hardware

What time-frame was employee given for vacating premises and returning company property? _____

What financial arrangements will influence the employee's final severance package?
- ☐ outstanding advances or draws
- ☐ fines or docked wages
- ☐ continuation of benefits or insurance coverage at employee's expense
- ☐ outstanding expense reports
- ☐ outstanding overtime
- ☐ outstanding commissions, royalties or other special compensation
- ☐ pension plan participation
- ☐ ESOP or stock options
- ☐ other

APPENDIX EIGHTEEN

RELEASE UPON TERMINATION

Specific states may require specific language in an enforceable release. Check with your local labor and/or industry regulatory authorities.

Company name _____

Date: _____

Employee name: _____

In consideration of the payment to you of $_____, less necessary withholdings and deductions, you hereby release this company and its directors, officers and employees from any claim you may have in connection with your employment at this company.

You also agree not to use or reveal to any other persons any confidential information which you may have acquired while an employee at this company.

In exchange for the benefits extended in this memorandum to you, you agree to release this company from any and all causes of action, known or unknown, arising out of, in any way connected with or relating to your employment (or its termination) with this company. Such causes of action include but are not limited to: breach of contract, impairment of economic opportunity, intentional infliction of emotional harm or other tort, the Age Discrimination in Employment Act of 1967, Title VII of the Civil Rights Act of 1964, the Americans with Disabilities Act, or any state or municipal statute or ordinance relating to discrimination in employment. However, you expressly reserve your rights under this company's pension plan or other post-employment benefits, as well as the right to institute legal action for the purpose of enforcing the provisions of this memorandum.

Company representative: _____

Date: _____

Employee's signature : _____

Date: _____

APPENDIX NINETEEN

WORKERS' COMPENSATION CLEARANCE LETTER

Company name _____

Department or division: _____

Date: _____

I testify that I have reported — through standard written channels — all work-related accidents, injuries or illnesses suffered while employed by this company.

I have informed the following supervisory personnel of any relevant injuries or illnesses:

1) _____

2) _____

3) _____

At this time, I know of no work-related accident, injury or illness for which I could seek workers' compensation—other than those I have already reported and/or for which I have sought compensation.

Employee: _____

Date: _____

APPENDIX TWENTY

EXIT INTERVIEW FORM

Information from company

Date: _____

Employee interviewed:_____

Interview conducted by: _____

Reason for leaving:
- ☐ voluntary
- ☐ involuntary
- ☐ layoff
- ☐ at-will termination
- ☐ for-cause termination (describe cause)
- ☐ other

Eligible for rehire?
- ☐ yes
- ☐ no

Hire date: _____

Last day worked: _____

Questions to ask employee

If you are leaving voluntarily, why?
- ☐ moving
- ☐ other employment
- ☐ problems with supervision
- ☐ problems with job duties
- ☐ disability
- ☐ failed to return from leave
- ☐ retirement
- ☐ other

What did you like most about your work at this company? _____

What did you like least? _____

Do you feel that you were properly placed in your work position, considering your interests and abilities?

☐ Yes ☐ No

Comments: _____

Did your receive sufficient orientation and appropriate training as a new employee?
☐ Yes ☐ No
If no, Please explain _____

Was you job defined and explained to you sufficiently when you were hired?
☐ Yes ☐ No
If no, Please explain how it wasn't _____

Did you receive a written job description? If so, was it appropriate to your position?

Did you received effective and fair supervision? ☐ Yes ☐ No
Comments: _____

Did your department function as a team? ☐ Yes ☐ No
Comments: _____

What did you like about your supervisor? _____

What did you dislike about your supervisor? _____

Did your supervisor urge you to find better and more efficient ways to do your job?
☐ Yes ☐ No
Comments: _____

Please rate your immediate supervisor on the following standards:

	excellent	good	average	fair	poor	unacceptable
Cooperation	☐	☐	☐	☐	☐	☐
Fairness	☐	☐	☐	☐	☐	☐
Clear instructions	☐	☐	☐	☐	☐	☐
Recognition and attention	☐	☐	☐	☐	☐	☐
Follows policies	☐	☐	☐	☐	☐	☐
Responsive	☐	☐	☐	☐	☐	☐
Availability	☐	☐	☐	☐	☐	☐
Flexibility	☐	☐	☐	☐	☐	☐
Attitude	☐	☐	☐	☐	☐	☐
Ethics	☐	☐	☐	☐	☐	☐

Please rate this company as a whole on the following standards:

	excellent	good	average	fair	poor	unacceptable
Cooperation	☐	☐	☐	☐	☐	☐
Fairness	☐	☐	☐	☐	☐	☐
Clear instructions	☐	☐	☐	☐	☐	☐
Recognition and attention	☐	☐	☐	☐	☐	☐
Follows policies	☐	☐	☐	☐	☐	☐
Responsive	☐	☐	☐	☐	☐	☐
Availability	☐	☐	☐	☐	☐	☐
Flexibility	☐	☐	☐	☐	☐	☐
Attitude	☐	☐	☐	☐	☐	☐
Ethics	☐	☐	☐	☐	☐	☐

If you had two improvements to suggest for the company, what would they be? _____

Do you have any suggestions which might improve workplace safety?

☐ Yes ☐ No

If yes, please give details: _____

Did you ever make a workers' compensation claim? ☐ Yes ☐ No

If yes, did you receive benefits? _____

If yes, is your case closed? _____

Have you reported all work-related injuries? ☐ Yes ☐ No

 If no, please explain: _____

Were you ever treated improperly or sexually harassed during your employment?

 ☐ Yes ☐ No

 If yes, please give details: _____

For layoffs only

If you were offered re-employment, would you work for us again?

 ☐ Yes ☐ No

 If yes, please give details: _____

 If no, why not? _____

Would you be willing to perform the same duties?

 ☐ Yes ☐ No

 If no, why not? _____

APPENDIX TWENTY-ONE

APPLICATION FOR AMERICANS WITH DISABILITY ACT LIABILITY INSURANCE

☐ The Home Insurance Company of Wisconsin

☐ The Home Insurance Company of Illinois

☐

APPLICATION FOR AMERICANS WITH DISABILITY ACT LIABILITY INSURANCE (Claims-Made-and-Reported Basis)

1. Name of Applicant: _____

 ☐ a) Corporation ☐ b) Partnership ☐ c) Sole Proprietor

 ☐ d) Other_____

2. Mailing Address: _____

3. City: _____ State: _____ Zip: _____

 Phone #: (_____)_____ Fax #: (_____)_____

4. List all locations owned or occupied by the insured with the following information on each one: Name of insured entity applicable at this location, nature of operations, square foot area of buildings, square foot area of owned parking lots and walkways, number of full time equivalent employees, date acquired or occupied. (Use the separate schedule attached.)

5. A. Limits Desired:

 ☐ $500,000 per claim/$1,000,000 aggregate

 ☐ $1,000,000 per claim/$1,000,000 aggregate

 B. Deductible Desired:

 ☐ $1,000 ☐ $2,500 ☐ $5,000⁻ ☐ $10,000

 ☐ Other $ _____

 C. Retroactive Date Desired (if different than policy effective date): _____

6. Describe all claims or suits alleging discrimination against a disabled person during the last five years (if none, please state).

7. At the time of the signing of this application, are you aware of any circumstances which may reasonably be expected to give rise to a claim under this policy? ☐ Yes ☐ No

 If so, give details: _____

8. How have you reviewed policies, practices and procedures to determine compliance with the ADA?

9. Have you developed an action plan to implement changes in your firm required to comply with the ADA? ☐ Yes ☐ No If yes, please explain._____

10. Is any person or persons in your organization responsible for ADA compliance, including public accommodations issues and employment-related functions? ☐ Yes ☐ No If so, provide names, titles and duties and to whom they report: _____

11. Do you expect any closings or layoffs within the next year? ☐ Yes ☐ No If so, please advise details. (Use a separate sheet.)

12. Have the following been reviewed to see if alterations, modifications or alternatives are necessary to accommodate the disabled?

Doors/Entrance Ways	☐ Yes ☐ No	
Parking Area(s)	☐ Yes ☐ No	
Bathroom(s)	☐ Yes ☐ No	
Workstations	☐ Yes ☐ No	
Steps/Stairs	☐ Yes ☐ No	☐ N/A
Elevator(s)	☐ Yes ☐ No	☐ N/A
Drinking Fountain(s)	☐ Yes ☐ No	☐ N/A
Locations Where Goods or Services are Provided	☐ Yes ☐ No	☐ N/A

13. Is an ADA poster conspicuously displayed in your workplace(s)? ☐ Yes ☐ No If not, have you ordered the poster from the EEOC or other source? ☐ Yes ☐ No

14. Have those employees responsible for hiring received instructions, including interview training, on ADA concerns? ☐ Yes ☐ No

15. Do you have written job descriptions which define the "essential functions" of each position? ☐ Yes ☐ No

16. Do your job descriptions include quantified minimum production/performance standards (e.g. type 60 words per minute)? ☐ Yes ☐ No ☐ N/A If not, please explain: _____

17. If you require physical examinations of job applicants, do you do so only after a conditional offer of employment has been made? ☐ Yes ☐ No ☐ N/A

18. Are medical records kept separate from other personnel records and secured in locked file cabinets? ☐ Yes ☐ No If not, how do you plan to maintain confidentiality of medical histories? _____

19. Are there written guidelines that specify how and under what circumstances employee medical files can be inspected? ☐ Yes ☐ No If not included in employee handbook, please attach a copy.

20. If qualification/skill tests are required of job applicants, are arrangements made to accommodate the disabled? ☐ Yes ☐ No ☐ N/A

21. If you are a party to any collective bargaining agreements, do they describe the duties of various jobs? ☐ Yes ☐ No ☐ N/A

22. Have written emergency and/or evacuation procedures been reviewed to ensure that the needs of the disabled have been considered? ☐ Yes ☐ No

23. If you use private employment agencies to recruit job applicants, have you explained to them in writing and documented that they must comply with the ADA? ☐ Yes ☐ No ☐ N/A

APPENDIX TWENTY-TWO

APPLICATION FOR EMPLOYMENT
RELATED PRACTICES LIABILITY INSURANCE

Application for
Employment Related Practices
Liability Insurance

Please have your licensed insurance representative send this completed application to:

The New Hampshire Insurance Company

401 City Avenue/Suite 210
Bala Cynwyd, PA 19004-1122

> THIS APPLICATION IS FOR A CLAIMS-MADE POLICY WHICH INCLUDES DEFENSE EXPENSE WITHIN THE LIMITS OF COVERAGE.
> IF ISSUED, READ YOUR POLICY CAREFULLY.

I. GENERAL INFORMATION

1. Named Insured: _____

2. Address: _____

3. Person to contact: _____

 Telephone: _____ Fax: _____

4. Business is: ☐ Corporation ☐ Individual Proprietor ☐ Partnership ☐ Other(Specify)

5. Nature of Business: _____

 Years in Business _____

6. Number of locations by state (including #2 above): _____

7. Desired Limits: Each Insured Event Limit/Total Limit (000's omitted)

 ☐ 500/500 ☐ 500/1000 ☐ 1000/1000 ☐ 1000/2000

8. Desired Effective Date: _____

9. Describe prior coverage for the past five years (if any):

Policy Period	Insurer	Premium	Limit	SIR/Deductible
_____	_____	$ _____	$ _____	$ _____
_____	_____	$ _____	$ _____	$ _____
_____	_____	$ _____	$ _____	$ _____
_____	_____	$ _____	$ _____	$ _____
_____	_____	$ _____	$ _____	$ _____

II. EMPLOYEES

1. Total Number of Employees, including Directors and Officers, (all locations):

	Full Time	Part Time	Seasonal	Temporary
Non-union:	_____	_____	_____	_____
Union:	_____	_____	_____	_____

 For seasonal and temporary employees, indicate total annual hours worked:

 Non-union _____ Union _____

2. Total number of employees for each of the last 3 years (all locations):

 Latest Year _____ Second Year _____ Third Year _____

3. Annual employee turnover rate for each of the last 3 years (all locations):

 Latest Year ____ % Second Year ____ % Third Year ____ %

4. How many employees have you terminated in the past three years (all locations):

 Latest Year _____ Second Year _____ Third Year _____

5. Percentage of employees with salaries greater than: $100,000 ____ % $250,000 ____ %

6. Number of employees by length of service: Less than 5 years _____ More than 5 years _____

LD 6550 (Rev.12/92)

III. LOSS HISTORY

1. List all EEOC or NLRB charges and demand letters from current or former employees or their attorney for the past five years. Include for each the applicable dates, damages incurred, legal expenses, current status and brief description of circumstances. Also indicate the valuation date and source of this data.

2. List all lawsuits and any negotiated settlements entered into with any current or former employee for the past five years. Include for each, the applicable dates, jurisdictions, Civil Action or Index Number, legal expenses incurred, current status, and brief description of circumstances. Also the valuation date and source of this data.

3. Are you aware of any circumstances which might give rise to a claim under this policy?

☐ Yes ☐ No **If yes, please provide details on a separate sheet of paper.**

IV. HUMAN RESOURCES

1. Do you have a Human Resource or Personnel position or department?

☐ Yes ☐ No **If no, how is this function handled?** _____

If yes, how many employees are there in this department? _____

2. Do you have a written manual of all your personnel policies and procedures?

☐ Yes ☐ No

If yes, do all your management and supervisory employees maintain a copy?

☐ Yes ☐ No

Do these staff members receive training in the proper implementation of your personnel policies and procedures?

☐ Yes ☐ No

Indicate the date your manual was last updated. _____

3. Do you anticipate any plant, facility, branch or office closings or layoffs within the next 24 months?

☐ Yes ☐ No **If yes, please provide details on a separate sheet of paper.**

4. Do you use an employment application for all your applicants for hire?

☐ Yes ☐ No **If yes, please attach a copy.**

5. Do you conduct an orientation for all new employees?

☐ Yes ☐ No

Is an orientation checklist maintained for each employee?

☐ Yes ☐ No **If yes, please attach a copy of the checklist.**

6. Do you publish an employee handbook?

☐ Yes ☐ No **If yes, please attach a copy.**

Do you distribute it to all employees?

☐ Yes ☐ No

Does the employee handbook contain written company policies pertaining to Equal Employment Opportunity and Sexual Harassment ? ☐ Yes ☐ No

If no, please attach a copy of your Equal Employment Opportunity and Sexual Harassment statement.

7. Do you provide written performance evaluations for all your employees?

☐ Yes ☐ No **If yes, how often?**_____ Please attach a copy.

Do your supervisory employees receive training in the proper method of conducting performance appraisals?

☐ Yes ☐ No

8. Do you have a written progressive disciplinary program?

☐ Yes ☐ No **If yes, please attach a copy.**

9. Do you have a written grievance program?

☐ Yes ☐ No **If yes, please attach a copy.**

10. Do you use any tests for screening employment applicants or for continued employment?

☐ Yes ☐ No **If yes, please describe.**_____

11. Do you have a formal out-placement program which assists terminated or laid off employees in searching for other jobs?

☐ Yes ☐ No **If yes, please describe on a separate sheet.**

12. Do you have an Employment Assistance Program (EAP)?

☐ Yes ☐ No **If yes, please describe on a separate sheet.**

13. Do you seek counsel from a human resource person or attorney prior to terminating an employee?

☐ Yes ☐ No

14. Do you conduct exit interviews when an employee relationship is ended?

☐ Yes ☐ No

15. Are you currently subject to any collective bargaining agreements?

☐ Yes ☐ No **If yes, please describe.**_____

Provide a brief history (on a separate sheet of paper) of any other collective bargaining in which you have participated.

16. Do you post, in places conspicuous to all employees and applicants for employment, all required notices relating to equal employment opportunity laws?

☐ Yes ☐ No

17. Do you have an inforce Directors and Officers Liability policy which includes coverage for employment related practices?

☐ Yes ☐ No **If yes, list the name of the carrier, policy period,**

deductible or SIR and limits of liability._____

Does this Directors and Officers Liability policy exclude "Discrimination", "Sexual Harassment" or "Wrongful Termination"?

☐ Yes ☐ No

V. Claims Handling

1. List the name of the individual you have designated to handle claims:

Name	Title	Phone Number

2. Do you have a written procedure for the prompt reporting of incident and claim information?

☐ Yes ☐ No

Have these procedures been communicated to all your management and supervisory personnel?

☐ Yes ☐ No

VI. Attachments

The following information must accompany the application if applicable:

- ■ Employment Application
- ■ Employee Disciplinary Procedures
- ■ Employee Grievance Procedures
- ■ Employee Handbook/Manual
- ■ New Employee Orientation Checklist
- ■ Employee Performance Evaluation Forms
- ■ Collective Bargaining Agreements
- ■ EEO and Sexual Harassment Policy

IF A POLICY IS ISSUED, A COPY OF THIS APPLICATION WILL BE ATTACHED TO THE POLICY AND SHALL BE THE BASIS FOR ISSUANCE OF THE CONTRACT. SIGNATURE BY APPLICANT CONSTITUTES A REPRESENTATION THAT ALL INFORMATION PROVIDED HEREIN IS ACCURATE AND COMPLETE. SIGNATURE ON THIS FORM DOES NOT CONSTITUTE BOUND COVERAGE.

> *Notice To New York and Ohio Applicants: Any person who knowingly and with intent to defraud any insurance company or other person files an application for insurance or statement of claim containing any materially false information or conceals for the purpose of misleading, information concerning any fact material thereto, commits a fraudulent insurance act, which is a crime.*

Applicant's Authorized Signature (of a Principal, Partner or Officer)	Title	Date Signed

Name of Producer

Address

City	State	Zip Code

Telephone	Fax

INDEX

Also available from Merritt

Whether you are a company president, risk manager, insurance professional, safety professional, security professional, or a business person striving to profit in today's competitive environment, The Merritt Company is a key part of your solution. We take complex, hard-to-understand issues and information and make them easily understandable for today's busy executive. Our team of industry professionals and editors gives you access to information you need to come up with game plans to profit by.

The following is just a partial listing of Merritt publications and services. Please call The Merritt Company at 1-800-638-7597 for a free catalogue or to place your order for additional copies. Choose from the following:

Books

Workers' Comp for Employers — Taking Control Series, 2nd Edition $29.95
How to cut claims, reduce premiums and stay out of trouble
ISBN 1-56343-073-8

Rightful Termination — Taking Control Series .. $29.95
Defensive Strategies for Hiring and Firing in the Lawsuit-Happy 90's
ISBN 1-56343-067-3

Glossary of Insurance Terms ... $14.95
Over 2,000 definitions of the most commonly used terms
ISBN 0-930868-68-4

Spanish Glossary of Insurance Terms .. $9.95
700 of the most commonly used insurance terms defined in Spanish
ISBN 0-930868-83-8

Newsletter Subscriptions

Workers Comp News (biweekly newsletter) ... $87/year
Help for employers: In every issue you'll receive news about regulators, analyses of case studies, tips to minimize your premiums, and much more

Risk Management News and Review (biweekly newsletter) $397/year
FREE BONUS: Your subscription price includes a 3-volume reference set which is updated quarterly

OSHANEWS (biweekly newsletter) .. $397/year
FREE BONUS: Your subscription price includes a 2-volume reference set which is updated quarterly

Protection of Assets (monthly newsletter) ... $397/year
FREE BONUS: Your subscription includes a 4-volume reference set which is updated monthly

For order information, please call Merritt Publishing at 1-800-638-7597.

FREE CATALOG

Find out about other books available from The Merritt Company, including the *Taking Control Book Series* on topics of interest to businesses owners and managers as well as publications on safety and insurance.

❏ **YES**. Please send me information on other Merritt publications. I'm interested in:

❏ Business Management ❏ Workplace Safety ❏ Insurance Training

Name _____

Company _____

Street _____

City _____ State _____ ZIP _____

Phone (_____) _____

MERRITT **The Merritt Company**

NMAA

FREE CATALOG

Find out about other books available from The Merritt Company, including the *Taking Control Book Series* on topics of interest to businesses owners and managers as well as publications on safety and insurance.

❏ **YES**. Please send me information on other Merritt publications. I'm interested in:

❏ Business Management ❏ Workplace Safety ❏ Insurance Training

Name _____

Company _____

Street _____

City _____ State _____ ZIP _____

Phone (_____) _____

MERRITT **The Merritt Company**

NMAA

FREE CATALOG

Find out about other books available from The Merritt Company, including the *Taking Control Book Series* on topics of interest to businesses owners and managers as well as publications on safety and insurance.

❏ **YES**. Please send me information on other Merritt publications. I'm interested in:

❏ Business Management ❏ Workplace Safety ❏ Insurance Training

Name _____

Company _____

Street _____

City _____ State _____ ZIP _____

Phone (_____) _____

MERRITT **The Merritt Company**

NMAA

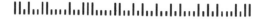

BUSINESS REPLY CARD

FIRST CLASS MAIL PERMIT NO. 243 SANTA MONICA, CA

POSTAGE WILL BE PAID BY ADDRESSEE

 THE MERRITT COMPANY

POST OFFICE BOX 955

SANTA MONICA, CA 90406-9875

BUSINESS REPLY CARD

FIRST CLASS MAIL PERMIT NO. 243 SANTA MONICA, CA

POSTAGE WILL BE PAID BY ADDRESSEE

 THE MERRITT COMPANY

POST OFFICE BOX 955

SANTA MONICA, CA 90406-9875

BUSINESS REPLY CARD

FIRST CLASS MAIL PERMIT NO. 243 SANTA MONICA, CA

POSTAGE WILL BE PAID BY ADDRESSEE

 THE MERRITT COMPANY

POST OFFICE BOX 955

SANTA MONICA, CA 90406-9875